Preservice Art Education:
Issues and Practice

edited by
Lynn Galbraith
University of Arizona, Tucson

1995

About NAEA...

Founded in 1947, the National Art Education Association is the largest professional art education association in the world. Membership includes elementary and secondary teachers, art administrators, museum educators, arts council staff, and university professors from throughout the United States and 66 foreign countries. NAEA's mission is to advance art education through professional development, service, advancement of knowledge and leadership.

ISBN 0-937652-86-5

CONTENTS

Contents *(continued)*

PART III—PRESERVICE PRACTICES

Preface

This National Art Education Association (NAEA) anthology presents a collection of papers that examine how selected preservice teachers, art specialists, and elementary classroom teachers make sense of their art teacher education coursework. Understanding how preservice teachers make the transition from college student to practitioner is a critical area of art educational research.

The contributors to this anthology answered an open call for papers solicited from the field. Correspondence with art teacher educators within the Higher Education Division of the NAEA indicated that many educators involved in art teacher preparation (particularly for elementary classroom teachers) are junior faculty, part-time instructors, and graduate students. The anthology therefore includes submissions from these art educators, as well as from established faculty who teach art teacher education courses. Correspondence indicated that in smaller and more teaching-oriented institutions, a single art educator is often solely responsible for preparing teachers. It is possible that the workload pressures and teaching obligations of these art educators prohibit them from contributing to texts such as this. I am optimistic that this anthology will express and reflect their voices, and if not, I urge them to participate in the ongoing preservice art education dialogue.

Preservice art education is a vital component of art education today; thus, it seems timely that the National Art Education Association has chosen to explore this area. I would like to thank Dr. Thomas Hatfield, the Professsional Materials Committee (PMC), and the NAEA Board of Directors for accepting my original manuscript proposal and allowing this anthology to be compiled. Finally, I wish to thank the contributors, the technical editors and my family especially my husband David, for their patience, assistance, and understanding as work on this anthology progressed.

Introduction

The Preservice Art Education Classroom

A LOOK THROUGH THE WINDOW

Lynn Galbraith
University of Arizona

Lynn Galbraith
University of Arizona

Dr. Galbraith is originally from the United Kingdom and is currently Assistant Professor of Art Education at the University of Arizona in Tucson. She is actively involved in teaching preservice art education methods courses for art specialists and supervising art student teachers. Her research focuses on art teacher education, which she is exploring via the use of interactive laserdisc technology and case study research. She wrote the original proposal for this NAEA anthology and has published in a number of journals, including *Studies in Art Education, Art Education,* the *Journal of Art and Design Education, Visual Arts Research,* and the *Japanese Journal for Art Education.* She initiated the NAEA Higher Education Division's Preservice Interest Group and is Chair of the NAEA Research Task Force on Teacher Education.

Introduction

The Preservice Art Education Classroom

A LOOK THROUGH THE WINDOW

Lynn Galbraith
University of Arizona

This National Art Education Association anthology seeks to add to the evolving knowledge base of art teacher education. It specifically covers preservice issues and is targeted toward both elementary and secondary art specialists and elementary classroom teachers. Throughout the text, insights are offered into how preservice art education is shaped and influenced by the preservice teacher and by the art teacher educator. Such perspectives allow us to more fully comprehend and analyze what actually constitutes preservice art teacher education. Hitherto, preservice art teacher education has most frequently been represented via course syllabi, college catalogs, general program and educational guidelines, and written national standards (National Art Education Association [NAEA], 1979; Rogers & Brogdon, 1990), rather than through studying, describing, and interpreting the activity of preservice art teacher educators. We believe, therefore, that this anthology is both meaningful and timely.

Elementary and secondary school classrooms have been described as communicative and shared environments (Doyle, 1977). This is also true of the preparation programs, cultural and instructional frameworks, and field and student practicum experiences that are encoun-

tered by preservice teachers. A glance through the windows of the various preservice art education classrooms depicted in the chapters in this anthology reveals an environment in which past, present, and future artistic and educational demands compete. These demands derive from the beliefs, experiences, values, emotions, interests, and needs of the individuals—administrators, faculty and preservice teachers—who work in these settings. The nature of competition within this environment is both complex and stimulating, and it gives rise to a host of theoretical and practical challenges and dilemmas commonly encountered by teacher candidates during their professional preparation.

Although this anthology is limited in terms of space and subject matter, and therefore can afford only brief glimpses into a few classroom settings, nonetheless it identifies a diverse and far-reaching series of questions concerning the challenges of art teacher education, and it provides assistance in finding the appropriate responses. The individual chapters provide a wealth of ideas. In some cases, common themes emerge that serve to illustrate the accomplishments of teacher educators and preservice teachers as they collaborate and work together effectively. In other cases, the writings bring to the forefront more troublesome, sometimes unresolved issues that many in teacher preparation recognize and grapple with on a continuing basis. Taking Mason's (1991) cue that art teaching and research are related, coupled with the notion that educators should examine their own practices (Galbraith, 1988; Rudduck, 1988), these papers also confront some of the ordinary issues and practices—art anxiety, grading policies, differing or similar expectations for art specialists and elementary majors, to name but a few—that are a familiar part of life in the preservice classroom. Other issues may appear more significant to the reader, for example, the dilemma of balancing successful art teaching practices needed for working in real schools with the need for school reform and change. Also questioned is the way in which the nature of the work of teaching is defined, valued, and represented in preservice art teacher education art classrooms and schools today.

As the initiator and editor of this preservice anthology, I have taken the liberty of grouping together chapters that contain similar ideas and themes. These groups are then placed within a larger, tripartite framework. Some papers are broader in scope and do not fit as neatly into these groups as do others. Nonetheless, I contend that if we are to make a start at interpreting and analyzing the tasks involved in preparing art teachers, we must develop a shared language that allows us to identify and evaluate key issues within preservice art education. Doyle (1990), whose ideas about teacher education in general have heavily influenced my own thinking, put it this way:

Rather the emphasis is to understand how meanings are constructed in classroom settings. To do this kind of analysis, one must have a powerful language to describe both events and the interpretations made of these events. It is not assumed that all entities have the same meaning to everyone; indeed the meaning of most objects and actions in the complex environment of classrooms is indeterminate. The assumption is made, however, that analytical knowledge about the interpretive process is possible. Research along these lines generates not indicators, but frameworks about what teachers know, how they act, and what judgments they make in solving teaching dilemmas. (p. 20)

Although Doyle was referring to research in schools in this particular passage, his words are relevant for those of us who wish to fathom how preservice teachers and art teacher educators negotiate and interact with one another in classroom settings. Meanings within preservice classrooms also become indeterminate, and the development of a collective knowledge base that describes these meanings becomes imperative.

Part I of the anthology, "Learning to Teach: The Preservice Teacher," brings to the table issues and practices involved in learning to teach art. The chapters grouped in this section explore how preservice art specialists and elementary classroom teachers interact and learn within specific preservice environments. They help us to begin to form a general understanding of how preservice candidates actually make the critical transition from college student to practitioner. This is a crucial but as yet seldom studied area of art educational research. The importance of developing a set of shared understandings about the tensions, expectations, and interactions that surface within the preservice environment cannot be understated.

Part II, "Teaching Others to Teach: The Art Teacher Educator," turns to the many issues and concerns involved in educating others to teach art. Specifically, the chapters examine how art teacher educators represent, verbalize, and model art education curricula and pedagogy in order to enhance the learning of preservice teachers. Research on art teacher educators is both mandatory and significant, particularly since issues related to their practices are rarely questioned. For example, what is the quality of the coursework they offer? How do they balance the institutional demands of teacher education coursework with the beliefs and values that they themselves hold? A call is raised for much-needed dialogue about the work of art teacher educators.

Part III, "Preservice Practice," illustrates a series of institutional and programmatic experiences that are part of actual preservice art education practices within colleges, universities, and professional art schools.

PRESERVICE TEACHER EDUCATION: A BRIEF OVERVIEW

Considering the complexity and morality of an activity such as teaching (Sockett, 1990; Tom, 1984), it is surprising that inquiry into teacher education practices is part of a relatively new research agenda that has only emerged as a field of study since the mid-1980s. Teacher educators are now beginning to take stock of what is actually happening within the extraordinarily large (over 1,200) number of teacher preparation frameworks found in the United States (Doyle, 1990). As Ryan (1975) aptly posited, "While teacher training has its fads and frills, it is basically an unglamorous subject. It is, nevertheless, a burning presence that lurks at the edge of all proposals to improve schools and cannot be ignored" (p. ix).

Criticisms of preservice teacher education in popular and professional journals and newspapers have focused on the quality of teachers and teaching: Each critic is, of course, an expert regarding public education. Unfortunately, public knowledge of what teacher education comprises typically is developed from familiar and ordinary descriptions that are not critically examined. This has contributed to the questioning and hammering that have left many administrators, faculty, and preservice students vulnerable and open to a variety of both positive and negative interpretations (Rudduck, 1991). One does not have to venture too far outside the doors of the higher education academy to encounter critics who are quick and eager to find fault with teacher education practices (Conant, 1963): Education is central to the experience of all.

A similar rhetoric is heard within higher education itself. Faculty who are involved with teacher education, and therefore closest to the professional requirements of schooling, are often given little regard either by colleagues in other subject disciplines (Goodlad, 1990; Lanier & Little, 1986) or by peers in other educational fields (Judge, 1982). Particularly troublesome is that many preservice candidates spend much of their time as undergraduates taking coursework with faculty who obviously have little interest in teacher education (Clark & Marker, 1975).

Historical divisions such as these (Conant, 1963), combined with recent economic and political trends and constraints, serve to threaten

and erode the qualities and the financial and human resources essential for maintaining and reflecting an image of collegiality within both the preservice classroom and the larger public sector. Art education pedagogy is unfairly curbed by the beliefs and values of school administrators and teachers, often because they are unable to evaluate its worth and therefore presume that it cannot amount to much (Greene, 1981).

Paradoxically, some of this persistent criticism has evolved from public scrutiny of schools and the way in which practicing teachers do their jobs. As a consequence, rather than closely observing and evaluating teacher education programs themselves, critics trace poor teaching back, more often than not, to teacher preparation programs. This is not to say that teacher education units are not preparing teachers adequately, but until recently there has been little examination of the actual goals and practices of teacher educators (Lanier & Little, 1986; Goodlad, Soder & Sirotnik, 1990).

Lack of substantive evidence documenting the contributions of teacher educators to the mission of schooling has caused the general public to use conjecture to assess teacher education practices and to listen to the accounts of beginning teachers themselves as they relive and recount their teacher education experiences. There is ample testimony that ongoing and familiar practices within schools are strong influences on beginning teachers (Valli, 1992; Zeichner & Tabachnik, 1981). Presumably, as preservice teachers enter schools they tend to leave (either willingly or unintentionally) the scholarship and advice of teacher education far behind. It seems imperative to develop images of teaching within the preservice classroom that strike a balance between successful practices needed for real schools and those that reflect the need for school reform and change. Yet all teachers must be equipped with a body of knowledge and pedagogical skills if they are to be consistently effective (Peters, 1977).

In most teacher preparation programs, there is a tendency for preservice teachers to take coursework in the liberal arts and sciences, the content area to be taught, the professional educational disciplines, and clinical practice and other fieldwork experiences within school settings (Doyle, 1990; Goodlad, Soder & Sirotnik, 1990). Specifically, art teacher education programs often comprise coursework divided between general education, studio education, generic pedagogy, and art education methodology, along with a final all-day, semester-long student teaching practicum. This series of discrete program components has changed little over the years (Sevigny, 1987).

It can be claimed that we have allowed life in our preservice art education classrooms to develop with little monitoring from the field (Davis, 1990; Galbraith, 1990; Koehler, 1979). This may be because getting a handle on the inner workings of actual preservice classroom life is difficult, considering the intricacies, protocols, and hierarchical structure of higher education and the actual terrain of art education. Furthermore, developing substantial and vivid descriptions (rather than mere accounts) of how knowledge is collaboratively constructed between art teacher educators and preservice teachers is not a simple matter. Nor is establishing how this knowledge should be valued and represented within classrooms. One of the goals of this anthology is to make a start at examining such issues and practices.

LEARNING TO TEACH:
THE PRESERVICE TEACHER

During their college or university years, most preservice teachers are grappling with new knowledge and ideas about teaching (Zimpher & Howey, 1987) and are also coping with the demands and requirements of the college or university teaching and learning environment (Cross, 1976). As preservice teachers participate in their preparation programs, they are asked to wear two academic hats—that of the college or university student and that of the beginning teacher. Not only are they involved in being educated about professional aspects of teaching in the form of subject matter content and pedagogical processes (Turner, 1975), but they are simultaneously engaged in learning how to educate others. The interchange between the roles of student and beginning teacher is difficult and stressful. It requires that preservice teachers balance their personal identities with those of a more professional nature and intent. Individual beliefs, values, experiences, family needs, outside employment, and age and gender differences at times come into conflict with those associated with the collective work ethic typically intrinsic to the general education, academic subject matter, and professional coursework requirements mandated for completion of teacher education and certification requirements.

These tensions are exacerbated by preservice teachers' own familiarity with schooling. Unlike practitioners of other professional occupations, prospective teachers have chosen a profession that they have personally experienced—and in a compulsory manner—for a good part of their lives (Calderhead, 1988; Lortie, 1975). Britzman (1991), in her elegant book on the struggles of learning to teach puts it this way: "Implicitly, schooling fashions the meanings, realities, and experiences

of students; thus those learning to teach draw from their subjective experiences constructed from actually being there" (p. 3).

The preservice art education classroom also serves metaphorically as the crossroads at which prospective teachers begin to make key decisions about their future lives. These decisions are influenced both by the beliefs and images of teaching and art held by these prospective teachers and by their current assessments of their university or college subject matter and teacher education coursework (Doyle, 1990). Research suggests that beliefs and practices about teaching (both positive and negative) are powerful forces in education (Calderhead, 1991; Smythe, 1987).

The chapters in Part I of this anthology clearly show that the circumstances surrounding the lives of preservice teachers are still unfolding. They highlight the idea that preservice teachers are not only being prepared to be trustees of the ways of life of the students they will eventually teach, but are also preparing to become stewards and authors of their own lives. The chapters also define two types of preservice teachers—the elementary classroom teacher and the preservice art education specialist—who comprise two distinct populations that generally hold differing images of what art teaching entails.

As previously mentioned, research into educating prospective elementary classroom teachers is sparse (Galbraith, 1991), and there have been few studies concerning the ways in which art specialists are prepared (Davis, 1990). The authors in this anthology provide insights into how prospective teachers think about art and teaching. Their writings lead toward a comprehension of the process involved as these future teachers undergo the transition into thinking like art teachers. They help us understand how future teachers figure out what is expected of them within their programs. The use of case histories from art teaching, illuminated by direct quotations from preservice teachers, provides glimpses into the "real world" of the preservice classroom. Interspersed within these chapters are clues that allow us to identify the intentions of their writers, who are art teacher educators responsible for art teacher preparation.

Deborah Smith-Shank's chapter, "Mickey Mouse or Mapplethorpe: Metaphors for Understanding Art Anxiety," explores how art anxiety fostered by early art experiences affects attitudes toward and knowledge about not only art itself, but also how art should be taught in schools. Her metaphors bring to the surface seldom-examined issues in art education.

Particularly important is the notion that preservice elementary class-room teachers enter with anxieties about art subject matter that can either hamper learning or (with the right kind of encouragement) lead them to follow new artistic directions. These prospective elementary teachers, many of whom will ultimately be responsible for teaching art to students, are frightened by the subject matter. Smith-Shank questions how to acknowledge these doubts and fears and yet at the same time help preservice teachers develop the understanding necessary for teaching appropriate art activities in their schools. She poses a series of questions not only about how preservice teachers think and behave, but also about the way we are actually teaching them in our teacher education programs. Her chapter suggests that we must begin to find alternative pedagogical strategies for methods course instruction. These should be based on the knowledge we have gleaned from the anxieties, self-doubts, lack of artistic confidence, and other problems demonstrated in preservice teachers' reflective analyses of their prior art experiences.

Smith-Shank's chapter alerts us to the need for major changes in the attitudes and perspectives about art education held by prospective classroom teachers. If preservice elementary education majors are seriously afraid of art and believe both that art is a difficult subject to teach (Galbraith, 1991) and that they need a store of ideas (a "recipe book") from which to teach, then art teacher educators have a great deal of work and soul searching to do. An obvious conclusion is that preservice teachers often fail to realize that, within school settings, they do not have to continually make art projects. Instead, they should employ their preservice training as a means to learn how to teach art *concepts*. How can we develop a pedagogy that will enable these prospective teachers to think beyond their personal insecurities, to develop an enthusiasm and willingness to teach art to children? How can we model appropriate practices for the elementary classroom? Fortunately, Smith-Shank concludes her chapter with a series of suggestions of issues that must be seriously addressed within our field. It is hoped that she and other art educators will continue research along these lines.

Mary Stokrocki's chapter "Creative Tension: Problems in Teaching Art Education to Classroom Teachers," examines how prospective class-room teachers negotiate the learning and teaching that takes place within the preservice art education classroom itself. Like Smith-Shank's chapter, this chapter reveals a series of issues that preservice classroom teachers bring to an art education methods course. The metaphor of creative tension describes instances of the pressures and dilemmas that surface between preservice teachers and the instructor

in a methods course. Stokrocki relates how preservice teachers' perspectives can influence the methods course learning climate in both negative and positive ways. Such perceptions have led to a series of cultural myths, dispositions, and stereotypes, not only about education, but also about what art education methods course teaching involves and the expectations of prospective elementary classroom teachers who are taking these courses. Art educators have denounced the myths that exist within art education and the ways in which these myths have been transformed throughout the years into the reality of our schools (Chapman, 1982; Efland, 1976).

It is not surprising that, as a university professor, Stokrocki is being confronted with elementary education majors who believe that art is a predominantly hands-on activity. Such myths abound in our schools, despite the concerted efforts of many in the field to dispel and clarify them. Explicit within Stokrocki's chapter is the issue of grading, a problem encountered by most art educators on a daily basis, especially in the instructional context of higher education. She recounts how many preservice classroom teachers perceive her methods courses as a means to getting an easy "A." She elucidates the common belief of preservice students that merely completing a quantity of work is the prerequisite for a superior grade. All too often this matter is readily dismissed by professionals in the field, typically by thinking that preservice teachers with these attitudes should not be in teaching anyway.

Upon further reflection, the issues become much more complicated than at first glance. It seems possible (as Smith-Shank's chapter also implies) that anxieties about art could also lead to the fear of not getting a good grade, especially as competition intensifies for places in elementary teacher education programs. Concerns about survival, competing course requirements, and maintaining a high grade point average are certainly part and parcel of the university or college student role. Given these valid concerns, we begin to understand some of the difficulties experienced by beginning teachers in these classes. It is possible that we in the art education profession (as well as in schooling in general) actually encourage these assumptions and fears through the persistence of studio activities in many school art programs, the widespread belief that art requires talent, and the fact that few changes have been implemented in the methods by which art is taught in schools (Gray, 1992; Jones & McFee, 1986; May, 1989).

Many preservice teachers regard their preservice student role as doing what is expected, and therefore they expend considerable effort trying to figure out these expectations rather than trying to resolve their problems through independent learning. On the one hand, these

future teachers are on target in that many professors expect the right answers to the problems they have set, especially if flexibility and negotiation are not built into the course expectations. On the other hand, it seems appropriate that art teacher educators should expect future educators to take risks, to be inventive, and to learn how to develop alternative solutions to curricular and pedagogical problems. This type of expectation seems entirely complementary to the goals promoting artistic thinking.

Stokrocki's chapter demonstrates that preservice teachers are concerned about their relationship with their institution. Many take a large number of units or credit hours per semester or are in other employment during their off-campus hours. Many view their teacher education coursework as a series of discrete, compartmentalized components. It is no wonder that some preservice teachers, unless they are helped, are unable to forge the links between the various courses they take and their larger professional goals. They particularly need assistance in constructing an intellectual framework within which they can develop their educational theories and combine them with practical, common-sense notions. Stokrocki's chapter highlights again the need for a significant reevaluation of the coursework for elementary education majors and an examination of its pedagogy.

In "Context for a Profile of a High Achieving Preservice Early Childhood Education Major in an Arts Methods Course", Read Diket describes an interesting case study of a prospective elementary school teacher. As the chapter unfolds, we see the other side of the preservice coin: Diket highlights a specific preservice classroom teacher who is talented in the visual arts and is particularly interested in furthering her artistic development. Diket chronicles this development, detailing how the preservice teacher eagerly works to overcome her perceived lack of art curricular and pedagogical knowledge. Implicit in this chapter is the problem of typecasting elementary classroom teachers rather than encouraging and accommodating the particular artistic insights and pedagogical strengths of individuals. Diket's chapter raises a number of questions about how we can nurture artistic talent in prospective elementary classroom teachers in our college and university courses. This concern is echoed by Carol Jeffers in a later chapter which portrays a preservice elementary education teacher who is thinking of changing her major in order to become an art specialist.

We must consider what preservice issues are raised when teacher educators encounter talented preservice candidates such as the one portrayed in Diket's chapter. She is talented in the sense that she clearly found her niche in her art education methods course. What I find

important is that this preservice elementary classroom teacher demonstrates a willingness to learn more so that, in turn, she can be a successful classroom teacher who will teach art.

Taken together with the chapters by Smith-Shank and Stokrocki, this work squarely presents the art teacher educator with a dilemma: the presence in art education methods courses of prospective elementary teachers who are either talented and enthusiastic or anxious and fearful of art. Issues of how we can accommodate a combination of different types of preservice teachers within our programs—and specifically in preservice art education classrooms—are raised. The dilemma of individual differences is not unlike those that will be encountered by future teachers as they enter the schools. A common theme interwoven within this anthology is the notion that teacher educators must critically review the choices they make in order to provide maximal benefit to their preservice students on an individual basis. Whether or not this is possible, given heavy research and teaching schedules of college faculty, is another question.

In the chapter that follows, "Reflections of a Preservice Art Specialist," the perspectives of a preservice art specialist are presented. The author, Maureen Byrne, has recently finished her art teacher preparation studies. She has embarked on her first year as an art teacher, while remaining enrolled as a part-time graduate student. Byrne reflects upon her teacher preparation and comments on her prior preservice role as a "new nontraditional student." She informs the reader how, at first, she did not want to take further professional development coursework, but that after taking her first class she realized how much she would gain from her teacher education program. She writes about what she learned at the university, about how much she was encouraged to *think like a teacher*, and about the way she developed a link between her teacher education program and the process of reform and change in schools.

As Byrne begins student teaching and talks to other teachers, she comes across an ongoing issue that haunts many teacher education programs, namely the criticism that colleges and universities do not adequately prepare teachers for the reality of teaching art in schools. Through a conversation with herself, Byrne examines the particular myth that "you don't learn anything in the university." She further outlines the dissonance that emerged as she evaluated the pressures of being with school practitioners who were insecure with her newly acquired and different knowledge about teaching.

Byrne represents a relatively rare subgroup of preservice art teachers in that most preservice teacher candidates embrace familiar patterns within the schools and do not see themselves as part of a link to any form of educational reform. Lampert (1985) has noted that practicing teachers' pedagogical work is personal and that the pursuit of this work results in a series of pedagogical quandaries. She has reminded us that one of the major goals of the preservice art teacher education environment should be to aid our preservice teachers to experience ambiguity and to understand the dissonance that they may encounter as they attempt to take on their art teaching roles. Nevertheless, student teaching all too often serves as a means of physical and intellectual separation from teacher education programs.

TEACHING OTHERS TO TEACH: THE ART TEACHER EDUCATOR

Art teacher educators may feel that teacher education per se is given little respect within higher education. Nonetheless, these educators are powerful figures in preservice art teachers' lives, and as such they belong at the heart of educational research and actions (Rudduck, 1991). Their intentional decisions, guided by their professional judgments, direct their varied preservice instructional settings. It is their wisdom, both conventional and practical, that usually determines and articulates what art curricular content and pedagogical strategies they judge to be appropriate for preservice teachers to use within preservice classrooms and ultimately within schools. At the practical level, art teacher educators usually select the content to be taught, decide and plan how to present it, devise class schedules, assign grades, and create working relationships within preservice art education classrooms. This is a hefty charge, and it involves many intellectual and ethical responsibilities. Art educators hold privileged positions; therefore, they influence the potential practices of teachers whether we like it or not. They not only act as authorities within their subject matter, but also hold significant jurisdiction over who can be initiated into the art education profession. The possibilities for abuse of this authority are great.

Art teacher educators are also in the business of trying to implement innovative pedagogy in the schools. Historically, their job descriptions revolve around teaching courses in art subject matter, pedagogy, and the supervision of student teaching and other field experiences. MacGregor (1988), drawing from the work of Donald Schon (1983), has urged us to identify "the metaphors by which the teacher makes sense of professional life" (p. 10). This is useful advice that may have further implications within the framework of art teacher preparation. How might art teacher educators actually work with others in their class-

rooms, and how might they simultaneously respond to the interests and needs of their preservice teachers? How might teacher educators' own associations with teacher education, their own research and teaching agendas, and their own biographical stories influence the preservice environments they foster? Essentially, how do art teacher educators give meaning to their "professional life" or what constitutes their "well-being" (MacGregor, 1988, p. 10) within the preservice art education environment?

Like the preservice teachers they educate, art teacher educators are active participants in their own stories, which are inextricably enmeshed with professional and personal issues of teaching, scholarship, tenure, collegiality, workloads, and so forth. This specifically affects the kind of preservice environment they produce, and this in turn becomes a significant component of the biographies of preservice teachers. These beliefs and values further complicate the preparation of knowledgeable and sensitive teachers.

Mason's (1983) comparative study of art teacher education programs in England, Australia, and the United States highlighted the general dissatisfaction that some preservice art teachers experienced with their art education methods courses. This dissatisfaction is rooted in the feeling that art teaching is most successfully learned on the job. Blame is placed on inadequate professional training, and practitioners decry the impractical nature of their methods courses.

Many art teacher educators contend with real teaching pressures and dilemmas in their preservice classrooms, from their institutions, and from the schools in their communities at large. These challenges are complicated by the requirement for substantial changes in the art education knowledge base and by shifts toward diversity and multiculturalism, as well as by limited budgets and dwindling resources.

What distinguishes the chapters that comprise Part II of this anthology is the consistent implication that the broadening of exemplary pedagogical techniques and the strengthening of art curricula must ultimately be driven by those who teach and conduct research at the college or university level. In order to implement these changes, we must fully understand what guides the decision making, content choices, and pedagogical methodology of the preservice art educator. Research is needed that will develop a comprehensive description and interpretation of this academic work and its familiar, yet personalized meanings and shared understandings for the teachers. This type of scholarship opens up considerable possibilities for renewal and change in the direction of

art teacher education, as well as documentation of successful curricular and pedagogical practices.

Phoebe Dufrene's chapter, "Resistance to Multicultural Art Education: Strategies for Multicultural Faculty Working in Predominantly White Teacher Education Programs," is a powerful reminder of the central role to be played by multiculturalism within the visual arts. Dufrene squarely presents the issues that she, as a professor with a "multicultural family history" and as an "artist of color," faces within her own preservice setting, comprising predominantly white and rural Midwestern students. From her biography, life history, and experiences, it is obvious that Dufrene imprints the lives of her preservice teachers. She relates a series of personal stories that detail the frustrations that she encounters as she goes about her teacher education work.

In her chapter, Dufrene invites us to reflect upon the predominantly Western artistic canon. At the same time, we cannot but notice the traditions that underlie the dynamics of teacher-student interactions within the preservice environment. Dufrene reminds us that preservice art education must be concerned not only with developing appropriate visual arts subject-matter content encompassing a diversity of artists and cultures, but also with fostering a pedagogy that enables prospective teachers to reflect upon their own values and assumptions about teaching. A respect for individuals is implicit in any curricular enterprise; preservice art teachers must be prepared for the diversity of situations and conflicting goals that teaching presents.

Dufrene alerts us to the powerful, personal, and practical knowledge and biases that her preservice teachers bring to her classroom. As teacher candidates from predominantly white and rural backgrounds, they react strongly to her as a person of color. This lends credence to her concern that the beliefs and values that these preservice teachers hold may be noncongruent both with Dufrene's beliefs and values as an instructor and with art education and multicultural thinking in general. Dufrene briefly alludes to her personal dissonance (and that of her preservice teacher students) that develops within the preservice setting that she has established. This leads to the following questions: If tolerating ambiguity, allowing oneself to confront contradictions, and recognizing that tensions will exist within classrooms at all levels are necessary qualities that art educators must foster, what are the implications for developing such traits within the preservice art education environment?

How can we develop a pedagogy that will allow preservice teachers to develop beyond their preconceived expectations for their courses, which often revolve around their own interests and concerns? Are there any guarantees that we can help preservice teachers to suspend their prior beliefs about art teaching so that they will be able to consider the fundamental ethical and professional obligations necessary for art teaching? How do we help such prospective teachers question their underlying assumptions, which they will automatically teach (Galbraith, 1991)? How can we convince them that these viewpoints are detrimental not only to reform in art education, but also to teaching our children in schools? Calderhead (1991) has suggested that it may be necessary at times to stimulate dissatisfaction with existing images of teaching and to engineer dissonance within the preservice environment in order to compel prospective teachers to begin to question and redefine their notions of teaching. The conflicts between the pressure to conform and the move toward change evidently can lead to further anxiety and stress.

As if to address some of these questions, Dufrene offers a series of strategies and references directed at helping her white preservice teachers embrace a more inclusive curriculum and pedagogy, and at collaborating with and educating, faculty and staff across the university campus. These important concerns and issues demand immediate attention. Opportunities for persons of color and diversity, as well as individuals with disabilities, children from special populations, and those considered at risk, must be incorporated into both preservice and school classrooms.

In "Who Teaches Art? Recycling the Question," Carol Jeffers depicts a conversation she had with a preservice elementary classroom teacher, when she was a graduate teaching assistant at the University of Maryland. This preservice teacher was thinking of changing fields in order to become an art specialist. Although this dialogue is helpful in answering the specific questions posed by the preservice teacher, it also serves as an exploration of the typical issues encountered by those who teach in preservice art education programs from an interesting and unusual viewpoint.

The first part of Jeffers's question: "Who Teaches Art?," brings up the point that many preservice methods courses, especially those for the preservice elementary classroom teacher, are taught by graduate assistants (often working alone), and not by interested and experienced professors (Watts, 1984). Jeffers discusses the role that graduate teaching assistants play in preservice art education. She argues that her involvement with preservice candidates allows her to experience at first

hand the structure and function of higher education in general and of art teacher education in particular.

The second part of Jeffers's title, "Recycling the Question," directs us to recognize the common conflicts that preservice art teacher educators encounter, whether as graduate assistants or as faculty. This leads us to examine precisely what and how we actually teach prospective art teachers.

After reading her chapter, I am prompted to wonder which decisions we really make regarding the knowledge of art content over the acquisition of pedagogical skills. Do our teacher education programs actually meet the criteria recommended by the Teacher Preparation Standards Committee of the NAEA (1979)? What teaching methods do we really employ within our preservice environment? Do we, as preservice art teacher educators, successfully model and exemplify the good and innovative art teaching we so advocate? Or do we merely disseminate information about art and art teaching? One of the major dilemmas for art teacher educators is how to introduce preservice teachers to this wider framework of art content and pedagogy simultaneously (Galbraith, 1992). These are fundamental and exciting questions that highlight the need for art teacher educators who are able to reflect, model, and encourage such understanding in their coursework—the very kinds of questions that Carol Jeffers would like us to tackle.

In "Recent and Relevant School Experience: Art Teachers as Art Education Lecturers," British art educators Richard Hickman and James Hall provide a fascinating report on the issues raised by the United Kingdom's Council for the Accreditation of Teacher Education (CATE). This national governing body oversees the quality and nature of school experiences provided by university and college education lecturers in teacher preparation programs. As a result of the United Kingdom's 1989 Education Reform Bill, all university lecturers responsible for training art teachers are required to demonstrate that they are continuing to work in the schools, and art teachers in schools are encouraged to take on joint appointments in institutions of higher education.

This particularly intriguing chapter not only adds an international dimension to the anthology, but also provides novel insight into the connections between theory and practice that link teacher education programs and education within schools. It also raises interesting and relevant questions about mandatory national standards. Although it is likely that many art teacher educators do establish school links, it seems unlikely that many have spent time actually teaching and work-

ing in a school setting. Dreeben (1987) has argued that teacher educa-
tion must take into account "the context of knowing about the nature of
the larger educational setting into which the work of teachers is inextri-
cably tied" (p. 363). Needless to say, preservice art teacher education
must furnish prospective teachers with ways in which to be successful
as practitioners. It must also prepare these teachers to act as agents in
bringing the message of art educational change to schools. It seems
possible that teacher education programs that involve having a "foot in
two camps" (the university and the school) can go a long way toward
establishing a healthy relationship between universities and schools.

These authors also provide some words of caution. They indicate
that the role of a university lecturer is different from that of a practic-
ing art teacher, since the institutional contexts and goals of universities
and schools are different. Dewey (1904) originally described the ten-
sions that exist between theoretical and practical orientations in peda-
gogy. Teacher educators, in general, consider teaching differently from
school practitioners working in the field (Eisner, 1982; Griffin, 1983).
Preservice teachers perceive art teacher educators as experts and as
instigators of new theoretical developments. Art teacher educators are
also perceived by practitioners as residing behind the well-insulated
walls of their institutions, rarely setting foot in schools. They are
viewed as being at least one step removed from the real and practical
issues facing art teachers today (Mason, 1983). From this perspective,
the institutional knowledge generated by teacher educators is frowned
upon by practitioners, particularly if it appears to be at odds with pre-
vailing art practices in schools.

The intriguing notion of teacher-oriented research is also discussed
by Hickman and Hall. They argue that this "joint appointment" facili-
tates a form of action research (Elliott, 1991; Rudduck, 1991;
Stenhouse, 1985), although they acknowledge that teaching duties tend
to infringe on available research time.

Aspects of the theory-practice debate and the use of action research
brought up by Hickman and Hall, are discussed further in Frank Susi's
chapter, "Developing Reflective Teaching Techniques with Preservice
Teachers." Susi examines the use of reflective writing in the preservice
setting and the features and values associated with reflective practice.
He goes on to describe how his preservice art education teachers actual-
ly use reflective techniques to organize and transform preservice theo-
ries into pedagogical practices in schools and to inquire more deeply
into their teaching.

After defining the meaning of *reflective teaching*, Susi examines how reflective capabilities can be used as ways in which to improve art pedagogy in schools. Susi offers examples from fieldwork of the ways in which preservice teachers can reflect upon their experiences profitably. In turn, he discusses ways in which the preservice classroom can be used as a forum for the discussion and evaluation of fieldwork teaching experiences.

Susi's research paves the way for an examination of how preservice teachers can become responsible for their own purposes, long-term growth, values, and learning (Zeichner, 1983). This means that preservice teachers will need to be given opportunities for study and reflection (Zeichner & Liston, 1987; Zimpher & Howey, 1987) in order to help them move beyond their prior premises and beliefs about teaching.

In a similar vein, Craig Roland's chapter, "The Use of Journals to Promote Reflective Thinking in Prospective Art Teachers," not only furnishes insights and research into Roland's own teaching, but also extends the theme of reflectivity and the utility of journal dialogues as pedagogical tools within the preservice setting. Roland details how his preservice teachers employ these approaches to reflect upon their past learning and thinking and to identify their own beliefs about and values in teaching. The chapter, quoting verbatim, illustrates how preservice teachers can begin to examine and question their self-perceptions as future teachers.

As depicted in an earlier chapter by Deborah Smith-Shank, the use of journal entries can assist in the development of more open and interactive communications between teacher educators and preservice teachers. Roderick (1986) has described how journals can serve as a means for a written dialogue, in a private manner, between professor and student. Clearly, Roland's chapter informs us that journal reflections enable teacher candidates to examine their roles as both university students and prospective teachers. Learning to teach is a personal endeavor.

Over all, Roland's teaching methods and research findings trigger an acknowledgment that preservice art teacher education must be concerned with developing potential educators who will maintain a sense of identity and collegiality within the field of education. As suggested earlier, it is not surprising that the interpretations that preservice teachers make of the theoretical and practical aspects of teaching art are interwoven within their own diverse and unique goals and their personal stories and biographies. Roland suggests that associations and images of art teaching in the past figure heavily in his preservice

teachers' writings. The task of journal writing also provides future teachers with models and opportunities for thinking about and acting like teachers in ways that are valuable and acceptable.

Craig Roland's and Frank Susi's chapters are thought provoking. The theme of reflection also appears in several other chapters of this anthology, specifically those by Deborah Smith-Shank and Maureen Byrne. It is possible that through careful and focused responses to jour- nal entries, art teacher educators can begin to encourage preservice teachers to explore more aesthetic, humanistic, and ethical theories and behaviors and so take responsibility for their actions (Van Mannen, 1977). If all children are to be exposed to high-quality art education art teacher education programs must develop teachers who are able to question and interpret the world of art (NAEA, 1986).

These chapters also encourage us to question the practices of teacher educators themselves. We can ask whether art teacher educators employ reflective techniques in their own teaching, or whether they simply relate teaching issues to those they have previously practiced and experienced (Doyle & Ponder, 1977-78). It has been noted that col- lege-level instructors and cooperating teachers in schools often do not model the practices they verbally promote (Zeichner & Gore, 1990).

Mary Erickson's chapter, "Art Appreciation and Preservice Art Education: A Taxonomy of Issues," examines the issues involved in developing a new art appreciation course for prospective elementary classroom teachers. This course is intended to provide a foundation upon which teacher candidates can develop ways to teach elementary students about artworks from different eras and diverse cultures. Erickson aptly raises and develops a series of questions (77 in all!) revolving around the teaching of art appreciation and notions of child development.

Her chapter is instructive, for we are able to sense Erickson's mind at work as an art teacher educator as she thoughtfully plans her course curriculum and prepares to put it into place within the context of her unique university environment. She reveals the thought processes involved in her scholarship and art teacher education pedagogy.

Issues of actual course content—namely what aspects of the visual arts should be taught—are addressed, as well as the suitability of this content for prospective elementary school teachers. In fact, Erickson's chapter invites us to ponder the differences between teacher education coursework in the visual arts for prospective art specialists and elemen- tary classroom teachers. Considering the expansive knowledge base

that comprises art appreciation, Erickson questions which aspects of the visual arts are learned by preservice teachers. In addition, she examines how this knowledge base might differ in the schools in which these teachers will eventually start their professional careers, as well as in the context of higher education itself.

Preservice elementary classroom teachers often make assumptions about what elementary children need to know about art despite their limited knowledge of art, and the curriculum ideas they develop prove to be either difficult or simplistic (Galbraith, 1991). Erickson's chapter addresses these points. It is obvious that she is acutely aware of how much her prospective elementary classroom teachers do not know, and so one of her aims is to design an art appreciation curriculum that will address their needs.

It was suggested earlier that teaching in higher education is often viewed as the transmission of information and is less than innovative. Erickson's chapter, aided by a helpful matrix, demonstrates her concern for the curricular and pedagogical relationships within art education and teaching in general. It is evident that her art appreciation course will model a range of ways of thinking and acting in terms of the disciplines of aesthetics, criticism, art history, and art production. Erickson's methods imply that artistic learning will be formed through experimentation with various artistic roles and choices. Above all, this art appreciation course appears to have been infused with the tacit belief that prospective elementary school teachers must act in ethical, sensitive, and culturally responsible ways in classrooms.

PRESERVICE PRACTICE

As indicated earlier in this introductory chapter, art teacher educators often work in environments in which they are subjected to criticism. Faculty involved with training art teachers face skepticism from faculty colleagues, both from within the arts and sciences and sometimes from within art education itself. It is helpful to pay heed to issues that revolve around the personal and workplace conditions of art teacher educators. Many are confronted with added pressures of teaching, advising, and scholarship, and many teach knowing that they face stiff competition from other courses in education or in school subject areas. Relatively little time is assigned to art education preservice coursework in higher education, especially that concerning art education pedagogy. Such competition across subject disciplines is worrisome.

The poor image of teacher education within higher education may well account for why many art education preservice methods course instructors regard themselves as teachers of subject matter (art), rather than as art teacher educators. To escape the criticism of being labeled as solely practical, methods course instructors often give their preservice courses a subject orientation in which content is emphasized over pedagogical methods.

Another concern arises from the almost schizophrenic persona that art teacher educators are forced to embrace by their institutions. Art teacher educators are typically located either in departments of art or in colleges of education. They are often perceived as neither artists (by those in art departments) nor educators (by those in faculties of education). Faculty colleagues tend to be suspicious of educators who are involved with students whose goal is to teach children below the 12th grade.

The chapters in Part III of this anthology examine actual preservice practices within various contexts of higher education. In the first chapter, "A Brief History of Preservice Education for Art Teachers in the United States," Peter Smith tracks selected historical developments in preservice art education in the United States. He explains how the effects of changing conditions, varying themes of art, and economic and educational constraints in teacher education are related to the patterns of preservice education that have developed over the years.

Smith's historical analysis is apt and insightful. The questions he poses toward the end of the chapter demand our immediate attention. He notes that the recent trend toward lengthier teacher education programs and the shift toward a discipline-based perspective will obviously require more in terms of time, schooling, and resources from both preservice candidates and art teacher educators. Preservice candidates will have to learn a great deal more about art in terms of both theory and practice. This emphasis on more coursework will have to be recognized by the schools in which these future teachers eventually teach. Otherwise there will no incentives for them to spend the extra time and money required for these longer programs!

Smith predicts that preservice art education will require restructuring in order to accommodate these new elements. Art teacher educators will have to think differently about the nature of what they model and represent in the preservice classroom. Smith's points are well taken: Many preservice art educators now find themselves in a quandary as to how much time to allocate to nonstudio activities in the form of art history, aesthetics, and art criticism. It can also be argued that not only

will we need to make room for these curricular areas, but we must also allow space for the role that pedagogy plays in translating them into specific school subject matter via a repertoire of practices. In the past, studio experiences may have provided a relatively "safe" option for teacher candidates. It is far easier and less risky to conform to traditional forms of studio art teaching in school than to develop or expand new programs. Many preservice teachers may be reluctant to discuss art history and aesthetics in classrooms, not only because they lack a substantial knowledge base in these areas, but also because they lack a pedagogy with which to transform these aspects of the visual arts into school subject matter.

So far, this anthology has tended to focus on the practices of art teacher education in colleges or universities. It would be incomplete without considering teacher training practices in professional art schools. Taking up this challenge, Karen Lee Carroll, Renee Sandell, and Henry Jones in their paper, *"The Professional Art School: A Notable Site for the Preparation of Art Teachers,"* write enthusiastically about the commitment to art teacher education fostered by the Maryland Institute, College of Art. Since few institutions undertake serious research on their contributions to preservice art teacher education, this chapter is particularly welcome. The authors suggest that professional art schools are effectively training future art specialists for the reality of today's schools, and their own teacher education program is readily becoming a model for other schools that are rebuilding and modifying their programs.

Carroll, Sandell, and Jones provide the reader with an examination of some of the philosophical and pedagogical strengths of their specific preservice teacher education program. They acknowledge that drawing from a large pool of well-qualified applicants means that their prospective teachers enter the program with strong art backgrounds and a strong commitment to the profession. They go on to examine how the professional art school model allows preservice teachers to study the disciplines of art in depth, take coursework in the liberal arts, and participate in special methods courses that examine art education pedagogy in the schools. The chapter succinctly describes the actual curricular goals and philosophical underpinnings of this program. A strong element appears to be the provision of various fieldwork experiences for students, such that practicum occupies one third of the preservice program.

One important issue that the authors mention as contributing to the success of their preservice coursework is the existence of a large cadre of cooperating teachers who are willing to work with preservice teachers

from the Institute. As the authors note, Maryland has been "blessed with a history of curriculum development in art," and so it is easy to find mentors for preservice teachers in the schools. This positive working relationship with the schools has been cemented further by the professional development opportunities that are offered for practitioners on the art school campus. This strong acceptance of these preservice teachers by art practitioners in schools may provide some answers to the challenge issued by Peter Smith. Some schools *are* eager to take on well-trained professional teachers who display a sound and broad knowledge of art content that goes beyond mere studio emphases.

Carroll, Sandell, and Jones point out the possibilities that exist within a "more sharply focused" preservice preparation program and within a smaller institution. There is no doubt that large institutions, and, in particular, land-grant and state universities, have to confront certain institutional issues (e.g., competition for financial and human resources, emphases on other subject disciplines, large numbers of majors and so forth) that tend to impede program development and enhancement.

As the authors note, the development of the artist as a model for teachers still holds much promise in the field. In addition, it appears that, as art teacher education faculty, the authors are having an impact on a number of studio art faculty. They are involving studio art faculty and graduate students in a seminar on teaching art at the college level. Courses such as this one should not only impact the quality of art education at the postsecondary level, but also allow future teachers to be taught by faculty who have a vested interest in how they model and verbally represent art pedagogy. Phoebe Dufrene urges in this anthology that similar collaborations between art educators and other art faculty be enhanced throughout higher education. It is encouraging to read about art teacher programs in which all faculty who come in contact with preservice candidates—not just those involved in teacher education—are interested in improving and reflecting upon their teaching.

In the next paper, George Szekely of the University of Kentucky introduces us in another successful collaborative partnership between an art teacher education program and local elementary and secondary schools in his paper, "Adopt-A-School Project: Art Educators in Residence." In this project, teacher education candidates actually complete university coursework in a local elementary school during their first years as undergraduate art majors and elementary education majors. The school site thereby becomes the preservice art education classroom. Szekely chronicles a host of teaching activities and methods that these future teachers get to develop during their stay in their

adopted schools. He also describes how the entire teacher education program is enhanced by the opportunities for teacher candidates to work with children early in their programs. An especially unique aspect of this program is that the university art educator serves as an art-educator-in-residence for the duration of the project. According to Szekely, the resident's goals are not only to direct and supervise the preservice teachers, but also to assist the school staff and introduce them to the arts in a nonthreatening manner. Thus, the resident works hard to involve the whole school staff, parents, community members, and other university faculty in the project. Although Szekely acknowledges that school practitioners are at first wary of the ideas and idealistic tendencies brought in by the university resident, they do eventually become receptive to these more innovative lessons and the excitement that is generated when the preservice teachers and school students begin to work together.

Szekely implies that teacher educators must help college students to ascertain early on in their university or college schooling whether or not they really want to pursue a career in teaching. This apt viewpoint touches on the debate about the frequency, availability, and appropriateness of the various field and student teaching experiences needed in preservice art education. There are significant benefits to be gained by having the residents participate in the teacher education experiences of prospective teachers. For example, the residents can model appropriate teaching methods, serve as catalysts for ideas, and provide immediate and responsive feedback regarding lessons after they have been taught. Szekely implies that these practical activities, along with research and reflection, are necessary components of an art teacher education program. The Adopt-A-School Program provides a healthy bridge and collaborative discourse between teachers in schools and higher education.

Another model of helping prospective teachers see the value of exploring art in classrooms is introduced by our last author, Sally Myers. "Aesthetic Scanning with Preservice Elementary Classroom Majors," discusses the notion of developing suitable practices for understanding artworks for naive art viewers. Myers introduces us to the merits of the aesthetic scanning method developed by Harry Broudy. She points out how, over the years, her university students—prospective elementary classroom teachers—have found this learning process to be meaningful and rewarding.

Myers walks us through her use of the scanning method with her prospective teachers and outlines its benefits. She also addresses the criticisms that have been aimed at aesthetic scanning, but contends

that it serves as a useful way of introducing teacher candidates to works of art. This element of success seems particularly important in light of many of the chapters by other authors in this anthology that have related some of the joys and frustrations of working with prospective elementary school teachers. Myers's assumption is apt that these teacher candidates need to find a successful way of acquiring knowledge about art. Too often, as some of the other authors have suggested, elementary education majors are fearful of and plainly underexposed to art. Many prospective teachers need to learn fairly basic ways of understanding art, and Myers suggests that scanning helps in this. Once their scanning skills have been acquired, she argues that her teacher candidates are well on their way to further researching and inquiring into artworks. Using these skills as a basis, her elementary teachers not only have skills in hand to use in the future, but, as students, they might be more eager to teach themselves.

The chapters in this anthology contribute to the development of a shared and evolving art teacher education language that will allow us to talk about and interpret issues and practices in the preservice art education classroom. I urge you to join with their respective authors and participate in the preservice dialogue. There are many windows to look through and classroom to visit.

REFERENCES

Britzman, D. (1991). *Practice makes practice: A critical study of learning to teach.* New York: State University of New York Press.

Calderhead, J. (1988). *Teachers' professional learning.* Philadelphia: Falmer Press.

Calderhead, J. (1991). *The nature and growth of knowledge in student teaching.* Paper presented at the Annual Meeting of the American Educational Research Association, Chicago.

Chapman, L. (1982). *Instant art, instant culture: An unspoken policy for our nation's schools.* New York: Teachers College Press.

Clark, D.L., & Marker, G. (1975). The institutionalization of teacher education. In *Teacher education* (74th yearbook of the National Society for the Study of Education, Part 11, pp. 53-86). Chicago: University of Chicago Press.

Conant, J. (1963). *The education of American teachers.* New York: McGraw-Hill.

Cross, K. P. (1976). *Accent on learning.* San Francisco: Jossey-Bass.

Davis, J. D. (1990). Teacher education for the visual arts. In W.R. Houston (Ed.), *Handbook of research on teacher education* (pp. 746-757). New York: Macmillan.

Dewey, J. (1904). The relation of theory to practice in education. In C.A. McMurray (Ed.), *Third yearbook of the National Society for the Scientific Study of Education* (Part 1, pp. 9-30). Chicago: University of Chicago Press.

Doyle, W. (1977). Learning the classroom environment: An ecological analysis. *Journal of Teacher Education, 28*(6), 51-55.

Doyle, W. (1990). Themes in teacher education research. In W.R. Houston (Ed.), *Handbook of research on teacher education* (pp. 3-24). New York: Macmillan.

Doyle, W., & Ponder, G.A. (1977-78). The practicality ethic in teacher decision-making. *Interchange, 8*(3), 1.

Dreeben, R. (1987). Comments on "tomorrow's teachers." *Teachers College Record, 88*(3), 359- 364.

Efland, A. (1976). The school art style: A functional analysis. *Studies in Art Education, 17*(2), 37- 44.

Eisner, E.W. (1982). The relationship of theory and practice in art education. *Art Education, 35*(1), 4- 5.

Elliott, J. (1991). *Action research for educational change.* Philadelphia: Open University Press.

Galbraith, L. (1988). Research-orientated art teachers: Implications for art teaching. *Art Education, 41*(5), 50- 53.

Galbraith, L. (1990). Examining issues from general teacher education: Implications for preservice art education courses. *Visual Arts Research, 16*(2) (Issue 32), 51- 58.

Galbraith, L. (1991). Analyzing an art methods course: Implications for preparing primary art student teachers. *Journal of Art and Design Education, 10*(3), 329- 342.

Galbraith, L. (1992). Pedagogical practices in preservice art methods courses for the classroom teacher: A research agenda. In A.J. Johnson (Ed.), *Anthology of elementary art education,* 51- 58. Reston, VA: National Art Education Association.

Goodlad, J. (1990). The occupation of teaching in schools. In J. Goodlad, R. Soder, & K.A. Sirotnik (Eds.), *The moral dimensions of teaching* (pp. 3- 34). San Francisco: Jossey-Bass.

Gray, J. (1992). An art teacher is an art teacher Fortunately! *Art Education, 45*(4), 19- 23.

Greene, M. (1981). Aesthetic literacy in general education. In J. Soltis (Ed.), *Philosophy and education* (80th yearbook of the National Society for the Study of Education, Part 1, pp. 115- 141). Chicago: University of Chicago Press.

Griffin, G. (1983, April). *Expectations for student teaching: What are they and are they realized?* Paper presented at the Annual Meeting of the American Educational Research Association, Montreal, Canada.

Jones, B., & McFee, J. (1986). Research on teaching arts and aesthetics. In M.C. Wittrock (Ed.), *Handbook of research on teaching* (3rd ed., pp. 906- 916) New York: Macmillan.

Judge, H. (1982). *American graduate schools of education: A view from abroad.* New York: Ford Foundation.

Koehler, V. (1979). Research on teaching: Implications for research on the teaching of the arts. In G.L. Knieter & J. Stallings (Eds.), *The teaching process & arts and aesthetics* (pp. 40- 63). St. Louis: Central Midwest Regional Educational Laboratory (CEMREL).

Lampert, M. (1985). How do teachers manage to teach? Perspectives on problems in practice. *Harvard Educational Review, 55*(2), 178- 194.

Lanier, J., & Little, J.W. (1986). Research on teacher education. In M.C. Wittrock (Ed.), *Handbook of research on teaching* (3rd ed. pp. 527-569). New York: Macmillan.

Lortie, D. (1975). *Schoolteacher: A sociological study.* Chicago: University of Chicago Press.

MacGregor, R. (1988). On the construction and occupancy of mazes, according to section 18B of the Building Code and APA 3. *Studies in Art Education, 30*(1), 6- 14.

Mason, R. (1983). Art teacher preparation in England, Australia, and the USA: Some observations. *Journal of Education for Teaching, 9*(1), 55- 62.

Mason, R. (1991). Art teaching and research. *Journal of Art and Design Education, 10*(3), 261- 269.

May, W.T. (1989). Teachers, teaching, and the workplace: Omissions in curriculum reform. *Studies in Art Education, 30*(3), 142-156.

National Art Education Association. (1979). *Standards for art teacher preparation programs* (1979). Reston, VA: Author.

National Art Education Association. (1986). *A quality art education.* Reston, VA: Author.

Peters, R.S. (1977). *Education and the education of teachers.* London: Routledge & Kegan Paul.

Roderick, J.A. (1986). Dialogue writing: Context for reflecting on self as teacher and researcher. *Journal of Curriculum and Supervision, 1*(4), 303-315.

Rogers, E.T, & Brogdon, R.E. (1990). A survey of the NAEA curriculum standards in art teacher preparation programs. *Studies in Art Education, 31*(3), 168-173.

Rudduck, J. (1988). Changing the world of the classroom by understanding it: A review of some of the aspects of the work of Lawrence Stenhouse. *Journal of Curriculum and Supervision, 4*(1), 30-42.

Rudduck, J. (1991). *Innovation and change.* Philadelphia: Open University Press.

Ryan, K. (1975). *Teacher education* (74th yearbook of the National Society for the Study of Education, Part 11).Chicago: University of Chicago Press.

Schon, D. (1983). *Educating the reflective practitioner.* San Francisco: Jossey-Bass.

Sevigny, M.J. (1987). Discipline-based art education and teacher education. *The Journal of Aesthetic Education, 21*(2), 95-128.

Smythe, J. (1987). *Educating teachers: Changing the nature of pedagogical knowledge.* New York: Falmer Press.

Sockett, H. (1990). Accountability, trust, and ethical codes. In J. Goodlad, R. Soder, & K.A. Sirotnik (Eds.), *The moral dimensions of teaching* (pp. 224-250). San Francisco: Jossey Bass.

Soder, R. & Sirotnik, K.A. (1990). *Beyond inventing the past: The politics of teacher education.* In J. Goodlad, R. Soden & K.A. Sirotnik (Eds.), *Places where teachers are taught* (pp. 385-413). San Francisco: Jossey-Bass.

Stenhouse, L. (1985). *An introduction to curriculum research and development.* London: Heinemann.

Tom, A.R. (1984). *Teaching as moral craft.* New York: Longman.

Turner, R.L. (1975). An overview of research in teacher education. In K. Ryan (Ed.), *Teacher education* (74th yearbook of the National Society for the Study of Education, Part 11, pp. 87-110). Chicago: University of Chicago Press.

Valli, L. (1992). Beginning teacher problems: Areas for teacher education improvement. *Action in Teacher Education, 14*(1), 18-25.

Van Mannen, M. (1977). Linking ways of knowing with ways of being practical. *Curriculum Inquiry, 6*(3), 205-228.

Watts, D. (1984). Teacher educators should be certified. *Journal of Teacher Education, 35*(1), 30-33.

Zeichner, K.M. (1983). Alternative paradigms for teacher education. *Journal of Teacher Education, 34*(3), 3-9.

Zeichner, K. & Gore, J. (1990). Teacher socialization. In R.W. Houston (Ed.), *Handbook of research on teacher education* (pp. 329- 348). New York: Macmillan.

Zeichner, K.M., & Liston, D.P. (1987). Teaching student teachers to reflect. *Harvard Educational Review, 57*(1), 23-48.

Zeichner, K., & Tabachnik R., (1981). Are the effects of university teacher education washed out by school experience? *Journal of Teacher Education, 32*(3), 7-11.

Zimpher, N.L., & Howey, K.R. (1987). Adapting supervisory practices to different orientations of teaching competence. *Journal of Curriculum and Supervision, 2*(2), 107-127.

Chapter 1

Mickey Mouse or Mapplethorpe

METAPHORS FOR UNDERSTANDING ART ANXIETY

Deborah L. Smith-Shank
Northern Illinois University

Deborah L. Smith-Shank

Northern Illinois University

Dr. Shank has been involved in a variety of careers (art teacher, gallery director, and education coordinator for an arts commission, to name a few) before completing her Ph.D at Indiana University, Bloomington, where she specialized in art education and semiotics. She is currently Assistant Professor and is responsible for teaching art education coursework at Northern Illinois University, DeKalb. Her research focuses on the power of personal stories, myths, and narratives to understand attitudes and beliefs about art and its cultural expression.

Chapter 1

Mickey Mouse or Mapplethorpe

METAPHORS FOR UNDERSTANDING ART ANXIETY

Deborah L. Smith-Shank
Northern Illinois University

I am going to make a confession. I have a touch of math anxiety, and, when pondering the possibility of graduate school, I envisioned statistics as my worst nightmare. I am not alone. Gary Larson, in a *Far Side* cartoon several years ago, vividly depicted "Hell's Library" as a bookshelf-walled room filled with books containing nothing but story problems!

While I was taking a statistics course at Indiana University, I was also teaching art methods for preservice elementary classroom teachers. One of their assignments was to write a reflective paper describing their early experiences with art. As I read the stories my preservice teachers wrote about art, I was surprised and a bit disconcerted to note that many of them were feeling toward art the way I had felt toward math. I talked to my colleagues, who agreed that they had also noticed these responses toward art from their preservice teachers. I began collecting reflection papers from my classes and those of my colleagues. This chapter is an attempt to understand the art anxiety expressed by these preservice elementary teachers.

Of the 123 stories I studied, 66 (54%) were positive. They were enthusiastic endorsements of art as it was experienced. However, 26 (21%) were negative. In addition, some described both positive and negative experiences: 19 (15%) started positively and ended negatively; 10 (8%) started negatively and ended positively. Nearly all of the negative responses were passionate. According to Dewey (1934), these passionate memories point to art experiences that were nonaesthetic: "There is an element of passion in all aesthetic perception. Yet when we are overwhelmed by passion, as in extreme rage, fear, jealousy, the experience is definitely non-esthetic" (p. 49).

Although art educators are in the business of encouraging aesthetic experiences in their students, it seems that quite often preservice art teachers are overwhelmed and aesthetic experiences become impossible. Unfortunately, along with their paper and pencils, many preservice teachers bring to art methods classes the legacy of their early experiences with art, which—for one reason or another—have led to art anxiety. Some preservice teachers raged at perceived injustice (Smith-Shank, 1992, 1993):

> *I had two art teachers who made me feel uncomfortable about and incapable of doing art. Is this what a student needs? Is this how we enrich our preservice teachers' lives—by having them hate art class?*

Some remembered their art class with fear:

> *I was always trying to please the teacher, but was afraid I couldn't. I was always afraid to start because I didn't know the rules to follow to get the right answer.*

And in many instances, jealousy was their most vivid memory:

> *I guess I was always extremely jealous of my friend who could draw and make the drawings look real.*

These elementary education majors with histories of intimidating encounters with art will be responsible for teaching art—a subject they fear, hate, and sincerely believe they cannot do or understand. Their attitudes about art will undoubtedly influence the quality, effectiveness, type, and amount of art experiences that will be offered in their classrooms (Colbert, 1984). If we expect elementary teachers to teach art—and in many educational communities we do—addressing these negative passions needs to be an integral part of the pedagogy of an art education methods class. What kinds of art experiences do preservice

teachers remember? Are there ways to address art anxiety in an art education methods class? Is there any way to avoid art anxiety altogether? These are some of the questions I will address in this chapter.

MICKEY MOUSE

With all the scholarly and practical conversation about an art education that includes history, criticism, and aesthetics along with art making, the students seemed to have very little memory of any art that was not product oriented. By and large, what preservice teachers remember is the "Mickey Mouse, Friday afternoon, when we finish all our important work" art. As one student put it:

> As an elementary school student, art was not a top priority in the curriculum. Most of my art experiences took place on Friday afternoons as sort of recess before the weekend—if we finished everything else. And I remember enjoying most of the activities.

Art, in this case, was remembered as reward for getting *important* work done. Another vivid memory for many of these preservice teachers, as you might expect, was holiday art. Most of these memories were positive, but a few were not:

> I remember in third grade when our teacher gave us a list of supplies to buy for art to make Christmas decorations. I was so excited about this, so my mom took me out to buy the supplies, and the next day in school my teacher told me that I couldn't do the art projects because I didn't finish my "important" work and this was my punishment. So I sat at my desk and wrote 25 times, "I will finish my work on time," as I watched everyone else making their decorations.

Most of these preservice teachers really wanted to succeed in art. They liked art and were disappointed when art activities and lessons did not live up to their expectations. There is, however, another type of art memory.

THE OTHER KIND OF ART

These are memories of experiences that gave preservice teachers the message "that art was not for them." They are memories of subtle and not so subtle censorship. This type of art is considered:

Fine for those who like that kind of thing, or who can do that stuff, or who understand it, but it's not for me.

This is the *other* kind of art—the kind that is not fun and not simple:

I am left-handed. When I was in primary school, there weren't scissors designed for left-handed people. At least I never saw them. My art classes consisted of a lot of cutting and pasting. The right-handed scissors have a small hole for the finger and a big hole for the thumb. Well, the small hole was the part that went on my thumb. It always felt like it was cutting into my thumb. Not only did it hurt my thumb, it caused me to cut real unevenly, so I always felt like an inferior cutter. Since I didn't think I could achieve in this area, it didn't bother me not to do well in art.

As I read these stories and tried to make sense of them, I realized that however enlightening the numbers were and however passionate the telling, simply summarizing and recounting stories is not enough to understand art anxiety. I needed a way to understand these stories, not just as individual accounts, but as sets of stories. In short, I needed a strategy for narrative analysis. I decided to try the semiotic ideas of Vladimir Propp (1968), which he laid out in *Morphology of the Folktale*. Propp's ideas have been adapted for use in understanding focus groups and long interviews by semioticians such as Umiker-Sebeok (1991) and Floch (1988).

This method looks at folktales as episodic events that provide insight into the beliefs, attitudes, and cultures of the people who tell them. I wondered what would happen if I used this method of narrative analysis and treated the preservice teachers' accounts as folklore. The results are intriguing. Simple accounts of art experiences are transformed into stories with settings and costumes, major and minor actors, plots and plotters. They are stories full of passion, heroes, and villains; full of triumphs and many disappointments. These stories are about teachers, about students, and about art in our cultures.

Armed with this technique, I want to share some of these reflective student stories with you, juxtaposed with narrative analysis. I will begin with stories by people who are art anxious and move toward those with more positive attitudes toward art. As the attitudes change, so do the stories. Patterns emerge that can give us insight into ways art anxiety might be addressed as part of an art educational pedagogy.

DISCUSSION

When narrative analysis is used, these self-reflections read like folk-tales. The stories have a hero (usually the writer) who is sent on a mission or is given a task to complete. (In most of the stories, the task was to make an art product.) The assigned task and the agreement to do the task constitute a contract. By completing the contract, the hero will gain something of value. (In many instances the object of value was a grade. In other cases, the object of value was an actual art object that, many times, became a prized family possession.) As the hero attempts to carry out the task, the issue of competence enters the narrative. Quite often, the hero faces problems because, for one reason or another, the task proves to be undoable. Like the princess who needed to spin straw into gold, many of these writers believed that the task was impossible, because they had either insufficient innate ability, insufficient instruction, or insufficient help to complete the task.

Those who believed they had the ability to carry out the mission obtained the sought-after object of value. They followed through on the contract. Those who found that they could not obtain the object of value (they couldn't spin straw into gold) indicated that there had been some trickery involved in the contract to begin with. They were attempting to complete a task that had little to do with their concept of the original contract, and they were receiving sanctions.

Sanctions are events or actions that signify success or, in many instances, failure. In this case, the sanctions fell into several categories. The most common sources of negative sanction, or failure, included the following:

• Reinforcement of belief that the student had no inborn talent.

• Unfathomable teacher standards.

• Lack of instruction, leading to failure.

• Unfair bad grade in spite of effort.

• Bad grade due to lack of talent.

• Exclusion from special programs/awards.

To refer again to Dewey (1934), there is more than an element of passion in the memories of these experiences. The memories triggered extreme rage, fear, and jealousy, rendering art education definitely non-

aesthetic for many of these preservice teachers. For the preservice teachers who believed a good grade to be the object of value, art class seemed especially frustrating. Some decided that they had no talent, so it followed that they would get poor grades:

By the time middle school came, I hated art. I had always had trouble coloring, drawing, and painting. My hands are not steady, so that didn't help either. I hated the fact that we went from pluses and minuses in elementary to letter grades in middle school. Then when it came time to make things, art became more of a hated subject. When I would finally make something I was proud of, it always seemed to come back with a grade in red ink that was a "C"! It always seemed that no matter how hard I worked, the teacher felt I didn't give enough effort.

In this case, the curriculum tied the hero into a contract: the duty to complete art class. However, this was a contract that would not result in the hero's object of value—a good grade. Our hero did not have the competence to carry out the task. In many cases, even though the grades were important, the memory associated the negative grade sanction not with lack of ability, but with lack of instruction and what amounted to unfathomable teacher expectations:

As an eighth grader, I went into art class with a horrible attitude. I had already gone through the things many young students go through; no left-handed scissors, laughter from other students. But this very class topped it all off. I flunked my color wheel. How can anyone flunk a color wheel? I had all the colors on it and mixed them the right way, but I still flunked it. From that point on I felt there was not anything about art that I could do. I did not even try to do well on other assignments. As a matter of fact, I didn't even do some of them.

Left-handedness and scissors were mentioned as problems several times in these reflections. In this case, it seems that scissors were a roadblock, but unfathomable teacher expectations actually broke the contract. Our hero perceived that she had, in fact, completed the contract adequately, but that the teacher had failed to reward the performance:

I always enjoyed coloring and drawing when I was a child, and when I was in the eighth grade I liked art class. But I was not doing as well as I thought I would. About half way

*through the school year, we had to draw in pencil a picture of
two men in a rowboat with rain gear on, in a terrible storm,
pulling in fishing nets. I wasn't able to capture the shadows
and depths very well. My teacher said she was sure I was try-
ing my best, but that I should probably be happy to be able to
write my name. She also said that if I continued to put forth
an effort she would give me a C in the class. When I asked her
what I was doing wrong, she told me it would take too long to
explain, just to keep trying. I was very upset, but I figured she
knew what she was talking about. I realize now that she was
worse at teaching than I was in art.*

Our hero in this case understood that she needed a helper to com-
plete the contract. She asked for, but did not receive help. This consti-
tuted a breach of the contract in which acceptance presupposed time,
support, and help to acquire the knowledge and skills necessary to carry
out the task. This lack of assistance is a frequent and passionate story
line. The art teacher was remembered not as a helper, but as a villain
blocking the hero's goal. I was surprised how often colorful language
was used to describe art teachers:

*I have no memories at all of doing art when I was in elemen-
tary school. However, I do remember in detail the man I had
to face twice a week in the room at the end of the hall for art
class! Mr. Green was a tall, blond-headed man who never
ever smiled. He had a chiseled face, stern eyes, and for some
reason, I remember he had an amazing amount of hair. Mr.
Green probably stunted my growth as an artist. Having very
little confidence, I needed someone with a smile who could
say, "That's a very nice try, let's try adding this or taking out
that." I never received this encouragement, because I was so
intimidated by Mr. Green that I never once had the courage to
approach the man and ask for help.*

In this case, the hero could not carry out the task because of a dragon
in the guise of an art teacher who was blocking the path. In several
instances, artistic talent was perceived as a special gift—and as a gift
that was not passed out democratically. In this beautifully written
story, our hero really wishes to carry out the task, but because of an
outside force, is unable to do so:

*It was the most amazing thing I had ever seen! I couldn't
believe my eyes. How could anyone do that? Look at him
stand there and act like it's no big deal. Why doesn't he see
what he's done? What he did in a half hour, I couldn't do in a*

week. I think the picture would amaze me today as much as it had in fifth grade. Why wasn't a person who had so much talent awed by it? Is it nothing to someone who can put ideas from their head onto paper? What he takes for granted, I can barely comprehend. Everyone else thinks his picture is good, but they stop there. They may not see the talent. They may not care. I care. I would have killed to be able to draw like he could. In my mind it took more than effort, it took a skill you were born with. I was convinced I lacked that skill and was never told otherwise. They wanted me to try a little harder. Couldn't they look in my eyes and see how hard I tried? I don't quite remember, but I know there was a point where I quit trying.

The contract in this case was impossible to complete. The contract was a cosmic practical joke, because without innate talent the hero believed that there was absolutely no chance to achieve his goal of being able to draw.

This next story tells of a shift in attitude toward art—and, it seems, a conquering of the fear that always seems to be present when there is art anxiety:

Art has been a subject I've always feared. I have never considered myself capable of doing art. Growing up, I never considered artistic talent and creativity an entity which was able to be learned or acquired with practice. To me, artistic ability was something innate. My first art class in college literally gave me hives from anxiety and frustration. When the instructor was giving explicit directions and showing examples, I understood completely. Unfortunately, when it came to creating the assignment, I was paralyzed. There was a time limit and precision factor in the assignment as well as a creative stance. It was one of the scariest experiences I've ever had. I was working with blades and equipment I've never before used, and I was shaking like a leaf, with beads of perspiration falling on the paper. I was yelling at myself to calm down and emphasized that my goal was completion and effort, not perfection. Thankfully, I became rational and finished the assignment to the best of my abilities. I proved to myself that I could, in fact, "do" art. A wave of relief and satisfaction came over me.

This student made a shift in the contract, from the goal of perfection to a realizable goal of completion and effort. In this instance, there was

also an attitude shift in the way art was perceived—away from irrational fear and toward acceptance. This indicates to me that there ought to be hope for a pedagogy to combat art anxiety, if we can find ways to address irrational fear and use positive sanctions. Such sanctions relate to positive memories; they include

- Family praise and encouragement.

- Teacher praise and encouragement.

- Awards and honors.

- Reinforced belief in innate talent.

- Personal satisfaction in creative self-expression.

- Having fun with no evaluative strings attached to it.

Although all of these sanctions were remembered as significant by my preservice teachers, the top three seemed to have occurred most frequently and may be the most satisfactorily addressed in the quest for a pedagogy to combat art anxiety. I was surprised to find that family approval was referred to most frequently:

> *Every morning during the summers I used to go outside with my chalk in hand and create. My driveway was my canvas, and my imagination was my inspiration. I would spend all afternoon creating different pictures. Each one was perfected, sometimes needing to be washed away by the hose to make way for a new thought. After I was satisfied that my painting was perfect I would call the ultimate judge of perfection, my mother. My mother, not unlike many others, always praised my work. I was an artist in her eyes.*

In this case, our hero's imagination sent her on the quest for creative expression. When she had completed the contract—when she was satisfied that her painting was perfect—she called the judge, her mother, to reinforce her belief in the perfection of her product. In this way, our hero obtained the object of value and desire—her own perception of the perfection of her artwork was reinforced by her mother's judgment. Although mentioned less frequently, positive sanctions by the teacher were also significant, especially in cases in which a student's confidence in her ability to do art was not strong:

All through school, grades have always been important to me. Consequently, a "B" in art meant that I wasn't good at it. As a result, that overall feeling of not being "good" at art has stuck with me ever since elementary school. That is, until this past semester. I had an instructor who was enthusiastic about what he taught and had a sincere desire to make art fun and interesting. My instructor made a comment somewhere along the line and asked if I had ever considered changing my major. He was implying I had potential as an art student. For the first time in my education career, I felt successful in art and had a sincere desire to learn more about it.

This teacher, unlike those previously discussed, served as a helper in our hero's quest. Although she was insecure about art, this teacher helped the student feel that the task was possible to complete. Sometimes what might appear to be an insignificant act may be an important factor in development of art attitudes:

When I was in middle school, I remember my art class as being fun. Despite the fun, I never thought I was good in art. I didn't think I was bad either, but there was always someone who did a better job than I did. Later in the year, the teacher picked through different art projects and found a number of works to represent the class in an art show. She picked one of my pictures. I was so thrilled and encouraged! I think it was at this point that I really began to try in art. After this encouragement, I even enrolled in my first drawing class in high school.

CONCLUSION

These stories could go on and on, but we have reviewed enough to begin to address the issue of art anxiety. The first step toward a pedagogy for addressing this issue is an acknowledgment that, just like math anxiety, art anxiety is very real for some preservice teachers. Let us return to the questions I started with and try for some answers:

What kinds of art experiences do preservice teachers remember? Students remember both good and bad art experiences. The bad memories are partnered with negative sanctions; the good memories with positive sanctions.

Are there ways to address art anxiety? To address art anxiety, first we need to acknowledge its existence. And second, we need to build a repertoire of positive sanctions to encourage our scholar heroes on their quests toward aesthetic understanding.

Is there any way to avoid art anxiety? I don't know. This chapter is part of ongoing research into the beliefs and attitudes of preservice elementary teachers toward art. As I read these stories, many more questions emerged than answers. One of the most intriguing questions to me is: *Why is there so much passion for a subject that we have heard repeatedly identified as a frill?*

Although there is a much larger percentage of preservice elementary teachers who appreciate art, enjoy doing art, and will more than likely include art as a significant slice of their curriculum than of those with art anxiety, we need to understand how positive and negative sanctions influence student attitudes. We need to reward and validate interest and enthusiasm. Yet even for those with positive memories of art, a disturbing question emerges: *What exactly is art for them? Is it Friday afternoon "Mickey Mouse" art?* Art educators and scholars need to inquire into all these questions. At the same time, we need to develop a pedagogy to directly help preservice teachers with art anxiety to explore their attitudes and beliefs about art. Chances are, they will be responsible for something called art in their curriculum. Unless we address this issue, it is possible that these preservice teachers, when they become classroom teachers, will, without reflection, censor art Mapplethorpe style.

I am convinced that this type of anxiety is not unique to art but is true of most, if not all, other subjects. By using semiotic narrative analysis to look at student reflections, insights can be gained into what it means to be anxious about art, or math, or science, or even school in general. And with these insights, it may be possible to develop pedagogy to address this type of anxiety. I am not convinced that anxiety can be "cured"; I still occasionally break out in a cold sweat when I see size effect data. Yet, even without a cure, a pedagogy that addresses this issue will go a long way toward eliminating its unreflected reproduction.

REFERENCES

Colbert, C.B. (1984). Status of the visual arts in early education. *Art Education, 37*(4) 28-31.

Dewey, J. (1934). *Art as experience.* New York: Capricorn.

Floch, J.M. (1988). The contribution of structural semiotics to the design of a hypermarket. *International Journal of Research in Marketing, 4*, 233-252.

Propp, V. (1968). *Morphology of the folktale* (2nd ed.) (L. Scott, Trans.). Austin: University of Texas Press.

Smith-Shank, D.L. (1993). Beyond this point there be dragons: Pre-service elemmentary teachers' stories of art and educaiton. *Art Education, 46,* 45-51.

Smith-Shank, D.L. (1992). Art attitudes, beliefs, and stories of pre-service elementary teachers. Doctoral dissertaiton Indiana University, 1992). *Dissertation Abstracts International, 52/06A,* AAC9133092.

Umiker-Sebeok, J. (1991, April). *The making of meaning in malls, museums, and classrooms.* Paper presented at the Annual Meeting of the American Educational Research Association, Chicago.

Chapter 2

Creative Tension

PROBLEMS IN TEACHING ART EDUCATION TO PRESERVICE CLASSROOM TEACHERS

Mary Stokrocki
Arizona State University

Mary Stokrocki

Arizona State University

Dr. Stokrocki is currently Associate Professor of Art Education at Arizona State University. Tempe. Her interests focus on multi cultural and cross-cultural issues. She has published extensively in numerous journals, including *Studies in Art Education, Art Education,* the *Journal of Art and Design Education,* and *The Journal of Multicultural and Cross-Cultural Research.* She is currently working on a major 3-year study examining art teaching on the Reservation of the Navajo Nation in Northern Arizona and New Mexico. In 1992, she received the NAEA Women's Caucus Mary J. Rouse Award.

Chapter 2

Creative Tension

PROBLEMS IN TEACHING ART EDUCATION TO PRESERVICE CLASSROOM TEACHERS

Mary Stokrocki
Arizona State University

After teaching art to preservice elementary classroom teachers for over 12 years, I am still overwhelmed by the stereotypes and myths they hold about art education. These misconceptions, which are both persistent and problematic, stem from a variety of sources including preservice teachers' backgrounds, interests, and lack of art experiences; their expectations for an easy course and high grades; and their views about art and art teaching. This chapter (a) presents data from a study that examined these issues and tensions, and (b) presents the metaphor of *creative tension* (Maitland, 1980) as a means with which to initiate discussions about art education practices for elementary classroom teachers.

METHOD

Participant observation methods dominate both my research and teaching of preservice teachers. Participant observation consists of data collection, analysis, and interpretation. I gather data through pre- and postquestionnaires, pre- and post drawings, letters of complaint, informal interviews, and class discussions. I usually give the prequestionnaire on the first day of class. Since questionnaires help me determine

the backgrounds of the preservice teachers and highlight their precon-
ceptions concerning art and art teaching, they have become an integral
part of my curriculum and form the basis of class discussion.

For this specific study, one class of 20 preservice elementary class-
room teachers electing the course "Art in the Elementary School" was
chosen as a sample. Of these, 16 were female and 4 were male. Most
were in their 20s, and three were older. Fourteen of the preservice
teachers worked part time. At the beginning of the course, I was
informed that these part-time preservice teachers had little time to do
homework, especially in an elective course.

FINDINGS
A Range of Backgrounds, Interests, and Art Experiences

The backgrounds of the preservice teachers were diverse. Of the 20
enrolled in the course, 9 had selected it to help them in teaching. Two
chose it to help in their work in child care, or on the recommendation of
their counselor. Three had heard that it was an interesting course (stu-
dents in aviation management, justice studies, and music). Their range
of experiences with art was equally diverse. Five preservice teachers
had no previous art experience, four had some high school art, four were
art majors, and two had taken other art courses at the college level.
This diversity reflected the fact that this course, although usually
required of preservice classroom teachers, was also open to any other
college student as a university elective.

A Diversity and Contradiction of Preferences

When preservice teachers were asked on a questionnaire to list their
favorite art experiences, their responses were diverse. Of the preservice
teachers responding, 20% preferred drawing, with two specifically men-
tioning working with pastels. One art student was a ceramics major,
and another worked in fibers. Two found visiting museums to be inspir-
ing. In regard to least-preferred art experiences, three of the students
identified drawing. One found still-life drawing was boring, another
mentioned that accuracy was hard to achieve, and third identified diffi-
culty in controlling watercolor. Finally, two preservice teachers thought
that museums were dull.

Student Expectations of an Easy
Course and High Grades

My course outline stated that the course would challenge preservice teachers' myths on art and education, develop their personal artistic growth, and introduce them to child art. On the first day of class, two boys giggled as I introduced the course scope, sequence, and expectations. When I questioned their reactions, they answered that they were in the wrong class. The next day, I was told that in the past the course was regarded as an easy "A" by preservice teachers. Later in the course, one preservice teacher dropped the class because she was taking too many credits. Another girl missed too many classes due to an outside job and nearly failed. Finally, one preservice teacher informed me that she was spending hours on her art projects at home because she was not able to complete the projects in class. Students were amazed that this course was more rigorous than expected.

One situation in particular caused conflict due to preservice teacher stubbornness. I first noticed that this preservice teacher, a senior, was the first to finish her assignments, and with minimal effort. Coaxing her to elaborate on her ideas was difficult. She complained in class that she needed to get an "A" and wanted to do extra credit work. She was already achieving a "B" because of test grades. I insisted that she needed to spend more time on her class projects and that extra credit assignments for her were not fair to other preservice teachers. She even argued with me over the meaning of the concept *three-dimensional*, which we had just reviewed the day before. Experience has taught me that when preservice teachers fail to listen to reason after repeated attempts, it is futile to argue with them. Not all preservice teachers will regard art seriously, and those that do not should be encouraged to drop the course. Professors who teach education courses have also recommended early conferences with such preservice teachers, with a third person as arbiter to eliminate charges of personality conflicts.

When asked on a questionnaire what grade they expected, the overwhelming majority indicated an "A." On my course outline, I explained that an "A" demanded excellent work "going beyond" the assignment, a practice that I have drawn from the work of Bruner (1965) in his book *Beyond the Information Given*. On the whole, prospective elementary classroom teachers seem to be grade driven. Experience has taught me that projects that are given more weight in terms of the course grade are taken more seriously than those of lesser weight. Thus, most preservice teachers can be induced to accept the challenge to go beyond, although some inevitably fight it.

Stereotypes About Art and Art Education

Helping preservice teachers overcome stereotypic ideas and icons in art continues to be the hardest part of my teaching. Examples of stereotypes are the rote repetition of popular images, forms of speech, and attitudes ("Art is fun" and so forth). Stereotypes become particularly noticeable when the preservice teachers are challenged by new ideas and new situations. It is clear that stereotypes represent obstacles to full response as barriers to learning, especially in adults (Chapman, 1978).

When covering Lowenfeld's and Brittain's (1975) developmental stages in art, I tried to convince preservice teachers that overcoming stereotypes should also be an integral part of their own development. I employed Chapman's (1978) interest checklist, even adding to their questionnaires the response category "I prefer to learn different points of view." Since adult preservice teachers often have difficulty recognizing stereotypes, let alone changing them, my challenge is to help them in these tasks.

One of my beginning lessons involves having the preservice teachers draw a cartoon representing themselves from different viewpoints, in order to develop a visual narrative (Wilson & Wilson, 1982) about their own development as a teacher. I ask them to use this as a tool to search their past in order to draw out the formative influences that pushed them into becoming teachers. In at least one frame of this cartoon, they must depict themselves doing an early art project or engaged in their favorite art form. I ask them to record personal cultural histories to cohere their identities as artists and teachers and to establish "shared communities of memory" (Zurmuehlen, 1991, p. 10). I ask them to personalize their character by making it look like themselves in hairdo, coloring, and favorite dress and props. In spite of constant reminders to go beyond the stereotypic, the preservice teachers tend to employ them (e.g., "smiley faces" and "cutesy bears") in subsequent assignments. I have to reinforce directions against stereotypes many times in different ways. If this sounds similar to teaching adolescents, the behavior is indeed related, since so many teachers have had little or no art education.

Conceptual and Creative Learning

According to the results of the prequestionnaire, the preservice classroom teacher group perceives art as a combination of creativity (30%) and free expression (50%). The preservice teachers' emphasis appears to be on the term *free*, by which they mean "doing anything you want,"

rather than involving the concept of freedom as risk taking. Thus, in response to the question "What is good art?", the predominant answer was personal preference (35%). As one preservice teacher commented, "Art is anything you've created that makes you feel good." Another preservice teacher wrote, "Art is anything you can get away with."

Given these responses, I try to persuade preservice teachers that art learning entails learning art concepts and that their artwork should exhibit the assigned concepts. I have found that concepts or criteria need to be clearly displayed, discussed, and reinforced for preservice teachers to remember them.

Hard Work Versus Completing the Task Assigned

Some preservice teachers feel that if they have worked very hard on a project, their work is successful. On one occasion, a preservice teacher cried because I asked her to add detail to the back of her mobile. She had forgotten that a mobile must look good from all sides or "in the round." I praised her for her technical achievement, but noted that her sculpture still needed something beyond white cardboard. We had just reviewed and explored the idea of "in the round" earlier in clay. Faulty ideas about work prevent preservice teachers from understanding the concepts taught. I now introduce a lesson as part of a series. The first attempt is the test [print]; the next attempts are experiments. These are followed by in-process appraisal of on-going work, individually and sometimes as a group. The last stage consists of reworking earlier attempts. In this way, preservice teachers learn that art making is a series of decisions and revisions and indeed hard work. Ironically, some preservice teachers are not used to working hard on art. Inexperienced preservice teachers in art feel that they did it once and do not have to redo or add to it. Art is not regarded as serious work. They must learn that work means not one attempt, but many. At the basis of this misunderstanding is the "project approach," which Dewey (1934) endorsed because of the constant process of perception and revision needed in making an art form.

Art Learning as Rule Driven and Rule Divergent

Preservice elementary classroom teachers often fail to understand that learning art in the beginning demands learning the rules, and later breaking them. This ambiguous nature of art learning is frustrating to them. Students demand clarity—to know exactly what an assignment entails. They have difficulty understanding that they have not met the requirement to add diversity to their work. The concept of being divergent, adding variety, being original, and adding some mystery is

ambiguous to them. They need to be shown how to do this. A typical exercise is to make composite or hybrid animals. I no longer grade studio projects, but give more tests and special assignments. Students are given the opportunity to do an assignment over once if their grade is lower than a "C."

Compulsive Versus Frivolous Behaviors

Preservice elementary classroom teachers seem to become more dependent as learners and compulsive about grades. Education courses seem to condition their behavior and attitudes. If they don't get an "A" in an art course, some will contest the grade. They crave exact procedures and instruction on how to achieve good results quickly. Such mechanical learners want deadlines and art experiences that free them of details (Michael, 1983). Others are more frivolous (intuitive and emotional) and give minimal attention to their work. As Michael (1983) noted, "Their work is centrally placed, a vaguely defined whole" (p.125). These preservice teachers need to develop greater skills and be coaxed into using more details.

Poor Conditions for Art Learning

The physical conditions of a setting can inhibit learning. At one time, I had a beautiful art room in the School of Education, until I had to surrender it to make room for computers. For 9 years, I taught art education in a basement that was too hot, where I had to compete with a noisy exhaust fan and humming fluorescent overhead lights. The room was often crowded with too many preservice teachers, many of whom my chairman would allow to take the course at the last minute. Such conditions made it difficult for me to teach and for preservice teachers to learn because the situation was uncomfortable and the preservice teachers became irritable.

I eventually gave up my art room, even after a new $2,000 exhaust fan was installed, which did not seem to solve the problem. I believe that the weather conditions—seasonal snow, cold, and general grayness, also made preservice teachers grumpy. As an instructor, I seemed to be the focus of every complaint in the university. On teaching evaluations, preservice teachers complained of such things as lack of room, university demands, or too much work. Chapman (1978) has acknowledged that the physical and psychological setting in which we examine art can determine which properties of a form will be available to our perception.

Postquestionnaires as a Way of Reviewing Teaching

At the end of the course, I ask preservice teachers various questions regarding the course content, their attitudes, and conceptions of art and education. When asked what they have learned that is new, the majority reflect on their stereotypic images, the patience and hard work needed in art, the development of multicultural education, and art appreciation. Some preservice teachers complain about the lack of clarity in the course, which seems unavoidable in spite of the many handouts I distribute. Some semesters are better than others. Instructors of such courses can try their best, work hard, be organized and extremely informed, and still not please preservice teachers. I believe it is the nature of the discipline and the times.

ART EDUCATION AS CREATIVE TENSION

Over the years, I have discovered that the task of teaching art education at this level is one of overcoming myths about art and education and conflicts of all kinds. This involves tension between (a) preservice teachers and the unknown media; (b) teacher and preservice teacher expectations; and (c) professional/university demands and professor survival. At the root of these conflicts is the nature of art itself as creative tension. Maitland (1980) described art as the creative transformation of tension:

> *Since discipline and obstacles are the necessary conditions of creative performance, through will [power] we can engage in the discipline of art and try to find, arrange, or correct circumstances in the hope of encouraging inspiration. In the end, however, one must wait in silence for the transforming power of creative freedom.* (p. 292)

In my own teaching, I have tended to accept creative tension as par for the course. Usually hidden, this phenomenon needs to be discussed more in teacher education because it is part of life, learning, and the creative process. I now cover the dominant myths about art and art education in class, discuss with preservice teachers their negative attitudes, and explore these misconceptions in written as well as studio projects.

Recently the name and focus of this course has been changed to "Studio Art and Human Development." This political maneuver has eliminated any emphases on teaching methodologies, and the course now supposedly reflects the substance of the visual arts disciplines.

Another course on the teaching of art appreciation and human development has been designed and is taught by another professor.

However, in spite of the studio nature of the course, I still find that discussing aesthetics and the concept of creative tension is important. Now I can lead preservice teachers more into their own development, because the adult stage of development is one of artistic dissonance (Eisner, 1976). We have started to discuss multicultural theories of development (Gardner & Perkins, 1989) and of art (Anderson, 1990). In fact, the dialogue between my preservice teachers and myself has opened beyond class, as I pull preservice teachers into my office for extra consultation. These dialogues require more work and time on my part. What seemed to be the easiest art education course to teach at the university at one time has become the most difficult and time consuming. The concept of creative tension as a metaphor for art education is in its formative state and needs to be explored further.

REFERENCES

Anderson, R. (1990). *Calliope's sisters: A comparative study of philosophies of art.* Englewood Cliffs, NJ: Prentice Hall.

Bruner, J. (1965). *Beyond the information given: Studies in the psychology of knowing.* New York: Norton.

Chapman, L. (1978). *Approaches to art in education.* New York: Harcourt, Brace, Jovanovich.

Dewey, J. (1934/1958). *Art as experience.* New York: Putnam.

Eisner, E. (1976). *The arts, human development, and education.* Berkeley, CA: McCutchan.

Gardner, H., & Perkins, D. (1989). *Art, mind, and education: Research from Project Zero.* Urbana: University of Illinois.

Lowenfeld, V., & Brittain, W.L. (1975). *Creative and mental growth* (5th ed.): New York: Macmillan.

Maitland, J. (1980). Creative performance: The art of life. *Research in Phenomenology,* 10, 279-301.

Michael, J. (1983). *Art and adolescence.* New York: Teachers College Press.

Wilson, B., & Wilson, M. (1982). *Teaching children to draw.* Englewood Cliffs, NJ: Prentice Hall.

Zurmuehlen, M. (1991). Stories that fill the center. *Art Education, 44*(6), 6-11.

Chapter 3

Context for a Profile of a High Achieving Preservice Early Childhood Education Major in an Arts Methods Course

Read Diket
William Carey College

Read Diket
William Carey College

Dr. Diket is Assistant Professor of Art and Education and Director of the Honors Program at William Carey College, Hattiesburg, Mississippi. She recently received her Ph.D. in Art, which is an interdisciplinary degree, from the University of Georgia, Athens, where she also served as a research associate. She is an experienced art teacher, and her research interests focus on cognitive functioning, phenomenology, and research methodology in visual arts education. She lectures extensively and presents at the annual meetings of the NAEA and the American Educational Research Association (AERA).

Chapter 3

Context for a Profile of a High Achieving Preservice Early Childhood Education Major in an Arts Methods Course

Read Diket
William Carey College

Preservice teachers at the University of Georgia, preparing to be early childhood and elementary classroom teachers, take an art methods course, "Art and the Child." During this class they learn about the Quality Core Curriculum (QCC) of Georgia, which is a discipline-based curriculum in art education (Advisory Committee, 1987). These non-art majors receive an introduction to developmental theory in the arts and also study about cognition and creativity in young children.

Most preservice elementary early childhood teachers enter the class with little formal knowledge of art history, perceptual phenomena, or critical methods for understanding art. Their experiential knowledge of how art is taught is outdated and naive. During the course they develop confidence in their ability to teach and may find unexpected talents; in each group, a few preservice teachers develop real expertise. This chapter is about one of those preservice teachers.

THE CONTEXT

The Quality Core Curriculum to which the course is oriented stresses four strands for the visual arts: perception, artistic heritage, criticism and aesthetics. Art methods classes require preservice classroom teachers to make and interpret curricular statements, as well as to design art lessons for young children. The preservice teachers extend whatever knowledge of art they enter the program with and gain some pedagogical skills. In most cases, the course instructor modifies the scope of art practice advanced in the state guidelines. The early childhood majors are not expected to perform as well as art education majors. They have direct personal experiences with a variety of art materials; learn a method of art criticism, which is often compared to other approaches for building aesthetic awareness; and prepare a short research paper on a historical figure in art. General classroom teachers are, in practice, conveyors of art education at the elementary level.

Atypical ability levels and behaviors surface even in a criterion-oriented environment. Preservice elementary/early childhood majors are for the most part diligent and conscientious apprentices. Most students discover latent abilities to make artistic products, talk about art, or appreciate the contributions of art to the development of mankind. A few preservice teachers achieve beyond the usual continuum and exceed course expectations for generalist preservice teachers. The high achievers thrive in alternative programming stressing acceleration and enrichment of the traditional methods course.

In providing an art methods class to preservice generalists, we are (a) perpetuating a myth, (b) assigning art methodology to a subordinate role in the curriculum, or (c) actually empowering these young men and women to teach art (Broudy, 1987). Practically speaking, generalists are extensions of specialized art education programming. I find that the level of complexity attained is dependent on upgrading class objectives to fit student capabilities.

General education students at the University of Georgia evidence a range of artistic, pedagogical, and scholarly abilities. Occasionally, a methods class preservice teacher demonstrates considerable talent in making, teaching, learning about, and discussing art. The preservice elementary methods course is presented as a model for differentiated curricula in the arts. Care is taken to assure class members that with diligence any preservice teacher, regardless of artistic aptitude, can meet the criteria for the class. Given a number of discipline orientations, most preservice teachers can expect to achieve superiority in at

least one of the verbal or performance areas in art or pedagogy. They are made aware of an expectation for success.

There is a need to motivate high-end preservice teachers with appropriate expectations. The instructor serves to recognize and nurture the desire for excellence in teaching. Because excellence in teaching involves reaching beyond prestated minimum criteria into the realm of the possible, we hope that teachers trained in such a manner will provide similar opportunities for their own students.

CHERYL: A CASE STUDY

Cheryl was majoring in early childhood education at the University of Georgia. Like 90.5% of her classmates, she had not previously taken an art class, but reported that she "enjoyed painting with stencils and decorating." When asked about museum visits in the previous year, Cheryl wrote about the National Gallery in Washington and a gallery visit. Her goals for the class were "to learn more about art and how I can be more creative," and further," to apply it [art knowledge and creativity] in different areas of my study." The first goal was shared by many of her classmates; however, Cheryl's desire to apply it to other areas of study was rarely reported by other preservice teachers. The first of Cheryl's successes was in a studio art project. After experimenting with line, drawing her own hand, and sketching a simple object, she drew a book bag. It was a canvas bag; the fabric was a complex of floral forms with intricate stitching. Her pencil drawing was rich with implied texture, delineated folds, and stitchery, and it contrasted as a dark form with the stark white negative space surrounding it. Completed outside the class, it was a personal triumph for Cheryl. It was her first work mastered completely on her own. Her drive for mastery of various materials continued throughout the quarter. She did other fine works in watercolor, printmaking, and clay, each time pushing the boundaries of the assignment.

Later in the course, Cheryl wrote about her favorite project, the watercolor project, that she could "look back at it today and know exactly how I felt." She continued:

I enjoyed being able to express exactly what that day meant to me. When I look at the picture I see life, life through my eyes, and I appreciate having the freedom to express my ideas. After looking at my peers' pictures, I realized that we all see things differently and place various meanings to the things we see. We all looked at the same trees, same sky, same mountain foothills, but we all interpreted these differently. Plus, I

enjoyed being placed in an art environment. I like being out-
side looking at what I was painting instead of painting from
memory, a picture, or looking through a window. By being
outside, I got to truly experience the painting.

Cheryl wrote that learning to mix colors was the most important thing that she learned in the methods class: "I value having to match the colors in our leaf project because the experience helped me see how to make various shades of color. I look forward to mixing colors with my students."

Cheryl seemed more aware and mature than many of her contemporaries. Each project was carried to a resolution. Cheryl learned from problems and often converted potential problems to advantages through creative strategies. She was enthusiastic about pushing the boundaries of her knowledge. Rarely did she choose a safe option; her works usually involved risk taking. While she did not seem overly concerned with the perfection of finished objects, Cheryl was able to resolve most of the art problems, whether art historical, critical, or studio in nature. She was willing to work on studio pieces as well as scholarly assignments out of class. She did not have many supplies at home and often made special arrangements to take art materials, texts, or equipment on loan overnight, as well as locating other resources on campus.

On several occasions, Cheryl organized other class members into cooperative ventures designed to save time and labor. For example, early in the course she divided a list of historical works so that each preservice teacher in the class would look up two artists/works at the library. She and two other class members then typed the information as a fact sheet for reproductions contained in the class packet. The cooperative venture resulted in higher-level cognitive functioning for class members on the final exam than for another class in which each preservice teacher compiled the fact list separately. Preservice teachers in the class were able to recognize works, and assign centuries and style; in addition, most of them articulated original critical or aesthetic responses to the works at exam time. Cheryl was quick to realize that preservice teachers can learn and extrapolate from each other as well as from the instructor. On another occasion she formed a study group to prepare for a midterm.

Cheryl did not see herself as part of the academic grind, nor was she dedicated to pleasing the instructor. She simply made full use of the class curriculum to fund her knowledge of art. Cheryl persevered on her own agenda, learning as well and as fast as she could about art disciplines. As her own experience widened, she was able to increasingly

connect art making, art talk, and art study to developmental statements from Lowenfeld, Piaget, and others.

During the same quarter, Cheryl was taking a course in music for the elementary classroom teacher that was also criterion based. The preservice teachers, regardless of prior musical background, were expected to perform music as well as to identify musical elements aurally and visually. While her musical abilities were less developed than her artistic capabilities, she doggedly struggled to master the music course. Toward the end of the art methods course, she had to expend more effort on musical problems. Her work remained high cognitively throughout the art methods course, but less time was spent on presentational aspects toward the end of the course.

Cheryl, like most of her classmates, synthesized criticism, studio knowledge, art history, and human development into a holistic approach to art study. Cheryl wrote about *Christina's World* by Andrew Wyeth in the final examination. She used the Feldman Method (Feldman, 1987), a phenomenological approach to art criticism, to describe and analyze the work:

> *When I look at this work I see a field, two houses in the distance, with one being farthest away. There appears to be a barn next to the closest house and a fence. There is a girl sitting in the field. The wind appears to be blowing because the girl's hair is curved out to the side. The curved lines repeat in the road leading out to the house and make it seem farther away. The field is depicted by textured vertical lines that look like wheat. The curved lines of the girl's body make her look like she is moving. The houses are painted with straight lines and geometrical shapes like squares, rectangles, and triangles. The shading of the work makes the girl appear closer to the viewer; it is darkest. The viewer focuses in on the girl because of the light color across her back, as if the sun is shining on her. The viewer is forced to look toward the houses because the girl does, and it seems as if they are upon a hill.*

In this piece of writing, Cheryl moved back and forth between subjectivity and objectivity speaking first to herself and then as an anonymous viewer. When she interpreted the meaning of the work, she tried to incorporate art historical information relating to the sensitivity with which Wyeth approached the making of this work:

> *When I look at this work I come with the knowledge that Wyeth painted it in 1948. One day Wyeth looked out of the*

window of the Olson home (a special house to him) and saw
Christina crawling in the field. Later he went down to the
end of the road and made a drawing of the house, but left
Christina out. He asked her permission before adding her to
the work. Christina cannot walk because of a birth defect.
Wyeth did not want to ask Christina to pose, so he got his wife
to substitute ... he then added her to the picture.

Cheryl concluded the essay with a highly personal evaluation of the
work; "I love this picture, and after knowing the background of it, it cre-
ates a strong emotion. Andrew Wyeth said he got letters from all over
the world asking about Christina." She implied that her own interpre-
tation was enriched by historical knowledge. She applied the criterion
of truth to this work and found: "This is truly Christina's world."

Cheryl's approach to the pedagogical question on the final was also
oriented toward the understanding of other people, other cultures.
Working from an artwork in a social studies text for first graders, she
listed the skill objectives as (1) to identify ways people are different and
alike, and (2) to categorize the ways that the student is like other chil-
dren and how he or she differs. As in her critical approach, the question
was presented as a concept and then interpreted for both personal and
interpersonal validity. She would have the children draw themselves as
happy, sad, afraid; then doing something they would do well. They
would collaborate on life-sized montaged figures that would be fastened
to a mural on the wall. Through the artwork, elementary students
would move from self-perception to a perceived value judgment outside
the self. Then the young students would progress to a small-group col-
laborative effort, and finally to a celebration of differences across
groups. Cheryl did not articulate all these layers of meaning. As with
her art criticism, she synthesized the underlying philosophy of the text
and interpreted the structure through art assignments. She wrote in
her philosophy of art education:

Art experiences are necessary to allow young children an
opportunity to reveal who [they are]. In art, the child can
have the freedom to communicate [his or her] ideas; that may
not be possible in other environments. Art can be used to
affect growth in other school subjects. . . When children learn
about a topic and then visually express it, that deepens the
learning experience.

Where better than through art education to demonstrate the reward
of seeking understanding and comprehension through visual means?
Preservice teachers like Cheryl work from their own experiences. She,

as did other exceptional elementary majors taking the methods course, took her study from art and placed it in a context of future work with children.

The disciplined and professional environment of the course "Art and the Child" introduced the preservice teachers to the cognitive, affective, and expressive outcomes of art education. Like most of her peers, Cheryl wrote about the pleasures of self-expression, the communication of ideas, and human development, instead of "fun." Although she saw art as "appealing" to children and a "favorite" subject, she did not consider it as play.

CONCLUSION

Art taught as discipline based and professionally demanding may lead to differing outcomes in practice from art taught as an activity. In the future, university art teacher educators, accountable to this population of preservice elementary classroom teachers, need to conduct follow-up studies as the preservice teachers enter the classroom. We must compare preparatory praxis to the actualized elementary classroom methodology and objectives of those we train. For example, what is the effect of a criterion-based grading system? If art is taught to non-art elementary education majors as a serious, meaningful human activity, will art make it into the elementary school classroom in the same guise? Will the top preservice teachers serve as models for other elementary school teachers? We may need to address the issue of "art as fun" versus "art is meaningful labor that brings a unique kind of pleasure to students." Can these concepts coexist?

REFERENCES

State of Georgia Advisory Committee (1987). *Quality core curriculum: Visual arts (K-12).* Unpublished document, Georgia State Department, Atlanta.

Broudy, H.S. (1987). *The role of imagery in learning* (Occasional paper #1). Los Angeles: Getty Center for Education in the Arts.

Feldman, E.B. (1987). *Varieties of visual experience.* New York: Abrams.

Chapter 4

Reflections of a Preservice Art Teacher

Maureen Byrne
University of Arizona

Maureen Byrne
University of Arizona

Maureen Byrne is a middle school art teacher in Tucson, Arizona. She received her Liberal Arts B.A. from Pepperdine University, Malibu, California, and studied art at the Corcoran School of Art in Washington, DC. She recently completed her Post-Baccalaureate Certification in Art (K-12) at the University of Arizona, where she is now pursuing her M.A. degree in Art Education part time. Her research interests focus on pedagogical issues in visual arts teacher education.

Chapter 4

Reflections of a Preservice Art Teacher

Maureen Byrne
University of Arizona

I recently completed my postbaccalaureate certification studies in art education at a large state university as a new non traditional student. Recollecting the faces of other preservice teachers in my classes, there seems nothing unusual about mature men and women returning to school to earn a teaching certificate. What still remains with me, after my reentry into the academic domain, however, is the realization that anyone, of any age or educational level, holds preconceived notions or beliefs about the way things are or how they should be in terms of teaching. The tradition of teaching seems rife with dubious truisms (Britzman, 1986). Some of these notions and beliefs are not necessarily based on facts; rather, they resemble myths (Cornbleth, 1986) that are handed down from practitioners to preservice teachers. For example, we are all aware of the truism "Never crack a smile before Thanksgiving."

The truism that I have found to be the most perplexing was told to me by a practicing art teacher whom I held in high esteem. "You don't learn anything at the university," she advised me during a school visit. "Wait until you have your own class; then it's different!" This specific myth that presupposes that teaching is learned on the job permeates

the attitudes and actions of many practicing teachers. Told and retold, this myth seems to transgress all institutional boundaries and levels of schooling, and has become a significant part of the collective vision of teaching.

AT THE UNIVERSITY: THINKING LIKE TEACHERS

I was fortunate to be required to repeat any professional development and art education courses that I had taken more than 10 years earlier. I was cajoled at first, and was told that learning theory had changed. It appeared that I needed to be more current in my thinking. Initially, I was annoyed, but after taking my first university class, I realized how different things actually were from my first go round years before. Learning theory was not all that had changed in my education courses; the education of the preservice teacher had changed as well. Still present were the emphases on professional knowledge and concerns of practice, but the didactic methodology that I had previously encountered had waned, for now theory and practice interacted.

Teacher education has been blamed for the poor performance of teachers in the schools. My university coursework was trying to respond to, and act on such criticisms. My professors were involved in examining the new research on teacher education and contributing to its scholarship in order to help bring about improvements in both teacher education itself and teaching in schools. Clearly this meant that, as educators and researchers, they were actively involved in reforming teacher education (Doyle, 1990; Galbraith, 1988, 1990; Griffin, 1983). I felt that there was both a purpose and philosophy of teaching behind my preservice experiences, and I was able to develop new insights about teaching. As I undertook my studies, I felt that I had entered into a new apprenticeship of observation (Lortie, 1975).

By assuming the role of the teacher, we analyzed what was problematic within the complex domain of teaching. We were required to undertake purposeful fieldwork experiences in both art and other subject area classrooms. As active participants in schools, we wrote about and reflected upon what we observed and did. We were constantly encouraged to discuss and confront our teaching beliefs as they related to practice and to examine objectively the practices we had observed in schools within the safe environment of the university classroom. This step was significant, for as Nadaner (1983) has argued, what is happening in schools is not necessarily an adequate guide to what *should* take place.

In addition to reflecting upon our individual experiences, we worked in teams or groups in our preservice classes. Simulating the role of a faculty of school practitioners, we tackled the issues facing schools in our local community and experienced a teacher's actual work. With a focus on problem solving, we participated in the review and writing of case studies.The skills of inquiry and reflection were practiced by preservice teachers and supported by faculty. Our professors modeled appropriate teaching practices and affective behaviors. We were encouraged to develop a teacher's vocabulary. All of this learning culminated in peer teaching events that were videotaped for us to study.

Over all, this period became a time of measurable growth, for as preservice teachers we were perpetually changing and growing. Divergent opinions were expressed in group discussions, and transitions in our thinking occurred as we exchanged our role as student of teaching to that of a teacher. These coursework activities helped facilitate the necessary connections between theory and practice.

IN THE SCHOOL: STUDENT TEACHING

It was early into my final art education student teaching practicum when I realized that word had not spread to some schools about what was happening in the teacher education program at the university. When my middle school cooperating teacher and I initially exchanged recollections and images of our preservice years, it became apparent that my cooperating teacher's experiences and training had been quite different from mine. As this student teaching semester progressed, we tried to adjust our roles and expectations to the reality of our situation.

It was during this time that I encountered at first hand the myth that "you don't learn anything at the university," since it was a belief that my cooperating teacher held. It became uncomfortable for me to bridge the evident disparities between my cooperating teacher's and my own beliefs about and goals for my student teaching experience. The inquiry-oriented approach to teaching used at the university became uncomfortable for my cooperating teacher. Traditionally, it has been the cooperating teacher who initiates the socialization of preservice teachers (Griffin, 1983). In my case, I felt my socialization already had been formed during my university preservice coursework. I wanted the opportunity to put my professional knowledge into practice. It was I who imposed changes on the expectations and attitudes of my cooperating teacher.

Many practitioners tend to view professional knowledge as that which only comes from active participation in the classroom and believe

that student teaching does not always suffice as *real* practice. They place a higher value on experience (Mason, 1983) than on any other teacher education activity. Although, I do not deny the value of practice, I hold the belief that research, analysis, and reflection also constitute part of the professional knowledge needed for working in schools. I respected my cooperating teacher's opinions and worked toward common goals for teaching, but I was disappointed that I was unable to act as a link between educational reform at the university level and reform in the schools during my student teaching. My experience suggests that preservice teacher education *had* changed, and so had the product, namely the student teacher.

REFLECTION

Reflection has been called the bridge between knowledge and action (Calderhead, 1991). Reflecting on my preservice teacher education program and my student teaching practicum has been important in my growth as an art educator. Why, then, is the accepted belief that universities do not teach preservice teachers anything perpetuated? How does it relate to practitioners' own university teacher education experiences? Why is such a notion still prevalent in the field, and what purpose does it serve? How can preservice teachers and art teacher educators help practitioners to understand and modify their attitudes and beliefs and inform them about the new reality of teaching and teacher education? Learning to teach is not a linear progression, nor is it the sum of techniques, skills, or experiences; rather it is a complex process encumbered with many variables.

The myth about the inadequacies of teacher education is rooted in deeply held beliefs that fulfill a need within the complex and hierarchical system of schooling. This particular myth helps maintain a political, social and economic status quo. Although it is seldom examined, it has widespread acceptance in schools. The reason for this is unclear to me. Preservice and beginning teachers must be allowed to enter the schools as equals and be provided with opportunities for practice.

It was my privilege to attend a teacher education program that addressed reform at the university level. I believe that the preservice teacher (as a student teacher) can serve as one link between the university and the schools. In turn, as new art teachers like myself enter the profession, hopefully we will encounter schools eager to address the current realities of educational reform, and so reevaluate and reconstruct the myths of education.

REFERENCES

Britzman, D. (1986). Cultural myths in the making of a teacher: Biography and social structure in teacher education. *Harvard Educational Review, 56*(4), 442-472.

Calderhead, J. (1991, April). *The nature and growth of knowledge in student teaching.* Paper presented at the Annual Meeting of the American Educational Research Association, Chicago.

Cornbleth, C. (1986, April). *The persistence of myth in curriculum discourse.* Paper presented at the Annual Meeting of the American Educational Research Association, San Francisco.

Doyle, W. (1990). Themes in teacher education research. In W.R. Houston (Ed.), *Handbook of research on teacher education* (pp. 3-24). New York: Macmillan.

Galbraith, L. (1988). Research oriented art teachers: Implications for art teaching. *Art Education, 41*(5), 50-53.

Galbraith, L. (1990). Examining issues from general teacher education: Implications for preservice art education courses. *Visual Arts Research, 16*(2) (Issue 32), 51-58.

Griffin, G. (April 1983). *Expectations for student teaching: What are they and are they realized?* Paper presented at the Annual Meeting of the American Educational Research Association, Montreal.

Lortie, D. (1975). *Schoolteacher: A sociological study.* Chicago: University of Chicago Press.

Mason R. (1983). Art teacher preparation in England, Australia, and the USA: Some observations. *Journal of Education for Teaching, 9*(1), 55-62.

Nadaner, D. (1983). Building theory practice interaction in art teacher education. *Visual Arts Research, 9*(1), 64-70.

Chapter 5

Resistance to Multicultural Art Education

STRATEGIES FOR MULTICULTURAL FACULTY WORKING IN PREDOMINANTLY WHITE TEACHER EDUCATION PROGRAMS

Phoebe Dufrene
Purdue University

Phoebe Dufrene

Purdue University

Dr. Dufrene is Assistant Professor of Art and Design, Purdue University, West Lafayette Indiana, where her major responsibility is the supervision of art education student teachers. She received a Ph.D. in Art Education from the University of Maryland, College Park, and an M.P.S in Art Therapy from the Pratt Institute, New York. Her frequent national and international lectures and publications reflect her research interests in multicultural and cross-cultural art education, art therapy, and Native American arts and culture. During her *free* time, she works with Powhatan tribal members to preserve their indigenous culture.

Chapter 5

Resistance to Multicultural Art Education

STRATEGIES FOR MULTICULTURAL FACULTY WORKING IN PREDOMINANTLY WHITE TEACHER EDUCATION PROGRAMS

Phoebe Dufrene

Purdue University

In a 1989 speech given at Purdue University, Henry Cisneros, former San Antonio mayor and chairman and CEO of Cisneros Asset Management Co., discussed population demographics that will affect future U.S. classrooms. More than half of the U.S. population growth in the next two decades will come from diverse ethnic populations. The population of Americans with European ancestry will decline at an accelerating rate. Hispanics comprise 40% of the immigrant population, and Asians comprise another 40% (Lee & Richardson, 1990).

Inquiry into issues affecting the multicultural classroom are once again being renewed because of the above-mentioned migration patterns. Since some of the most crucial problems facing U.S. educators

Editors note: An earlier version of this chapter was presented at the USSEA Symposium *Beyond the Traditional in Art*, Columbus, Ohio, 1991.

and students are caused by cultural and racial misunderstandings, the universality of artistic expression can be a vehicle for multicultural dialogue (Dufrene, 1990b). Art education philosophical inquiry must now, more than ever, have a multicultural/crosscultural basis. It is imperative for university art education professors and their teacher trainees to be aware of the subtleties needed to work with students of varying backgrounds. Art educators have a responsibility to their students to determine, through appropriate and efficient observation and research, the extent to which their students' creative productions are influenced by ethnic, racial, tribal, religious, and other heritage factors. True, there is much that is universal, much that is common to all humankind, but when differences do exist, different strategies for art teaching must be considered (Joseph, 1974).

There is a need for a multicultural aesthetic literacy that is sensitive to the multicultural character of our society. Currently, multicultural and crosscultural aesthetic examples are given minimal representation in art textbooks, state curriculum guides, and art education methods courses. The prevalent myth is that the ivory tower of academia would be tarnished by a "lowering of standards," as if one culture or ethnic group has a monopoly on standards of cultural excellence (Nicholson, 1990). Educational institutions should be in the vanguard of reform in the areas of multicultural/crosscultural art education. University art exhibits, research, permanent art collections, and art textbooks should reflect our multicultural environment. The art education discipline must cease negative stereotyping of art based on race, religion, or ethnicity and avoid labeling nonWestern art as "savage," "exotic," or "primitive."

Lucy Lippard, a white feminist art historian and critic, has written of a new, globally inclusive curriculum that treats "Western civilization as one of many worth studying in a multicultural nation, where white students will be encouraged to see themselves as simply another Other" (1990, p. 23). Superficial overviews of Asian, African, and PreColumbian art are included in introductory art history courses. However, few university art courses acknowledge the Third World's contributions to Western culture or treat these civilizations as cultural equals (Lippard, 1990).

In my role as a university art education professor with a multicultural family history, I try to prepare my 98% white preservice art teachers for America's future multicultural classrooms. Because Indiana is ranked 35th out of the 50 states for multicultural populations, it is a challenge to convince my preservice teachers that the demographic structure of the U.S. classroom is really changing. Out of approximate-

ly 36,000 Purdue University students, only 1,000 are African American, 500 are Hispanic, and approximately 25 are Native American. This chapter addresses some of the resistance I encounter from the preservice art education teachers and offers strategies to remediate it.

BACKGROUND

During my appointment at Purdue University, I have been reading extensively on Native American art and culture, contemporary art and culture from other diverse non-Western traditions, feminist art criticism, and art education issues affecting the international art community. In addition, I have published and given lectures on multicultural art issues at national and international conferences. Investigation and contemplation of these matters has focused upon applications for the K-12 art classrooms and university art education.

This inquiry was first initiated during my graduate research and was supported by a 1990 National Endowment for the Humanities grant to participate in the summer institute "Myth, Memory, and History" held at the Newberry Library's D'Arcy McNickle Center for the Study of the American Indian. The institute consisted of 25 U.S. and Canadian interdisciplinary faculty who explored oral traditions and art and artifacts from North and South American indigenous cultures. From this experience I wrote two papers, "Contemporary Powhatan Art and Culture: Its Link with Tradition and Implications for the Future" (Dufrene, 1990a), and "Traditional Powhatan Art: Historical Traditions and Contemporary Aesthetics" (Dufrene, 1990d), which were presented in October 1990 at the University of Chicago's TwentySecond Algonquin Conference. In 1991 I began addressing multicultural/crosscultural issues on the international level through invited lectures in Cuba and Mexico. I was invited to discuss these issues again in 1992 in Brazil, Cuba, and Mexico. Many of my publications and invited lectures have been concerned with forming professional collaborations with national and international scholars who have similar research interests.

But perhaps my greatest contribution to teacher preparation in multicultural art education is my personal experience as an artist of color. Growing up in a family of artists that uses our Native American (Powhatan) heritage for artistic inspiration and intermarriages with other nationalities (Asian and Caribbean) for international understanding, it has always been easy for me to identify with art from various cultures. Unlike many North American professors for whom multiculturalism is an intellectual exercise, for me it has always been a way of life. In my extended family, 29 of us have careers in the arts as photographers, visual artists, musicians, writers, dress designers, art teachers,

medical illustrators, technical draftsmen, art therapists, and university art professors. My maternal aunt, Georgia Mills Jessup, is the only artist of Native American descent to have a painting in the permanent collection of the National Museum of Women in the Arts.

Growing up surrounded by Oriental rugs, Japanese pottery, Native American ceramics and textiles, and Caribbean art gave me an early appreciation of art from diverse cultures. As a person of color traveling in Cuba and Mexico, it was easy for me to relate to Latin American cultural expressions, the aesthetic affinities with indigenous African and Indian art forms, the sense of unrushed time, and the sensuality (Dufrene, 1991b).

Although this is my 6th year supervising a class of predominantly white preservice student teachers, it is still a culture shock to enter the room on the first day of class. It is a two-way cultural shock, because many of my preservice teachers come from rural Indiana and have never had a personal encounter with someone of a different race until attending Purdue. Their only previous exposure to other races has been from the media.

This is the 6th year that I have asked preservice student teachers to prepare slide packets that include artists of color (male and female) and Western women artists. Once again I am faced with a class that has never been exposed to Native American artists such as Jaune Quick-To-See Smith, Jimmie Durham, Harry Fonesca, George Longfish, Fritz Scholder, or T. C. Cannon; African-American women artists such as Faith Ringgold, Betye Saar, or Elizabeth Catlett; Mexican artists such as Frida Kahlo, Rufino Tamayo, or Diego Rivera; and culturally mixed artists such as Wilfredo Lam (Cuban-Chinese-Mulatto) and Isamu Noguchi (Japanese-Anglo-Native-American). The 6-week senior student teaching seminar does not offer enough time to compensate for 4 years of male Eurocentric art education. The results are frustration on my part and resistance from preservice teachers who think multicultural art is not relevant in Indiana.

Consistently, the male students have been the most receptive to collecting slides from non-Western artists (male and female), and the females have been mainly interested in white European and American artists. Hispanic-American, Asian-American, African-American, and Native-American women artists are not perceived as "women artists." Relationships between women artists of color and the white feminist art movement have not always been cordial. Racism and classism within the feminist art movement are realities that are often ignored (Goldman, 1988). Furthermore, many art education preservice teachers

do not realize that contemporary Third World artists who are not discussed in U.S. university art courses may be internationally recognized and acclaimed in Europe or Latin America. With this lack of personal exposure, it is difficult for them to plan art education curricula that are globally inclusive. What will these future art teachers do when confronted with a class of Hispanic, Asian, or Caribbean immigrants? Will they be able to introduce aesthetics, criticism, and art history relevant to diverse populations? Exclusionary policies based on disinterest result in distorted views of art in general, and of the breadth of art from white Americans in particular (Goldman, 1988).

STRATEGIES FOR REMEDIATION

To overcome preservice teachers' resistance to the facts of the changing population demographics and the necessity to develop more multicultural art education curricula, it is necessary to prepare them adequately before the senior year teaching experience. Preparation should include a review of the literature pertinent to multicultural/crosscultural art education. Readings should include research from the 1960s to the present that examines topics, discussions, and conclusions that may be adopted for use in art curricula.

Also important is the development of research methods that focus on the sociocultural context in which art is produced. Ethnographic investigation involves an examination of the structures relevant to the production and use of art within a cultural context. Similarities and differences among the arts in various cultures are analyzed through social, political, and economic systems.

As a way of understanding art outside our own culture, art historian Arnold Rubin (1989) offered three universal areas that delineate the ways art functions in a society. These areas include (1) the establishment and proclamation of individual and group identity, (2) a didactic system linking generations in shared beliefs and behaviors, and (3) the technology by which people relate to their environment and secure their survival (Dufrene, 1991a). According to Rubin's theory, art from all cultures possesses three properties: material, motif, and workmanship. In his book *Art as Technology: The Arts of Africa, Oceania, Native America, and Southern California*, Rubin labeled art from various cultures by geographic areas instead of using derogatory terminology such as "savage" or "primitive." Rubin also analyzed art from these cultures within a social, political, and economic context. He felt that formal and stylistic analyses were insufficient to study art outside of one's own culture. Society's impact on art is emphasized in Rubin's writings.

In a similar vein, British art scholar Guy Brett (1986), in *Through Our Own Eyes*, examined the artistic expressions of people living in countries that have experienced overwhelming, traumatic political changes. The book documents the human potential to create art despite conditions of war and other hardships. Art is incorporated into liberation movements. Art made during times of oppression in various places such as Africa, Europe, Japan, and South America is analyzed in its traditional context of ritual and healing (Dufrene, 1990c).

Implementing some of the strategies suggested by Rubin and Brett for a more culturally diverse art history, aesthetics, and criticism is beyond the limits of most art teacher education methods courses. Therefore, to fully develop balanced teacher preparation materials, art education professors must work closely with art history professors and art library personnel. Professionals in other art disciplines must be willing to help broaden the canon. Unfortunately, within the art canon currently used in most universities, the art periods studied from non-Western cultures only include ancient times through European colonialism/imperialism. The past is overemphasized, and students are left with the false impression that Africans, Native Americans, and other indigenous peoples have not made valid contributions to modern or postmodern art.

Romantic misconceptions of Native Americans (and Africans and Oceanic peoples) as nontechnological, Stone Age artisans dominate the literature, thereby reinforcing the tendency to dismiss evolving contemporary art by indigenous peoples. In fact, the aesthetic experiences of artists of color have survived colonialism, forced servitude, racial discrimination, and rapid technological changes (Dufrene, 1990a).

Since there is no one standard text that can adequately prepare preservice art education teachers for multicultural teacher preparation, I have included a list of additional readings that might prove helpful to art educators at the end of this chapter. This modest list includes topics on feminist art; multiculturalism in general; modern/postmodern art of African Americans, Hispanic Americans, and Native Americans; politically conscious art; contemporary art by Africans, Asians, and Oceanic peoples; and cultural issues affecting people of color. It is a sampling of some of the research that has interested me and has helped me expose my art education preservice teachers to diverse cultures. If I had to recommend just one book that covered all of these issues from a contemporary perspective, I would select Lippard's (1990) *Mixed Blessings: New Art in a Multicultural America*. To quote the Native American poet Joy Harjo (1990), who writes on the back cover, it is "more than a book

about art a round dance of cultural concepts, ideas, and meanings a crossroads of memory expressed in form, color, spirit, words."

To complement the objective, scholarly research necessary for art teacher preparation, a more personal approach is also needed. This can involve faculty and preservice teachers' honestly sharing their personal feelings about groups outside of their respective cultures; sharing thoughts most group members from their particular culture feel about "outsiders"; bringing in art objects from their personal collections; and establishing friendships with people from different races, religions, and countries.

I will never forget my first year at Purdue, when a student teacher told the class that white Americans were an "endangered species" and would have a hard time getting teaching positions because "minorities get all the good teaching jobs now." The previous semester, the student had had an African instructor. Having me the following semester may have been overwhelming. Until feelings like that are resolved, multi-culturalism will continue to be a conference theme or a curriculum instead of a way of life.

CONCLUSION

At this time in world history, as walls are literally being torn down, cross-cultural studies of art can be used to reveal similarities among people as well as unique differences. A culturally sensitive art education curriculum will more equitably represent the diversity within the classroom, the community, the nation, and the world. Many Americans are unfamiliar with the different races and cultures both within and outside the United States. Too many Americans think that the dominant racial groups in the United States are only Caucasians and African Americans. The media have been guilty of portraying racial issues as only a manifestation of black and white problems. Racial nomenclature in the Western hemisphere developed under colonialism and racism. Racial identification can be a controversial issue for indigenous Americans of mixed ancestry. Revisions are needed in the history of race relations and in the study of modern African, Native-American, Hispanic-American, and African-American cultures (Forbes, 1989).

One way for preservice art teachers to explore their feelings concerning racism, sexism, or other "isms" is to use the creative process. In the context of the political, economic, and social changes taking place since the Civil Rights Movement, artists of color have used their art as vehicles of political protest (Sims, 1988). Sims, a female African-American

art curator, has been documenting the ways performance art is used to connect black, feminist, and social issues.

Black feminist writer Bell Hooks (1988) thinks that the higher educational institutions have limited our understanding of racism as a political ideology. Hooks's writings state that professors deny the truth and teach students to accept racial polarity in the form of white supremacy and sexual polarity in the form of male dominance. Americans have been taught to accept a version of U.S. history that was created to maintain racial and sexual imperialism, "for how does one overthrow, change, or even challenge a system that you have been taught to admire, to love, to believe in?" (Hooks, 1988, p. 550).

These words may seem harsh to many professors, students, and Americans in general. But how or why should one change the art canon or any other canon if one believes that the status quo is sufficient? Ultimately, the canon will only change when political and social consciousness is heightened.

REFERENCES

Brett, G. (1986). *Through our own eyes.* Philadelphia: New Society.

Dufrene, P. (1990a, October). *Contemporary Powhatan art and culture: Its link with tradition and implications for the future.* Paper presented at the University of Chicago's Twenty-Second Algonquin Conference.

Dufrene, P. (1990b). Exploring Native American symbolism. *Journal of Multicultural and Crosscultural Research in Art Education, 8*(1), 38-50.

Dufrene, P. (1990c). Through our own eyes [Book review:] *Studies in Art Education, 31*(4), 253-255.

Dufrene, P. (1990d, October). *Traditional Powhatan art: Historical traditions and contemporary aesthetics.* Paper presented at the University of Chicago's Twenty-Second Algonquin Conference.

Dufrene, P. (1991a). Art as technology: The Arts of Africa, Oceania, Native America, and Southern California. [Book review] *Art Therapy, 8*(1), 29-31.

Dufrene, P. (1991b). Latin-American meeting on artistic teaching. *INSEA News, 1*, 20-26.

Forbes, J. (1988). *Black Africans and Native Americans.* New York: Blackwell.

Goldman, S. (1988). "Portraying ourselves": Contemporary Chicana artists. In A. Raven, C.L. Lange, & J. French (Ed.), *Feminist art criticism* (187-206). Ann Arbor, MI: UMI Research Press.

Harjo, J. (1990). Book cover. In L. Lippard, *Mixed blessings: New art in a multicultural America*. New York: Pantheon.

Hooks, B. (1988). Racism and feminism. In E. Jones, & G. Olson (Eds.), *The gender reader* (446-552), Boston: Simon & Schuster.

Joseph, C. (1974). *Art therapy and the Third World*. New York: Cliff.

Lee, C. C., & Richardson, B. O. (1990). *Multicultural issues in counseling: New approaches to diversity.* Alexandria, VA: American Association for Counseling and Development.

Lippard, L. (1990). *Mixed blessings: New art in a multicultural America*. New York: Pantheon.

Nicholson, B. (1990). Multiculturalism: The challenge of the ivory tower. *USSEA Newsletter, 14*(1), 1-5.

Rubin, A. (1989). *Art as technology: The arts of Africa, Oceania, Native America, and Southern California*. Beverly Hills, CA: Hillcrest.

Sims, L. (1988). Aspects of performance in the work of black American women artists. In A. Raven (Ed.), *Feminist art criticism.* Ann Arbor, MI: UMI Research Press.

ADDITIONAL READINGS

Araeen, R. (1989). *Third text: Third World perspectives on contemporary art and culture*. London: Kala.

Beardsley, J. (Ed.) (1987). *Hispanic art in the U.S.* New York: Abbeville.

Coe, R. (1986). *Lost and found traditions: Native American art 1965-1985.* Seattle: University of Washington Press.

Grigsby, J. (1977). *Art & ethnics: Background for teaching youth in a pluralistic society*. Dubuque, IA: Brown.

Heller, N. (1987). *Women artists*. New York: Abbeville.

Highwater, J. (1976). *Song from the earth: American Indian painting*. Boston: Little, Brown.

Highwater, J. (1982). *The primal mind*. New York: NAL.

Highwater, J. (1983). *Arts of the Indian Americas*. New York: Harper & Row.

Lewis, S. (1984). *The art of Elizabeth Catlett*. Los Angeles: Museum of African-American Art.

Lewis, S. (1990). *Art: African American*. Los Angeles: Hancraft Studios.

Locke, A. (1940). *The Negro in art*. New York: Hacker Art Books.

McElroy, G. (1989). *African-American artists 1880-1987*. Washington, DC: Smithsonian Institution.

Nochlin, L. & Harris, A. (1979). *Women artists 1550-1950*. New York: Knopf.

Parry, E. (1974). *The image of the Indian and the black man in American art: 1590-1900*. New York: Braziller.

Reed, A. (1960). *The Mexican muralists*. New York: Crown.

Rosen, R. (1989). *Making their mark: Women artists move into the main-stream 1970–1985.* New York: Abbeville.

Rubinstein C. (1982). *North American women artists from early Indian time to the present.* New York: Avon.

Strickland, R. (1981). *Magic images: Contemporary Native American art.* Norman: University of Oklahoma Press.

Young, B. (Ed.). (1990). *Art, culture, and ethnicity.* Reston, VA: National Art Education Association.

Chapter 6

Who Teaches
Art?

RECYCLING THE QUESTION

Carol S. Jeffers
California State University, Los Angeles

Carol S. Jeffers
California State University, Los Angeles

Dr. Jeffers is Associate Professor of Art Education at California State University, Los Angeles. She was previously an assistant professor at the Wichita State University in Wichita, Kansas. She received her Ph.D. from the University of Maryland, College Park. Her research interests cover a broad range of issues in art education and multiculturalism. She is interested in examining how it is possible to teach about art in today's schools given their conformist nature. Dr. Jeffers's articles have been published in *Studies in Art Education, the Journal of Aesthetic Education,* and *Art Education.* This paper recounts one of her experiences as a former graduate assistant.

Chapter 6

Who Teaches Art?

RECYCLING THE QUESTION

Carol S. Jeffers
California State University, Los Angeles

Not long ago, a preservice teacher enrolled in the elementary art methods course that I was teaching for classroom teachers came to my office and asked me about becoming an art teacher. Following is the dialogue that may have occurred between the student, whom I call Denise, and myself, at that time a graduate assistant at another university.

A DIALOGUE

Denise: During this [elementary art methods] course, I have found myself wondering about what it would be like to be an art teacher instead of the elementary classroom teacher I was planning to become. I wonder whether someone like me could teach art, or even whether I should teach it. I also wonder: What would I teach? Or perhaps I mean to ask: What *should* I teach? How would I teach it? How would I be evaluated? How would I know that my students were learning? Also, I need to know what would be involved in changing my major. What goes into becoming an art teacher? How would I be prepared? Who would teach me? I guess I am pretty confused. I seem to have a lot of questions.

Graduate Assistant: Gadamer [1975/1986] says that understanding begins with questioning, and yours are important and provocative questions, Denise. They require a great deal of thought, and hopefully they will further your understanding of yourself and the larger teaching profession. Please have a seat.

Denise: Thanks.

Graduate Assistant: Interestingly enough, I wonder about many of the same issues myself and am trying to address some of them in my research. It turns out that we are not alone; many art educators have been asking these questions for decades.

Denise: Is that right?

Graduate Assistant: Here, let me read this to you. It is from the catalog description of a session at the 1977 Annual Convention of the National Art Education Association [NAEA, 1977]. We call it the NAEA for short. My advisor lent me this catalog, and I am finding it very interesting to look back at what was going on in art education in those days—to see how what went on then has shaped the research agendas and policies of today.

Let me see, yes, right here it says, *NAEA Bicentennial Commission Report* [Dorn, Taylor, Eisner, Hurwitz, & Madeja, 1977]. This is a presentation and discussion of the Commission's Report which represents over 15 months' work on such issues as: 'Who should teach art? How should programs be evaluated? What should be taught and to whom?'" [p. 20]. And look right here, there is mention of a committee that met to discuss accreditation standards for art teacher preparation programs. Perhaps this committee was asking questions about how art teachers should be prepared, and by whom.

Denise: Isn't that something—those *are* some of my questions!

Graduate Assistant: You know, Denise, art education is a young and evolving field. I think that art educators have wrestled with these questions and will continue to do so because we are curious about this relatively new field. We want to understand what it means to teach art. When we seem to gain some understanding, and when we find some answers to our questions—your questions— we then try to establish standards for the teaching of art. For example, within 2 years of the 1977 Convention, the NAEA did publish its *Standards for Art Teacher Preparation Programs* [1979]. For some people, such standards help to clarify questions about how to prepare art teachers. However, they can also trigger new questions, and sometimes the questioning leads to a revising of the standards. By 1990, Rogers and Brogdon had asked the question: How closely do art teacher preparation programs actually comply with the NAEA standards?

In order to find out, they conducted a survey of the colleges and universities that prepare art teachers.

Denise: What did they find?

Graduate Assistant: Well, of those art teacher preparation programs represented in the survey. . . Let's see, I've got the journal *Studies in Art Education* right here. Okay, in the article, Rogers and Brogdon [1990] write that about 35% of the programs meet or exceed the NAEA's recommended total number of semester hours in studio art, art history, and art criticism. Furthermore, 80% of the programs meet the studio art requirement and 66% meet the art history requirement. You know, it would be interesting to compare our program's requirements with the NAEA standards to see where we would fit into the survey results. Remind me to get you a copy of our requirements, Denise.

Denise: Sure, I would like to see them.

Graduate Assistant: Look at this—Rogers and Brogdon [1990] ended up by asking two additional questions: "Why have national standards? What standards are reasonable?" [p. 172].

Denise: What does all of this mean?

Graduate Assistant: Well, we are not sure yet. The survey results tend to indicate that many programs are not meeting the NAEA standards, possibly for economic reasons. There are certainly some implications for further research. But let's talk about you. You may be making a key decision about your future, your teaching career. Let's start with your question about whether or not a person like you could teach art. That is really the "Who teaches art?" question, or perhaps the "Who *should* teach art?" question.

Denise: Yes, I suppose it is.

Graduate Assistant: As we just saw, art educators have been trying to address these questions for some time. Let's look at the research. I have some research findings right here; they are a part of my dissertation literature review. You will notice that answers to the question "Who teaches art?" can vary, depending on who formulates the question and the type of methodology used to carry out the research.

Denise: What do you mean?

Graduate Assistant: For example, some of the doctoral dissertations that I am referring to in my literature review are descriptive studies of the experiences of one art teacher. The researchers observed, interviewed, and pretty much lived with the art teacher for an extended period of time, such as a school year. This dissertation, written by Rogena Degge [1976] is a case study and theoretical analysis of Mrs. Allen, a junior high school art teacher. Here is another one, a phenomenological study of one art teacher's experience of the preadolescent world. It was written by Stanley Folsom [1976], and it reads like a story. Over there is another one. Can you reach it? Yes, this particular dissertation may be helpful to you. It is a study of the life-world of a first-year art teacher done by David Hawke in 1980. I have photocopied some chapters from this study. Would you like to borrow them?

Denise: May I?

Graduate Assistant: Certainly. This research may offer you some glimpses into the life experience of an art teacher and some insights into who the art teacher might be. But there is also another body of research—some survey research I dug up for one of my research methods courses—that may interest you. The survey's results encompass the viewpoints of hundreds and hundreds of art teachers. For example, Laura Chapman [1979] designed a survey questionnaire that was published in *School Arts.*

Denise: Oh, you mean that magazine in the curriculum lab?

Graduate Assistant: Yes, the one that is widely read by preservice and inservice teachers. The survey results were published in 1979. I don't think the curriculum lab will have that issue on the shelf. It's probably on microfiche in the library. If you want to look it up, it is titled "Teacher Viewpoint Survey." Now it may be easier to find it in Laura Chapman's book *Instant Art, Instant Culture: The Unspoken Policy for American Schools,* published in 1982 by Teachers College Press. In the book, the survey appears as "Appendix A."

Denise: Okay, thanks for giving me the citation.

Graduate Assistant: Anyway, "Teacher Viewpoint" is a questionnaire survey of 710 elementary, junior high, and senior high school art teachers. The results provide a description of these teachers' professional lives both in and out of the classroom, their perceptions of their roles, and their attitudes toward the conditions under which they must play these roles. This nationwide survey was followed by two derivative surveys conducted at the state level in Nebraska and Missouri, I believe. Let me see, yes, Ellis, Shields, and Spomer [1981] surveyed Nebraska art teachers between 1978 and 1980, and Lahr [1984] surveyed Missouri art teachers and reported the results in 1981.

Denise: What were the results?

Graduate Assistant: The statewide survey results [Ellis, et al., 1981; Lahr, 1984] were fairly consistent with those of Chapman's findings. From all of these results, we get a picture of an elementary art teacher who must perform a variety of duties, often in too small a room, with too few supplies and little storage space, and who must deal with many unresponsive students.

Denise: Well that is a pretty bleak picture. Is it true in your experience?

Graduate Student: Well, yes and no I can tell you that the elementary art specialists who are serving as the cooperating teachers for the student teachers that I am supervising are not complaining about lack of budget, supplies, or support. They seem to be working in bright, inviting, and well-equipped art rooms. Each of their schools owns a complete set of Shorewood prints, and these art teachers really use the prints as instructional resources. I wish I had a set here. And I haven't seen any unresponsive children in these art rooms. On the contrary, the children are very excited about their once-a-week art class.

Not to mislead you, but scheduling is a bit of a problem for these elementary art teachers because they have to see on average 500 children each week. These teachers are very busy, as you can imagine; they keep up a fast, nonstop pace. The student teachers in these situations work very hard. I don't know whether that influences your decision, but hard work is a fact of life in the art room. I'd be happy to arrange for you to observe one or two of these art specialists if you'd like. Or perhaps you could talk to some of the student teachers, to get their experiences first hand. Some of them are finishing up their coursework and are here on campus some evenings. I can ask them to meet with you.

Denise: Would you?

Graduate Assistant: That way, you can see for yourself, and you may or may not verify the survey results. My own experience as a high school art teacher does tend to verify the survey results. While there were many rich and rewarding moments, and some wonderful students, I certainly could have used more space, more budget, and more time to reflect on things. And you know, I feel that way now, teaching art on the college level. We don't have enough storage space or budget.

Denise: Well, I noticed that we are just about out of glue. And I couldn't find any black construction paper last week.

Graduate Assistant: I've been wondering whether other art teachers on the college or university level feel this same way. Do you suppose other places are short of glue and construction paper?

Denise: I don't know. Are they?

Graduate Assistant: In fact, I've been wondering about my role in preservice education. I find myself asking: Who works in preservice education? Under what conditions? Who prepares art teachers at the college and university levels?

Denise: What's the story? Is there any research available?

Graduate Assistant: Well, I did find some surveys of men and women art educators in higher education. Two surveys were completed in 1977. Let's see, they are somewhere in this pile. Here they are: John Michael [1977] conducted one on the leadership roles held by men and women art educators. Lovano-Kerr, Semler, and Zimmerman [1977] surveyed the rank, salary, professional activities, and degrees held by men and women art educators in higher learning. These researchers sent questionnaires to the members of the Higher Education Division of the NAEA.

Denise: And what did they find out?

Graduate Assistant: Women seem to be in lower ranks than men.

Denise: What do you mean by "rank?"

Graduate Assistant: In institutions of higher learning, there are hierarchical ranks, like rungs on the career ladder. In many institutions, the rank of instructor is often the lowest; next is assistant professor, then comes associate professor and full professor is at the top. Anyway, the surveys found that not only are women in the lower ranks, but they also tend to stay in rank longer than men. That is, men seem to move up faster. Women often carry heavier teaching loads than men, and women teach more undergraduates than men. This may explain why women sometimes engage in less research activity than men. Since most university reward systems favor research activity over teaching, it may have some bearing on why women tend to stay in the lower ranks.

I also have some anecdotal evidence. Dr. Greenberg, one of my colleagues who is a professor of art education, wrote me a letter saying that the man who was her department chair some years ago told her that it was a waste of her ability as a faculty member to be out there supervising student teachers. [P. Greenberg; personal communication, 1990]. She said she couldn't believe it. She views working with future teachers as an important part of her professional activity. Perhaps her chair thought she was wasting her ability to *do research*. Her personal experience seems to support the survey results. In spite of her department chair's attitude, however, she did make full professor.

Denise: That's encouraging, right?

Graduate Assistant: Yes, and it gives me hope. Like you, I have to think about my future career. I would like to continue working with preservice teachers, but I'd also like to think that I could advance and someday make full professor.

Denise: You want to become a professor?

Graduate Assistant: I think so, But for now, I am a university graduate assistant art educator. Oddly enough, graduate assistants like me and the roles that we play in preservice education are rarely mentioned in the literature. If the picture of higher education is bleak, it also seems incomplete. Yet, it will remain incomplete unless we again grapple with the questions: Who teaches art at the college and university level? Who works in preservice education? and who prepares art teachers? If the answer to many of these questions is "graduate assistants," then a number of other questions will need to be explored. For example, I am curious to know whether other graduate assistants are out there teaching elementary art methods and supervising student teachers. If so, how many? And where are they?

Denise: Do you suppose that other colleges and universities use graduate assistants?

Graduate Assistant: I guess so; but I haven't been able to find any numbers describing how many graduate assistants there are nationwide. I don't know how widespread is the practice of using graduate assistants in the teaching and supervision of preservice art education students. Oh sure, I've met a few graduate assistants from other universities when I have gone to national conferences. In fact, we've even tried to do some networking, exchange ideas, and provide support for one another. I organized a symposium [Jeffers, et al., 1991] in which we tried to examine the role of graduate students in preservice art education. Yet, in spite of these efforts, it seems as though we might be part of an unspoken policy in higher education and preservice art education.

Denise: Sounds as though someone should conduct some research on this.

Graduate Assistant: Yes, definitely! I'm sorry I can't offer you any more information on this.

Denise: Oh no, this is very interesting, although I do have a class coming up—children's literature.

Graduate Student: Okay, let me know when you'd like me to set up those observations for you.

Denise: Fridays are good for me; I don't have any classes and I don't have to be at work until 4:00.

Graduate Assistant: Great, I'll see what I can do.

Denise: Thanks a lot. And thanks for talking with me. It was helpful.

Graduate Assistant: I should be thanking *you.* Your questions were very helpful to me. Actually, we seem to have a lot in common. We are asking similar questions as we try to see into the murky future. I think it helps if we take turns holding the light.

REFLECTIONS

As Denise picked up her backpack and hurried off to class, I began to reflect on the similarities between us. We both seem to be struggling with that deceptively simple and apparently recycled question, "Who teaches art?". Or perhaps the question is "Who *should* teach art?". As a graduate assistant, this latter question is perhaps the most perplexing. At best, *should* is a normative term, and at worst, it is prescriptive. Can we actually prescribe a set of standards for persons who teach art? Do we presume to know what these standards might be? I tend to think not.

Still, the question of who should teach art nags me. Like Denise, who wonders whether she should teach art, I too, as a graduate assistant, wonder whether I should teach it. Wouldn't the professional needs of future teachers be better served by associate and full professors? The question is rhetorical; my point is moot. The fact is, I *am* teaching art; it is a matter of what is, rather than of what ought to be. However, it is important that Denise's questions have at least prompted me to speak of what seems to be an unspoken policy.

What are the implications of the policy of using graduate assistants to teach art at the college and university levels? One of the many is that graduate assistants like myself gain access to an invaluable and enriching experience. I am indeed grateful to have the opportunity to work with students like Denise. In a real sense, these preservice teachers are teaching me about the structure and function of higher education in general, and of art teacher education in particular. It is they who are helping me to gain entry into the world of higher learning; they who hold up the career ladder so that I might grab the lower rung. As I reflect further on our conversation, it appears that Denise and I have recycled our own questions about who teaches art, or who should teach

art. In this recycling, an important and more humbling question sur-
faces: Who is teaching whom? I did not see the significance of this final
question until my conversation with Denise. As Gadamer (1975/1986)
said, "We must keep open the question because it opens to the next
question" (p. 266). With this next question, I hope the dialogue will con-
tinue.

REFERENCES

Chapman, L.H. (1979). Teacher viewpoint survey: The results. *School Arts* 78, 2-5

Chapman, L.H. (1982). *Instant art, instant culture: The unspoken policy for American schools.* New York: Teachers College Press.

Degge, R. (1976). *A case study and theoretical analysis of the teaching practices in one junior high art class.* Unpublished doctoral disser-tation, University of Oregon, Eugene.

Dorn, C., Taylor, A., Eisner, E., Hurwitz, A., & Madeja, S. (1977, April). *NAEA Bicentennial Commission report.* Paper presented at the annual convention of the National Art Education Association, Philadelphia.

Ellis, M., Shields, R., & Spomer, M. (1981). *Nebraska art teachers pro-file, preparation, and opinions.* Unpublished manuscript.

Folsom, S. (1976). *The art educator in the preadolescent world: A phe-nomenological descriptive study of teacher and children.* Unpublished doctoral dissertation, the Pennsylvania State University, University Park.

Gadamer, H.G. (1975/1986). *Truth and method.* London: Sheed and Ward.

Hawke, D. (1980). *The life-world of a beginning teacher of art.* Unpublished doctoral dissertation, University of Alberta, Edmonton.

Jeffers, C., Galbraith, L., Diket, R., Greenberg, P., May, W., & Brown, L. (1991, March). *Preservice art education: Views from the trench-es.* Symposium presented at the annual convention of the National Art Education Association, Atlanta.

Lahr, J.S. (1984). Who teaches art: A report of recent surveys. *Studies in Art Education, 25*(2), 115-120.

Lovano-Kerr, J., Semler, V., & Zimmerman, E. (1977). A profile of art educators in higher education: Male/female comparative data. *Studies in Art Education, 18*(2), 21-37.

Michael, J.A. (1977). Women/men in leadership roles in art education. *Studies in Art Education, 18*(2), 7-20.

National Art Education Association. (1977). *Arts Renaissance: Reach into the future.* Catalog of the 17th Annual Convention, Philadelphia. Reston, VA: Author.

National Art Education Association. (1979). *Standards for art teacher preparation programs.* Reston, VA: Author.

Rogers, E.T., & Brogdon, R.E. (1990). A survey of the NAEA curriculum standards in art teacher preparation programs. *Studies in Art Education, 31*(3), 168-173.

Chapter 7

Recent and Relevant School Experience

ART TEACHERS AS ART EDUCATION LECTURERS

*Richard Hickman and
James Hall*
University of Reading, United Kingdom

James Hall
and
Richard Hickman
University of Reading, United Kingdom

Mr. Hall became full-time Lecturer in Art and Design at the University of Reading in the United Kingdom after completing his joint appointment contract between the University of Reading and the Berkshire Education Authority in 1988. He completed his M.A. in Art and Design education at the University of London Institute of Education in 1989. He also studied at Newcastle-upon-Tyne Polytechnic and Goldsmiths College before taking up teaching positions in the northeast of England and Comberton Village College, Cambridge, where he was head of Art and Design. His research interests are in art and design teacher education and in the teaching of printmaking.

Dr. Hickman has been employed by the Singapore government to help train art teachers in the Republic of Singapore since completing his joint appointment contract between the University of Reading and the Berkshire Education Authority in the United Kingdom. Until recently, he was a Senior Examiner and Senior Moderator for the General Certificate of Secondary Education (GSCE) examination in the United Kingdom. He is a practicing painter and has exhibited his work widely, with several solo exhibitions. His research interests are concerned with multicultural art education, and at the University of Reading he is actively involved with research into the relative difficulty of art concepts. He is currently a member of the Editorial Board of the *Journal of Art and Design Education.*

Chapter 7

Recent and Relevant School Experience

ART TEACHERS AS ART EDUCATION LECTURERS

*Richard Hickman and
James Hall*
University of Reading, United Kingdom

This chapter addresses one of the issues raised by the United Kingdom Council for the Accreditation of Teacher Education (CATE), namely the quality and nature of school experience held by education lecturers within teacher preparation programs. As a result of the United Kingdom's 1988 Education Reform Act, all lecturers responsible for the training of art teachers are required to have substantial, recent, and relevant school experience. This chapter examines the joint appointment model in the light of 3 years' experience of such a scheme.

The chapter's original subtitle was "Pioneering the Obvious," because colleagues elsewhere have described the arrangements at the University of Reading as "pioneering" in the field of art education. The response might be to point out that the notion of art education lecturers' having ongoing school experience is such an obvious principle that it is difficult to imagine how it could be otherwise. In accordance with this,

CATE has stipulated the need for education lecturers to have *substantial, recent, and relevant experience* in schools, and this has gone some way toward promoting the development of practicing teacher involvement in the initial training of teachers. A circular from the Department of Education and Science (DES) for England and Wales dated March 1984 stated:

> *The staff of training institutions who are concerned with pedagogy should have school teaching experience. They should have enjoyed recent success as teachers of the age range to which their training courses are directed, and should maintain regular and frequent experience of classroom teaching. (U.K. Government, 1984)*

To meet this directive from the DES, many art education programs have been developing links of various kinds between themselves and local schools. The joint appointment scheme between the University of Reading and the Berkshire Education Authority is one such example, and it provides the focus for this chapter.

ART TEACHERS AS ART EDUCATION LECTURERS: A JOB DESCRIPTION

The initial job description, sent out to art teachers by the University of Reading in order to attract suitable joint appointees as art education lecturers, was as follows:

> About two and a half days a week will be spent in the school(s) to which the successful candidate is appointed, and a similar period in the University, where the lecturer will have a broad commitment to Method work on the Postgraduate Certificate in Education, and some responsibility for the supervision of teachers on teaching practice.

The actual teaching contract was a standard Berkshire Education Authority contract, which placed the joint appointees on a head of department scale, but with the following special conditions:

> For the first three years you will be seconded to Reading University as a lecturer. This will involve working directly for the University on a half-time basis and acting as an assistant teacher in one or more Berkshire Secondary Schools for the remainder of the week.

Two joint appointees were appointed to work alongside one full-time university art education lecturer. However, anyone who has ever

worked part time will realize that two part-time jobs add up to more than one full-time job.

THE UNIVERSITY OF READING POSTGRADUATE CERTIFICATE IN EDUCATION

The University of Reading Postgraduate Certificate in Education (PGCE) is a 1-year teacher training program (divided into 3 academic terms) that prospective teachers enter after receiving their undergraduate degrees from various institutions across the United Kingdom. Over all, each year about 120 students, divided among eight specific school subjects, are accepted into the PGCE course at Reading, and of these about 20 postgraduate students are art and design specialists. The postgraduate students spend time working on university-based coursework, and they undertake periods of school-based experience at specific school locations.

Joint Appointees as University Lecturers

The joint appointees taught at the university during the postgraduate students' university-based time (as opposed to school-based experience time). These days were designated "main-method" days, which means that the postgraduates were involved with their specialist subject areas. In the case of art and design, for example, the methods entailed practical art and design workshops and seminars and lectures, all revolving around the theory and practice of art and design education. During the periods of school-based experience, the joint appointees supervised the postgraduate students in their teaching practice schools, giving support, help, and advice in the form of group and individual tutorials and written notes.

During the remaining 3 days, the postgraduates were usually in educational studies seminar groups with students from other discipline areas in the PGCE. They also spent a half day on "second subject work" at the university; this was usually, as far as the art specialists were concerned, an aspect of art and design other than the principal subject area of their first degree. A variety of specialist subject areas were offered, such as printmaking and critical/analytical studies. It was during this part of the week that the joint appointees taught in their local comprehensive schools.

Joint Appointees as Art Teachers

The schools in which the joint appointees were placed are both within a 7-mile radius of the university. One placement was a coeducational comprehensive school with about 800 pupils from 11 to 18 years of age. The school commitment was as follows (see Table 1): two second year (7th grade) classes (one of which was designated "design," the other "art"), a fourth year (9th grade), a fifth year (10th grade), and a sixth form group (11th - 12th grades). The other placement was a large single school of 1,200 girls ages 11 to 18 years. The art-teaching commitment there consisted of two first year (6th grade) classes, a second year (7th grade), and a fourth year group (9th grade). In addition, two sixth form graphic communication groups, plus one each of fourth and fifth year design groups, were taught. The joint appointees, were, in effect, part-time temporary assistant teachers, so they did not have the responsibilities of heads of department. They did, however, have some influence on departmental policy making, and they worked closely with their respective heads of department on curriculum matters. School colleagues were very helpful and willingly covered for these part-timers when the joint appointees needed to be at the university during school times.

The joint appointees did not have any choice regarding the schools in which they were placed. They were simply offered a school in which to teach. The schools made no special provisions for them, nor were the schools selected on any basis other than the fact that they had part-time vacancies for art teachers.

Table 1			
Grade Assignments by Age for Students in the United States and the United Kingdom			
Age (Years)	**U.S. Grade**	**U.K. Year (Secondary School)**	
		Pre-1991	**Current**
11—12	6	1	7
12—13	7	2	8
13—14	8	3	9
14—15	9	4	10
15—16	10	5	11
16—17	11	Lower Sixth	12
17—18	12	Upper Sixth	13

Benefits of the Joint Appointment Scheme

As stated earlier, there were in fact three lecturers involved with art education at the university, the third lecturer remaining full time at the university. During the periods in which the joint appointees were teaching in school, the full-time lecturer was conducting educational seminars and dealing with administrative matters. However, the full-time lecturer made use of the joint appointment situation by taking over classes on a regular basis in the two schools. The joint appointees' part-time presence in each school made this sort of ad hoc arrangement easier to organize. Similarly, other colleagues in the host schools could more easily participate in university activities such as interviewing prospective postgraduate student teachers and giving lectures and seminars on such topics as "What I Expect from a Student Teacher" and "The Role of the Head of an Art Department."

More important, perhaps, from the point of view of initial training, the joint appointment scheme allowed postgraduate students to observe or work in the host schools with a minimum of disruption. For example, during the teaching practice period, when the postgraduates were expected to work in schools for all or most of the week, many were placed in the two schools. However, it was felt that the postgraduate students might feel under pressure if their tutor (as the joint appointee) were there all of the time, and so although the joint appointees were directly responsible for the supervision of students on teaching practice, they did not act as the supervising tutor for those students who were placed in the appointees' host schools. This also ensured that the students benefited from more than one viewpoint.

Another opportunity for postgraduate students to work in the host schools was during "Method Week," in which all of the PGCE students' time was devoted to main subject work. On one occasion, there were eight postgraduates working in each of the host schools. All of the 16 postgraduate students worked on a similar theme so that they could compare teaching approaches and discuss their results back at the university. It is perhaps unlikely that practicing art teachers in schools would welcome the prospect of sharing their classes and their work space with eight student art teachers, but this type of arrangement was easy to bring about because of the dual role of each joint appointee.

At the University of Reading, as at with other PGCE centers, exhibitions are held at the end of the course that include examples of postgraduate student teachers' work in schools. This event is regarded as a crucial point of contact during the course year. The university can play host to the schools that have hosted postgraduates over the year and

give teachers the opportunity to see work from a range of schools, initiated by student teachers from a broad variety of backgrounds. An opportunity such as this for teachers to meet together is always valuable, and it is facilitated by the joint appointees' having "a foot in both camps," to borrow from a *Times Educational Supplement* (Haggarty & Roselman, 1986) article.

There are many activities and initiatives associated with teaching and lecturing, not the least of which is research. The joint appointment lends itself to engagement in action research activity, such as participant observation (e.g., Hall, 1991). The brief in this scheme, however, was simply to "get in there and teach," which is just as well because school timetables do not normally allow for work that might be considered by some to be peripheral to teaching.

The joint appointees were monitored by appropriate meetings of interested parties—university advisors in art and design, the chief advisor, the chairman of the university's School of Education, the head teachers (principals), and their immediate colleagues. Through this example, a closer liaison between the initial training establishment and local schools was developed.

OTHER ISSUES

To return to the joint appointment as a means for achieving the involvement of practicing teachers in teacher education, the Department of Education and Science's *Quality in Schools* (1987) stated:

> *By far the most ambitious and difficult mode of involving staff was the joint appointment. The examples seen demonstrated the advantage of enabling the holder to maintain a concurrent grasp of two crucially related roles, notably those of the college tutor and classroom teacher, but there were instances of conflicting demands on time and personal commitment working to the disadvantage of both roles.*

This statement raises two points, the first being that *joint appointments are difficult to arrange.* It is almost to be expected that difficulties can arise when a higher education institution and a local education authority attempt to create a teaching position, jointly fund it, co-write the job description and contract, and then actually hire the appointee and develop a working timetable. Ideally, this involves cooperation and collaboration by all involved including the host school(s).

The second point is that *the two roles of being an art education lecturer and a practicing teacher in the schools need to be concurrent and fundamentally related.* The DES report mentioned *maintaining* a grasp of the two roles when, to the newly appointed teacher-lecturer, the lecturing role is wholly new and untried. It cannot be assumed that every teacher with a dozen or more years' teaching experience, usually at the head of department level, can make a smooth and successful transition into higher education and its new demands and disciplines. The role of a university lecturer is a different role—teaching graduates rather than children and requiring different skills—and adjustment and self-development are required before a *grasp* is made. A lecturer's role includes offering students access to a range of theories and practices, while a teacher's focus is normally on one school.

CONCLUSIONS

The standard of art education that children receive in state schools is largely dependent upon the standard of teaching. This, in turn, is largely dependent upon the standards of preservice and inservice training for both specialist and generalist teachers. To maintain good standards, it is necessary to ensure that university art education lecturers are able to engage actively in theory and practice. Ideally, "practice" should encompass the practice of *teaching* art and *producing* and *reflecting upon* art. The joint appointment, in which art teachers function as art education lecturers, ensures, at the very least, a greater liaison between schools and higher education institutions. Notwithstanding the problems associated with joint appointments outlined here, the fundamental philosophy behind such positions remains relevant and worthwhile. The joint appointment scheme still operates at the University of Reading, but not currently in art and design.

Debate on the future of teacher training need not be polarized; cooperation between schools and higher education institutions is an essential prerequisite for teacher training. Ultimately, it will be the consumers, the school students, who will benefit from being taught by teachers who themselves have been well taught with a thorough grounding in both theory and practice.

REFERENCES

Haggarty, L., & Roselman, L. (1986, March 28th). A foot in both camps. *The Times Educational Supplement,* p. 17.
Hall, J. (1991). Roles of practicing teachers and University Lecturers in initial training of teachers in art and design. *Journal of Art & Design Education 10*(3), 317-327.

U.K. Government, Department of Education and Science. (1984). Circular 3/84: *Initial training: Approval of courses.* London: HMSO.

U.K. Government, Department of Education and Science. (1987). *Quality in schools: The initial training of teachers.* HMI Survey. London: HMSO.

U.K. Government, Department of Education and Science. (1988). *Education Reform Act.* London: HMSO.

NOTE: Since passage of the U.K. Education Reform Act of 1998, all pupils in the first, second and third years of secondary school (since 1991, defined as years 7, 8, and 9), are required by law to study art and design. This normally involves two periods per week of about 35 minutes per period. In the fourth and fifth years of secondary school (years 10 and 11, using the 1991 definition), pupils may opt to study art and design toward taking a standardized national examination (the General Certificate of Secondary Education—GCSE) in this subject. This normally involves four periods of study per week. In the sixth form (years 12 and 13, since 1991), pupils may opt to study art and design for the General Certificate of Education (GCE) at the advanced level. This would normally involve six to eight periods of art per week.

Chapter 8

Developing Reflective Teaching Techniques with Preservice Art Teachers

Frank D. Susi
Kent State University

Frank D. Susi

Kent State University

Dr. Susi is Professor of Art at Kent State University in Kent, Ohio. His research focuses on the teaching of art and preservice practices. In particular, he is interested in the role of the classroom environment, reflective teaching, and clinical supervision in art teacher education. He has published in *Art Education, Studies in Art Education,* and *Action in Teacher Education,* and has a chapter in *Secondary Art Education: An Anthology of Issues* published by the NAEA. Dr. Susi is active with the NAEA. A past president of the Ohio Art Association, he serves on the editorial board of the *Ohio Art Education Association Journal.*

Chapter 8

Developing Reflective Teaching Techniques with Preservice Art Teachers

Frank D. Susi
Kent State University

Reflection is a way to reconsider experiences that involves looking back on one's behaviors, strategies, and goals as a systematic and deliberate process of self-analysis and evaluation. When used in teaching, it provides a basis for increasing self-knowledge about educational practice and improved instructional performance. When included as part of pre-service art teacher education, reflective content includes teaching pre-service art teachers about the role of self-knowledge and how the review of their thought processes and behavior patterns can lead to improved teaching. Moreover, reflective practice helps preservice art teachers clarify their understanding of educational concepts while addressing the puzzling and perplexing aspects of classroom life encountered during field experiences and student teaching. This chapter examines the concept of reflection within teaching, developing reflective teaching

techniques with preservice art education teachers, and the features and values associated with reflective practice.

THE CONCEPT OF REFLECTION

Reflection involves looking back on experiences as a way to reconsider and better understand what happened. Through this process, an individual examines personal behavior patterns, analyzes problems, and evaluates decisions as a means to improve performance. Reflective teachers apply this concept as part of the regular and systematic examination of what they have done. They want to rethink the intended and unintended outcomes of their instructional strategies.

Reflection can be compared to replaying a sporting event on a videotape machine. Reflective teachers review lesson sequences from different perspectives, stopping the action at key points to study behaviors in detail. The use of slow motion and stop action further enhances the recall and analysis of events. A reflective teacher reconsiders the major points and minor details in a lesson, comparing instructional techniques used, student actions, and lesson outcomes to personal standards and expectations. This process promotes the development of promising practices while identifying approaches to set aside.

Mature individuals benefit most from their experiences by preparing in advance for what they will do, then looking back on what happened to determine the effectiveness of their actions in light of preset objectives. If preparation helps in getting ready, reflection enables one to examine the relationship between consequences and expectations (Posner, 1985). Reflection can extend beyond the reexamination of preplanned activities to include the reconsideration of on-the-spot experiences during which immediate and spontaneous actions occur. While reflection involves a conscious and deliberate thought process, it can include an ongoing review and reexamination of what just happened (Fellows & Zimpher, 1988).

Thus, the purpose of reflective teaching does not center on the discovery or generation of new knowledge. Rather, it emphasizes knowing better something that is already known in some sense, but knowing it in a deeper and more thorough way. In teaching, preservice teachers who engage in reflective practice can obtain a deeper and more insightful comprehension of an experience away from the immediacy of the time in which it took place (Berlak & Berlak, 1981).

Gardner (1989) described reflection as stepping back from one's own perceptions or productions as a way to better understand the goals,

methods, difficulties, and effects achieved. In this view, the capacity to reflect becomes a necessary component in building competence. In teaching, reflection includes pedagogical knowledge and philosophical awareness as part of a constant dialectic, with each step in the analytic process informing and enriching others. Schon (1987) described reflection this way: Reflection-*on*-action focuses on practice and one's behaviors and thoughts after completion of the action. Reflection-*in*-action emphasizes reviewing practice and one's actions and thoughts in the midst of action. A third type of reflection, reflection-*for*-action, combines the desired outcome of both types of reflection. According to Schon, reflection guides future thought and behavior. While examining past and present actions, one generates knowledge that will inform future strategies. In this view, reflection as a process spans all time designations—past, present, and future.

Reflective teachers stand apart from the self to critically examine their own instruction-related practices. This process allows for the development of more consciously driven modes of behavior. Reflective skill results from a combination of practice and repetition and the cultivation of a philosophical orientation strengthened through commitment and self-discipline. It should not be construed as an automatic, intuitive, or reflexive act. The background necessary for reflective teaching includes the following components:

1. Process skills such as an awareness of instruction as problematic and the ability to modify and extend one's perception of educational phenomena.

2. Attitudes such as open-mindedness, willingness to consider the possibility of error, and the capacity for self-evaluation.

3. Knowledge of content, including subject matter, pedagogical theory, and ways to increase self-knowledge (Ross, 1988).

REFLECTION IN ART EDUCATION

Reflection as a means to improve educational practice has much potential in the preparation of art teachers. When it is introduced during methods courses and practiced during field experiences and student teaching, preservice art teachers can begin to accept reflection as a way to learn about teaching at an early point in their preparation. Field experiences such as Saturday art school classes, museum education placements, alternative schools, and regular K - 12 classrooms allow preservice art teachers to work directly with students in a variety of real-life educational situations. As part of these experiences, they can

practice reflective teaching in their ongoing effort to convert the educational theory learned in college classrooms into effective classroom practice.

The trial and error teaching that occurs during these early experiences forms the foundation upon which preservice teachers' ideas about teaching are built, tested, and refined. Reflective teaching practiced as part of field-based programs can help them look within themselves to clarify instructional intentions, examine assumptions that underlie expectations, and consider the personal sensitivities necessary for effective and productive interactions with youngsters. The thought and value systems sharpened as part of the reflective process play a key role in determining future professional conduct.

In the campus-based classroom sessions related to the field experiences, reflection-minded preservice teachers can discuss their experiences and questions with classmates. Their ideas and perceptions serve as a sounding board for reviewing what they have done. Points that can serve to guide such discussion might include (a) areas in a lesson where particular pressure was felt; (b) parts that were effective or ineffective; (c) the characteristics of such phases of the lesson as entry, demonstration, questioning, and closure; (d) the nature of student participation in expressive and responsive activities; (e) perceptions of how the particular lesson helped in reaching art education goals; (f) the effectiveness of management techniques used to control behaviors; and (g) procedures that did and did not go as planned (Hanhan, 1988).

Encouraging preservice art teachers to probe for deeper meanings in their teaching opens avenues for inquiry into specific instructional approaches. Questions that relate to creating and responding to works of art might include the following:

1. To what extent did students understand directions or expectations?

2. What factors helped or hindered students as they worked?

3. What changes in the arrangement of the classroom space, the sequence of lesson events, or the use of time can be tried to improve outcomes?

4. What role did instructional resources play in motivating students or clarifying procedures?

5. To what extent did the various stages of the lesson progress as anticipated?

6. What effect did critiques, individual conversations, and other interpersonal factors have on individual students?

Haynes (1991) has described the reflective teacher as one who engages in action research as a participant observer. In this approach, the consideration of teaching practice focuses on questions such as the following: In what ways did experiences differ from expectations? How or why? What actions by the teacher were most important? When a naturalistic research approach is used, an *a priori* hypothesis is not required, and any conclusions are withheld pending the gathering, organization, and analysis of data. This approach to reflective teaching includes three stages:

1. *Contextualization.* Prior to the start of the lesson, the teacher/ researcher prepares a map of the physical setting, an inventory of important contents of the room, and a schedule or sequence of classroom events. This information adds background and depth to the process.

2. *Data collection.* During this phase, the teacher/researcher develops written descriptions of both objective (what actually happened) and subjective (the feelings and reactions related to the incidents) phenomena.

3. *The explanatory stage.* At this point, data analysis occurs. The identification and organization of common elements and recurring patterns enables the teacher/researcher to group information into such classifications as

 a. *Ideology.* Beliefs, values, attitudes.
 b. *Resources.* Management of time, materials, space, and information.
 c. *Social relationships and interactions.*

Reflective Writing

While informal discussion of events that took place during a lesson provides a means for describing experiences, some preservice teachers may not want to share details of their performance with classmates in a college classroom. Reflective writing provides a means for organizing thinking and recording perceptions. As a focal point of the reflective process, effective writing requires concentration, care, and caution in recording reality. Written assignments that direct preservice teachers to discuss connections between their prior knowledge of teaching and

personal experiences, beliefs, and goals will provide a basis for documenting behaviors and thought processes. Points to consider when preparing assignments should include descriptions of the learners; lesson content; areas of congruence and conflict with lesson plans; and techniques used for planning, management, and instruction. As preservice teachers gain maturity and skill as reflective writers, they can begin to address increasingly more complex aspects of their performance, the nature of progress being made in solving problems, and the effects of subtle changes in their actions and classroom conditions (Canning, 1991). Writing enhances the reflective process because the process provides a means by which the preservice teacher can organize the critical analysis, while the written document offers faculty members an opportunity to respond to their preservice teachers' thinking about teaching. Papers returned to preservice teachers can include questions, suggestions to guide further reflection, and comments that support and encourage good writing or clear thinking.

The use of structured formats for written assignments will facilitate the writing process for preservice teachers who are new to the reflective process. Specific questions or topic headings can provide the organization many preservice teachers need as they begin a new undertaking. Some preservice teachers prefer less direction and structure and will appreciate the opportunity to respond to such open-ended categories as "Strong Points" and "Areas to Improve." Many preservice teachers prefer specific direction during the early stages of their writing, then shift to a preference for more freedom and a less rigid format as they gain confidence and trust in the process.

Posner (1985) encouraged the use of general categories as a way to organize thinking about classroom happenings. He suggested that preservice teachers prepare a general description of the lesson, the physical environment, and related classroom circumstances. They can then identify and discuss three significant events that occurred in the class and provide a detailed analysis of a critical incident. In evaluating the content of reflective writing, teacher educators should reward candor while avoiding any penalties for frankness and honesty. When discussing aspects of their performance that did not go well, preservice teachers' discussions of motives, uncertainties, concerns, and mistakes should be conducted without fear that such directness will result in a lowered grade.

Problems or limitations associated with the reflective process may limit the quality of what preservice teachers write. Some of the difficulties preservice teachers may experience include the following:

1. Recalling everything that happened during a lesson. After an especially busy class, the details of specific events may be fuzzy or inaccurate.

2. Recognizing key events or problematic situations. Some preservice teachers may not realize that their students have not understood directions or that noise levels were excessive.

3. Allowing sufficient time to write the reflective statement. Many times, details are forgotten when preservice teachers do not make notes or record their impressions immediately after the teaching episode. Most preservice teachers benefit from the reflective process if they can make notes while events are still fresh in their mind.

4. Talking to others about what happened in the lesson prior to making notes. Discussing the lesson just after it was taught seems to dull the memory of some individuals. Interns should write reflections first and talk about the lesson later.

The development of reflection-related assignments should anticipate such concerns. In most cases, the design of course content and the setting of clear expectations will offset the limitations listed here.

Evaluating Reflective Skill

According to Kichener (1977), reflective judgment becomes increasingly complex over time, progressing through seven stages. As an individual's view of the nature of knowledge matures, his or her ability to identify and use convincing evidence develops. As part of this process, the individual's willingness to accept responsibility for decision making increases and openness to alternate points of view grows. In the less mature stages, the phenomenon being viewed is perceived as simple, knowledge is seen as finite, and authorities are thought of as the source of all knowledge. In the middle stages, different points of view are acknowledged as relative to varying perspectives. The individual gradually develops the ability to interpret and evaluate evidence, but personal belief and whim are often used in making decisions. In the more advanced stages, the reflective individual begins to make judgments based on reasoning and new evidence. Advancement through the stages of reflection results from a combination of factors including experience, maturity, education, and practice.

Schmidt (1985) reported that nontraditional college students (i.e., older than their classmates) tend to have higher scores on indicators of

reflective ability than their classmates, but nontraditional freshmen score below traditional juniors. The majority of college students score in the middle stages of reflective development. Higher levels of reflection are observed most often in graduate students. Students who have worked with reflection-related assignments as a regular part of their field experience describe a variety of positive points associated with the activity, including:

1. Awareness of reflection as a personal learning tool they can use to become better teachers.

2. Realization that although problem areas tend to stand out in one's consciousness, most lessons include both good points and bad.

3. Examination of mistakes and thinking in detail about classroom events as first steps toward preventing future problems.

4. Coming to grips with personal thoughts, frustrations, and concerns as part of the reflective process.

5. Reflection as a positive and constructive process.

FEATURES AND VALUES ASSOCIATED WITH REFLECTION

When college study is concluded and new art teachers enter their own classrooms, the direct feedback about teaching provided by field experience supervisors, methods course instructors, cooperating teachers, and university supervisors of student teaching is no longer available. Except for occasional observations by colleagues, principals, or supervisors, new art teachers are on their own to analyze and evaluate what they have done (Ross, 1990).

As Rudduck (1984) stated: "Not to examine one's practice is irresponsible; to regard teaching as an experiment and to monitor one's performance is a reasonable professional act" (p. 6). Preservice teachers who develop reflective skills tend to incorporate inquiry as a key part of the career-long process of becoming a teacher. Research-minded art educators can address issues related to reflection by systematically collecting evidence that shows the impact of reflection in developing thinking skills and artistic outcomes. Through study and practice in applying the concept of reflection to professional development, art teachers can begin to translate the relevant aspects of such inquiry into a deeper and

richer understanding of their own growth. Reflective skill grows and matures with practice.

The reflective process typically embraces the methodology of naturalism and qualitative inquiry and stands apart from approaches based on positivism, measurement, and control. The specific behaviors associated with this abstract concept are not likely to be quantified. Answers to questions as to what reflection is, what the best ways are to develop the reflective abilities of preservice teachers, and how the extent of one's reflective skill can be measured may not result from systematic study.

CONCLUSION

In the recent teacher education literature, reflection has been suggested as a means to improve the self-knowledge of teachers. Art educators who are prepared as reflective practitioners will possess a potentially powerful tool for facilitating ongoing professional development. As an aspect of their field experiences and student teaching, preservice teachers can be challenged to clarify their ideas about teaching while increasing their ability to work in thoughtful and productive ways. When they enter classrooms as reflective practitioners, these art educators can be expected to examine and analyze their own instructional practices as a regular part of professional practice. The process of reflection is an aspect of self-study and has strong potential in art education. When emphasized as a means to improve performance, it can play a key role in preparing the next generation of art teachers.

REFERENCES

Berlak, A., & Berlak, H. (1981). *Dilemmas of schooling: Teaching and social change.* New York: Methuen.

Canning, C. (1991, March). What teachers say about reflection. *Educational Leadership,* pp. 18-21.

Fellows, K., & Zimpher, N. (1988). Reflectivity and the instructional process: A definitional comparison between theory and practice. In H. Waxamn, H. Freiberg, J. Vaughan, & M. Weil (Eds.), *Images of reflection in teacher education* (pp.18-19). Reston, VA: Association of Teacher Educators.

Gardner, H. (1989). Zero-based art education: An introduction to Arts Propel. *Studies in Art Education,* 71-83.

Hanhan, S. (1988). A qualitatively and quantitatively different format for the evaluation of student teachers. *Action in Teacher Education, 10*(3), 51-55.

Haynes, J. (1991) Reflective practices for the art instructor. Paper presented at the Ohio Art Education Association Convention, Cleveland, OH.

Kichener, K. (1977). Intellectual development in late adolescents and young adults: Reflective judgment and verbal reasoning. Unpublished doctoral dissertation, University of Minnesota, Minneapolis.

Posner, G. (1985). Field experience: A guide to reflective teaching. New York: Longman.

Ross, D. (1990). Programmatic structures for the preparation of reflective teachers. In R. Clift, W. Houston, & M. Pugach (Eds.), Encouraging reflective practice in education (pp. 97-118). New York: Teachers College Press.

Ross, D. (1988). Reflective teaching: Meaning and implications for preservice teacher educators. In H. Waxamn, H. Freiberg, J. Vaughn, & M. Weil (Eds.), Images of reflection in teacher education (pp. 25-26). Reston, VA: Association of Teacher Educators.

Rudduck, J. (September, 1984). Teaching as an art, teacher research and research-based teacher education. Second Annual Lawrence Stenhouse Memorial Lecture, University of East Anglia, Norwich.

Schmidt, J. (1985). Older and wiser? A longitudinal study of the impact of college on intellectual development. Journal of College Student Personnel, 26(5), 388-394.

Schon, D. (1987). Educating the reflective practitioner. San Francisco: Jossey-Bass..

Chapter 9

The Use of Journals to Promote Reflective Thinking in Prospective Art Teachers

Craig Roland
University of Florida

Craig Roland
University of Florida

Dr. Roland is Associate Professor of Art Education at the University of Florida, Gainesville. He received his Ed.D. degree in 1983 from Illinois State University in Normal. Before taking his position in Florida, he was on the staffs of Eastern Illinois University and Purdue University. He has taught art at the elementary, middle, and secondary school levels, including 5 years at the American School Foundation of Monterrey, Mexico. His ongoing research interests include effective teaching practices and learning strategies in the visual arts, the applications of new technology in the arts, and developing students' thinking skills through art.

Chapter 9

The Use of Journals to Promote Reflective Thinking in Prospective Art Teachers

Craig Roland
University of Florida

Over the past 2 years, I have used journal writing as a vehicle for help-ing preservice art education teachers develop a personal and delibera-tive approach to the institutional process of becoming art teachers.[1] This chapter, describes how I introduced journals to my preservice teachers and provides some brief glimpses of what they wrote about in their journals. It also discusses some of the insights that I have gained into the mental lives of prospective art teachers by reading my preser-vice teachers' journals and some of the implications that result from studying the ways in which preservice art teachers think about art and about teaching. Before taking up these two main themes, however, I will first summarize some of the pertinent literature on writing, cogni-tive theory, and teacher learning that lends supports to the use of jour-nals with prospective teachers.

BACKGROUND

The idea that journal-writing methods can be used to promote preservice teacher thinking and learning has considerable support among teachers, researchers, and theorists (Bolin, 1988; Prisco, 1990; Staton, Shuy, Peyton, & Reed, 1988). For instance, the noted Soviet psychologist Vygotsky (1962) believed that self-initiated, purposeful writing is thought written down, which in turn is reinternalized into one's ongoing thinking. Likewise, Yinger and Clark (1981) described the act of writing as offering immediate self-provided feedback in which rereading and reflection are important components. They explained:

> As writers read the words they have just written, the words tell them whether or not they have communicated as they want to. Writers' inner purposes and goals, the expressive component of writing, provide a model of sorts for immediate matching and comparison. By posing the question, "Is that what I really think and feel?" writers are learning about themselves. (p. 6)

Bruner (1968) described writing as a tool for "ordering thoughts about things and thoughts about thoughts" in symbolic form (p. 112). This symbolic transformation of things or thoughts from their original context into a linguistic context enables greater manipulability and, consequently, greater understanding to occur as one perceives experience in a new light. Similarly, Odell (1980) pointed out that the conscious and deliberative search for meaning demanded by writing enhances one's knowledge of the subject at hand. In short, it appears that writing is not only a medium of thought, it is also a potentially powerful vehicle for developing it.

I define journal writing as a personal reflective process embedded in a social context. It involves thinking about past learning and thinking as one attempts to make sense of the world and the things that occur within it. This kind of self-directed learning is well grounded in current cognitive theory that assumes that knowledge is actively constructed by learners as they interact with objects and people in their environment (Vygotsky, 1978). Cognitive approaches to learning place considerable emphasis on the role played by prior knowledge in the acquisition of new knowledge (Shuell, 1986). It is now generally recognized that learners build their own knowledge structures of the world using their previously formed ideas and beliefs. That is, they continually interpret and accept or reject new information in terms of what they already know (see Anderson, 1984; Glaser, 1988; Nussbaum & Novick, 1982).

Research on teacher learning confirms that teacher candidates enter teacher education programs with their own beliefs and assumptions about teaching, learning, and subject matter which have evolved over a lifetime of experiences in schools (Eisner,1972; Lortie, 1975). Preservice teachers are typically unaware of the beliefs on which they operate. Their assumptions about educational matters are often so ingrained that they are simply taken for granted. And yet, several studies indicate that the tacit knowledge of preservice teachers forms the basis for their expectations of how they should act as teachers, their perceptions of teachers and children they encounter in classrooms, their understandings of the subjects they will teach, and their interpretations and judgments of topics and field experiences typically included in teacher education programs (see Clark, 1988; Weinstein, 1989). More important, these studies show that while the implicit beliefs of preservice teachers are often in conflict with what is taught in teacher education programs, they are extremely robust; that is, they frequently remain intact through preservice teaching despite exposure to contradictory theories and practices.

Since preservice teachers' implicit beliefs about teaching, learning, and subject matter exert such a strong influence on the process of becoming a teacher, helping them identify those premises and examine them directly seems logical. Presumably, bringing these unconscious beliefs to a conscious level, puts preservice teachers in a better position to evaluate the assumptions they hold and to revise or discard them if need be as they encounter new ideas, theories, and practices during their formal study of teaching. From a broader perspective, encouraging teacher candidates to identify their beliefs and reflect upon them enables them to know what they are about when they finally get the opportunity to act as teachers in the classroom. I believe that this type of introspection is crucial in developing a long-term professional growth model for preservice teachers and that it should be initiated early in undergraduate teacher education programs.

To summarize thus far, research suggests that teacher educators need to make provisions for teacher candidates to create their own personal meanings of the specific ideas, theories, or practices being addressed in the teacher education program. The goal of instruction might be seen as one of leading preservice teachers to generate new and better understandings of the complexities of teaching by activating, restructuring, and expanding their present models of teaching. In essence, this involves helping preservice teachers unfold, examine, and reshape their own educational beliefs and assumptions so that they are able to integrate new conceptions of teaching, learning, and subject matter within their own emerging knowledge structures. The learning

process that might prove most useful in uniting these functions is that of writing in journals.

THE JOURNAL ASSIGNMENT

After 5 years of trying to force ways of thinking about the practice of teaching art upon prospective art teachers who seemingly had their own firm ideas about the subject, in the fall of 1989 I began to work in the other direction. By this I mean that I began encouraging my preservice teachers to take charge of their own professional growth and to further develop their own personal theories about art and about how one learns or goes about teaching it. The primary method I used to facilitate this kind of self-directed learning was to have preservice teachers write in personal journals.

The context in which the use of journals is discussed here is an introductory course to art education. This class is one of three art methods courses that preservice art teachers at The University of Florida take prior to an 11-week internship in a local public school art program. During the first week of class, I explained the journal assignment to my preservice teachers by describing what I wanted to them to write about in their journals and why I wanted them to do this on a regular basis. At a minimum, the preservice teachers were asked to make two entries during each week of the semester: one related to a topic discussed in class that particular week and the second based upon an outside professional reading or school observation completed on their own.

Class seminars were designed to help preservice teachers begin thinking about such questions as the following: "What is my definition of art?" "Why do I think art is important for children to learn?" "What are my responsibilities as an art teacher?" "What does being a really good art teacher mean to me?" Students were encouraged during these sessions to articulate their current views regarding the topic being addressed; support their views in an open forum; and examine alternative points of view, including those shared by peers, myself, or various writers in the field. By linking preservice teachers' initial beliefs to the course content in this way, I hoped to set the stage for the thoughtful consideration of those beliefs in the context of new ideas. Selected readings and directed school observations provided the preservice teachers with additional opportunities to explore other perspectives on the professional knowledge being presented in class.

While the preservice teachers were given certain questions and guidelines to help them organize their thoughts and observations, I allowed them considerable leeway in developing their own journal-writ-

ing styles. The reason for this is that I believed that the journals were largely personal in nature and that each preservice teacher would interpret the course content and approach the task of writing in the way that made most sense to him or her. In summary, I hoped to achieve two objectives by introducing journals into my course. First, they were intended to serve as a means to promote active, persistent, and careful consideration on the part of preservice teachers as they encountered various conceptions and beliefs about the practice of teaching art—particularly their own. Second, the journals were meant to provide a source of feedback for both preservice teachers and myself about the ways in which they thought about their learning and about their own professional development as art teachers.

The students shared their journals twice with me during the semester—once at midterm and once at the end of course. On both of these occasions, I made comments and raised questions in each preservice teacher's journal designed to recognize important insights, suggest alternative ways of thinking about the topic being addressed, and point out ideas in need of further elaboration and thinking. While I sometimes challenged preservice teachers' ideas in the process, I did so without attacking their whole perspective. In this way, the journals served as a means for interpersonal dialogue between each preservice teacher and the teacher as well as for intrapersonal dialogue between each preservice teacher and his or her inner self.

WHAT PRESERVICE TEACHERS THINK

What preservice art teachers think of art, of teaching, and of themselves as teachers lays the foundation for what they will say and do as art teachers. When beginning preservice art teachers are asked to examine their beliefs and explain what they think, a few common issues emerge.

One issue deals with preservice teachers' reasons for choosing teaching as a career. Research suggests that individuals are often attracted to teaching for altruistic reasons; that is, they "want to work with children" or "help children acquire knowledge" (Joseph & Green, 1986). This calling has clearly been evident among many of the preservice teachers with whom I have worked over the past 2 years. Several preservice teachers indicated in their journals that their "love" of children and of art led to their decision to become an art teacher. As one preservice teacher, Leslie, put it: "I have always been interested in art and that combined with my love of children influenced me to become an art teacher." Not surprisingly, some preservice teachers felt that teaching would provide them with job security or "summers off" so that they

could continue to do their own artwork. Others suggested that they were strongly influenced by former art teachers in making the decision to teach. For example, another preservice teacher, Kim, wrote in her journal; "I had a great high school art teacher who really helped me. I knew I wanted to do something in art, and it was because of her encouragement and support I chose teaching. I want to help students the way she helped me."

While many of my preservice teachers expressed their reasons for wanting to become art teachers early in their journals, some returned to this issue again and again in later entries. In this way, they seemed to be continually asking themselves, "Why do I want to be an art teacher?" or perhaps more pointedly, "Do I really want to be an art teacher?" The periodic reflection on motives by these art education preservice teachers was due, I believe, to their increasing realization that teaching art was going to be a lot more demanding than they originally thought. This suggested a second area of concern.

Art education preservice teachers often bring to their formal study of teaching a mental image of the art teacher's role as one of explaining or showing a studio procedure and then allowing children to work on their own. This picture has most likely emerged after years of watching not only their elementary and high school art teachers at work, but also their university studio professors. From this perspective, many preservice art teachers feel quite familiar with the performance side of teaching art. They tend to believe, as a result, that teaching is something they already know how to do and that learning to teach art is simply a matter of being given some lesson plans and some tips on classroom discipline so they can get started.

Guided by these assumptions, it is not surprising that preservice art teachers are often shocked by the enormous amount of planning, decision making, and evaluating involved in teaching art on a daily basis. Their first encounters with the cognitive side of teaching art are quite revealing, as illustrated in the following comments by Kris:

> *I never knew how much planning went into a lesson or unit a teacher taught. I just thought all the information was out of some giant book of lessons and she just transferred that information to the students. I just figured she said everything out of her head as she went along and everything was from memory of things she learned in school. . . I don't think anyone outside the teaching profession realizes how much work it actually is.*

Similarly, Kim wrote in her journal:

> *I am surprised at how much planning goes into teaching. I'm not sure what I thought happened, but I'm getting the idea that I'm not going to have a lot of free time. I was hoping that I would be able to continue making my own art while I teach. This may raise a conflict, depending on my energy level. I do not want to compromise either endeavor.*

The *artist versus teacher* conflict, which is troubling Kim here, is another perplexing issue facing preservice art teachers as they try to make sense of becoming art teachers. As previously mentioned, some preservice teachers view teaching as a stable source of income that will allow them to continue working and producing as artists. For some others, teaching is a way of covering up their insecurities about being an artist. While both of these motives are self-serving in nature, each creates a mental obstacle for its owner as the realities of being an art teacher come into view. For example, in response to a class discussion regarding whether or not art teachers should be producing artists, Jackie wrote in her journal:

> *Today's class helped me put my artist vs. teacher dilemma more in focus. I've been concerned about this ever since I started the art education program. I always thought that a lot of art teachers were artists that didn't make it—that weren't good. I've always felt insecure about myself as an artist. Thus I called myself a teacher first. I guess today for the first time I've come to realize that in order to fulfill my dream of being "a great art teacher" I must find my passion in art.*

Later in the semester, Jackie returned to this issue once again:

> *A turning point for me this semester was my "becoming" an artist. In my ceramics class, I found that part of myself. I have no doubt that it was because I had your class too. You sent me out of your room with a lot to think about, and this came out in my artwork. I was struggling—Am I an artist or a teacher? I found out that I am both and that I am at peace with that.*

I personally find this entry both encouraging and illuminating. It shows how journals can be a powerful tool for self-resolution. As Jackie became increasingly aware of her own thoughts and feelings, she recognized how her prior assumptions and biases affected her perceptions of art, of teaching, and of herself. In the deliberative process, knowledge becomes dynamic and personal. New possibilities emerge.

Gardner (1983) referred to the kind of knowledge at work here as intrapersonal intelligence, which is the capacity to access one's own feelings and emotions in order to know or better understand oneself. Interpersonal intelligence, on the other hand, is the capacity to know others by being able to recognize and make distinctions among their feelings, motivations, and behaviors. According to Gardner, these two forms of personal intelligence are dependent on each other and are bounded by the sociocultural context within which they develop. In other words, one's capacity to know oneself is "dependent upon the ability to apply lessons learned from the observation of other people," while one's knowledge of others "draws upon the internal discriminations the individual routinely makes" (p. 241). It is through the particular symbolic and interpretive systems of a culture that these forms of intelligence become represented and understood. This suggests that as prospective art teachers develop an explicit awareness of their own inner feelings through writing, their capacity to grow professionally and to teach effectively might develop correspondingly.

In addition to uncovering a few common concerns of preservice art teachers, an analysis of my preservice teachers' journals revealed that they also shared certain assumptions about the nature of art education. Many believed, for instance, that the primary benefit of art education for children lies in general psychological development, as the following statements by Angela and Dawn, respectively, illustrate:

> *For me, the most important facet of teaching art is tapping into a child's imagination or creativity. . . Art is a creative process where the intent to create is evident. This process stimulates the right side of your brain, gives you an outlet for expression, and helps you to better understand yourself and your relationship to the world. Art is the only class in school in which this can occur, and it is important to a child's overall concept of self.*

> *I feel that art is needed in schools to enhance the students' creativity and to encourage intuitive thinking. In addition, it promotes individuality and personal awareness.*

While the belief in fostering creativity as a goal of art education was quite pervasive among my preservice teachers, they seemed to have only vague notions of what creativity is or how they would actually go about teaching for it. Yet, this preoccupation with creativity often influenced preservice teachers' perceptions of the content they encountered in class and the art lessons they observed in schools. The following excerpts from Dawn's journal reflect this kind of imprint:

I feel this movement [discipline-based art education] totally inhibits the child's growth. There are some aspects I agree with but many I disagree with . . . after reading a couple articles and discussing it in class, I feel there are a lot of gaps as to what the program expects and what the outcomes are. A set curriculum in each school sounds really great. Yet, the aims and outcomes seem to be an inhibition to the child's individual creativity. (September)

I think that a teacher's instruction can inhibit children's creativity and self-expression. I feel the teacher should explain the general idea and let the kids go from there. I observed one class where the students followed the step-by-step instructions of the teacher. If the child was lost for a minute in his own creative mode he had to stop and ask what was to be done next. I noticed that the teacher walked around and made sure the kids were doing it right. Some actually had to start over because they didn't follow directions properly. I definitely feel this can inhibit their creative growth. (October)

Another implicit assumption embedded in my preservice teachers' journals is that what is taught in art is determined by the art teacher's preferences rather than by consideration for the field of study, the particular needs and interests of children, or the sequential development of art knowledge and skills. According to this view, the art teacher's decision to teach something is all that is needed to validate the learning experience. The following statements by Lynn and Stephanie suggest this perspective:

You can't teach kids everything! My concentration is on drawing, so I believe drawing is essential in the classroom. I just want to teach them the "proper" way to draw. The way society sees fit.

I have a desire to teach what I myself find interesting. In other words, feminist art, Postmodernism, and fabricated photography. I have a desire to throw in some of my favorite poets and some of my favorite short stories.

A third assumption that emerged from my preservice teachers' journals is that the best (or only) way to learn art is to engage in some type of studio activity. While these prospective art teachers generally recognized the social and cultural significance of art, when it came to the study of art they tended to emphasize the value of personal exploration through art materials. In this way, art was viewed as a source of pri-

vate meaning that need not be held up for public analysis, discussion, or criticism. The following journal entry by Allison provides the best illustration of this frequent point of view:

> *It seems to me that we ought to teach what is considered by the public to be art education. That is pretty obvious. We can teach students about art criticism, aesthetics, and art history. But I think it is very important that we teach art as an individual experience that is often meaningful and profound for the artist. Art doesn't have to be done for other people to look at, analyze, talk about, or critique. It is a good thing for people to do just for themselves. Art therapy is a good example of that.*

Perhaps the most interesting outcome of this study concerns the effectiveness of journal writing in promoting higher levels of thinking in prospective art teachers. What I found most striking about a number of my preservice teachers' journals was not *what* they thought, but *how* they thought. By asking preservice teachers to monitor and report on their own learning over the course of a semester, a significant development took place. Their attention shifted from what was happening in class to what was going on inside their heads. On September 29, for example, Marcia wrote in her journal:

> *I'm more and more conscious of my actions and the kids' reactions to how I present the classes and activities. I feel less self-conscious and more of a removed awareness of what I'm doing—probably want to be less attached to how I intend the class period to go and more willing to accept the various conditions that affect the way things work.*

Leisha made a similar observation on October 1:

> *I taught a lesson to fifth graders today. I felt extremely intimidated by the kids, as if they were gonna run me out of the classroom. The less I concentrated on that, the more I was able to smile at the possibility that this lesson could really just be plain fun—for them and me.*

Cognitive researchers refer to such self-monitoring activities as *metacognition* and affirm that the strategies involved are essential to the process by which a student comes to take charge of his or her own learning (Costa, 1984; Glaser, 1988; Kuhn, 1986; Nickerson, Perkins & Smith, 1985; Shuell, 1986).

CONCLUSION

It is appropriate to think of the implicit beliefs of preservice art teachers as strands in a loosely woven fabric. Each strand supports and is supported by the strands connected to it. In studying this fabric, I've simply pulled out some of these strands for the purpose of identifying them. While the journal has been a useful tool in this process, it may not be sufficient in providing a full and accurate picture of the thinking of prospective art teachers as they engage in their professional studies. Analyzing preservice teacher journals in order to find significant patterns in their thinking is a difficult, time-consuming task and one in which there exists a possibility of misinterpretation of the data (Staton et al., 1988). It is also possible that some preservice teachers are not able to put into words what they are actually thinking or feeling. Thus, much of the richness and complexity of the fabric I have spoken of still remains hidden from our view.

Nevertheless, the results of this study suggest two useful implications. First, the findings suggest the need for art education faculty to help preservice art teachers examine and discuss their motivations to teach, as well as the realities of teaching, early in the teacher education program. In the process, art teacher candidates should be encouraged to consider the genuineness of their motives and the disillusionment that may come from not being able to achieve their goals—especially early in their careers. As Joseph and Green (1986) have pointed out, "It should be of grave concern to teacher educators that idealistic candidates enter the profession but rapidly abandon it" (p. 32).

Second, this study strongly suggests that if art education faculty hope to help preservice art teachers develop meaningful views of art and productive views of teaching, they will have to help them overcome the naive assumptions and misunderstandings about teaching art that they already hold. The practice of having preservice teachers reflect on their views and learning in journals may be partly beneficial in this process. But this writing activity alone does not appear to provide sufficient impetus for preservice teachers to modify or discard their beliefs, even given the input of alternative points of view. In this context, the problem of identifying the instructional strategies that might lead to conceptual change in preservice art teachers is in need of further research.[2]

NOTES

[1] I draw here from Dewey's (1910) definition of reflective thought, which involves "active, persistent, and careful consideration of any belief or supposed form of knowledge in light of the grounds that support it and the consequences to which it leads" (p. 9). Routine

action, on the other hand, is guided by tradition, external authority, and circumstance. See Dewey (1904) for a discussion of the importance of promoting reflective thinking in preservice teachers.

[2] Johnson (1989) provides an excellent illustration of instruction designed to increase art education preservice teachers' awareness of their prior knowledge of art. She recommends that preservice teachers make conceptual maps of their understanding of art in order to help them recognize the strengths and gaps that exist in their own knowledge; the categories they use to organize their knowledge; and how their understandings compare with those of their peers. Johnson's strategy highlights the fact that preservice teachers must build their own ideas about a subject, rather than simply digest the ideas of their teacher or some distant authority, if real learning is to occur. Also, see Ahmad (1986) for a discussion on instruction designed to change the attitudes that elementary education majors have toward art education.

REFERENCES

Ahmad, P. (1986). Changing attitudes towards art in elementary schools: A strategy for teaching the classroom teacher. *Art Education, 39*(6), 7-11.

Anderson, R.C. (1984). Some reflections on the acquisition of knowledge. *Educational Researcher, 13*(9), 5-10.

Bolin, F.S. (1988). Helping student teachers thinking about teaching. *Journal of Teacher Education, 39*(2), 48-54.

Bruner, J.S. (1968). *Toward a theory of instruction.* New York: Norton.

Clark, C.M. (1988). Asking the right questions about teacher preparation: Contributions of research on teacher thinking. *Educational Researcher, 17*(2), 5-12.

Costa, A.L. (1984). Meditating the metacognitive. *Educational Leadership, 42*(3), 57-62.

Dewey, J. (1904). *The relation of theory to practice in education.* The third NSSE yearbook (Part 1). Chicago: University of Chicago.

Dewey, J. (1910). *How we think.* New York: D. C. Heath.

Eisner, E.W. (1972). The promise of teacher education. *Art Education, 25*(3), 10-14.

Gardner, H. (1983). *Frames of mind.* New York: Basic Books.

Glaser, R. (1988). Cognitive science and education. *International Social Science Journal, 40*(1), 21-44.

Johnson, N.R. (1989). Teaching art: Pre-service teacher lessons. *Arts and Learning Research, 6*(1), 142-151.

Joseph, P. & Green, N. (1986). Perspectives on reasons for becoming teachers. *Journal of Teacher Education, 37*(6), 28-33.

Kuhn, D. (1986). Education for thinking. *Teachers College Record, 87*(4), 495-512.

Lortie, D.C. (1975). *Schoolteacher: A sociological study.* Chicago: University of Chicago Press.

Nickerson, R.S., Perkins, D.N., & Smith E.E. (1985). *The teaching of thinking.* Hillsdale, NJ: Erlbaum.

Nussbaum, J., & Novick, S. (1982). Alternative frameworks, conceptual conflict and accommodation: Toward a principled teaching strategy. *Instructional Science, 11*, 182-200.

Odell, L. (1980). The process of writing and the process of learning. *College Composition and Communication, 30,* 42-50.

Prisco, K.L. (1990). The aesthetic journal: A creative tool in art education. *School Arts, 90*(3), 24-26.

Shuell, T.J. (1986). Cognitive conceptions of learning. *Review of Educational Research, 56*(4), 411-436.

Staton, J., Shuy, R.W., Peyton, J. K., & Reed, L. (1988). *Dialogue journal communication: Classroom, linguistic, social and cognitive views.* Norwood, NJ: Ablex.

Vygotsky, L. (1962). *Thought and language.* Cambridge, MA: MIT Press.

Vygotsky, L. (1978). *Mind in society.* Cambridge, MA: Harvard University Press.

Weinstein, C.S. (1989). Teacher education students' preconceptions of teaching. *Journal of Teacher Education, 40*(2), 53-60.

Yinger, R.J., & Clark, C.R. (1981). *Reflective journal writing: Theory and practice.* East Lansing: Institute for Research on Teaching, College of Education, Michigan State University.

Chapter 10

Art Appreciation and Preservice Art Education

A TAXONOMY OF ISSUES

Mary Erickson
Arizona State University

Mary Erickson
Arizona State University

Dr. Erickson is Professor of Art at Arizona State University and was the second Visiting Scholar at the Getty Center for Education in the Arts. Her theory and research interests are in understanding and responding to art, especially art history. She has co-authored a range of art learning games and resources, including a curriculum resource called *A Story of Art in the World*, published by CRIZMAC. She has been active in discipline-based art education theory development, advocacy, and inservice projects across the country. She is currently completing a major study on the development of young people's art historical understanding. Dr. Erickson has edited an anthology called *Lessons about Art in History and History in Art* published by ERIC:Art, and together with Stephen Addis, an art historian, Dr. Erickson has written *Art History and Education*, published by the University of Illinois Press.

Chapter 10

Art Appreciation and Preservice Art Education

A TAXONOMY OF ISSUES

Mary Erickson
Arizona State University

Art appreciation is a term commonly used to label a variety of practices in and justifications for art instruction in elementary schools. Even though the term carries a variety of connotations within the art education community, it is sufficiently familiar to the general public to suggest instruction that involves looking at artworks, as distinct from instruction that involves art-making activities.

The issues presented in this chapter are raised in the context of planning a course for elementary education majors titled "Art Appreciation and Child Development." The course is intended as a foundation upon which preservice classroom teachers can construct plans for introducing children to artworks from different eras and diverse cultures. Structures and concepts for raising curricular and pedagogical issues have been provided by Clark (1991) in his recent, and quite sensible, assessment of discipline-based art education as a curriculum construct,

and by Galbraith (1991) in her work on describing the range of issues that art education preservice education confronts.

The issues identified in this chapter were generated with the aid of a matrix (see Figure 1). The vertical axis of the matrix is defined by the two major areas of course content, art appreciation and child development. Art appreciation is considered first in general and then as related to Western and non-Western artworks; cultural factors; the art of nondominant populations; and finally art criticism, aesthetics, and art production. The horizontal axis of the matrix is defined by the following educational components: course content, the elementary education preservice teacher, the elementary school setting, the university art educator, and the university setting. Additional issues could surely be identified using this matrix. Other matrices would yield additional issues.

CONTENT COMPONENT ISSUES

Planning a preservice course on art appreciation and child development obviously necessitates planning in the two major content areas of art appreciation and child development. Issues related to art appreciation in general include: What does it mean to *appreciate* art? What role does knowledge play in art appreciation? What role do values play in art appreciation? How have Western artworks been valued in their own time? How are Western artworks valued today? How have non-Western artworks been valued in their own cultures? How are non-Western artworks valued in the West? How have cultural factors (such as economics, religion, politics, social class, and technology) influenced the valuing of artworks?

As the focus on art appreciation is broadened, content issues such as the following are raised: What range and variety of objects are valued as artworks by nondominant populations within a culture? Can the popular arts be appreciated as art? Can mass-produced consumer goods and images be appreciated as art? Can folk arts be appreciated as art? Can crafts be appreciated as art?

As attempts are made to integrate art appreciation content with other art content, issues such as the following arise: How can art criticism contribute to art appreciation? How can aesthetics contribute to art appreciation? How can art production contribute to art appreciation? To what extent, if at all, can Western notions of art criticism and aesthetics be applied to non-Western artworks?

With regard to the second major area of content, child development, here are some issues about children's aesthetic development that might

Figure 1
ISSUE GENERATION MATRIX

	Course Content	Elementary Education Student	Elementary School Setting	University Teacher	University Setting
ART APPRECIATION					
Art Appreciation in General					
Western Art History					
Non-Western Art History					
Art and Culture					
Art of Nondominant Population					
Art Criticism, Aesthetics, Production					
CHILD DEVELOPMENT					
Aesthetic Development					
Social Studies Development					
Cognitive Development					

be considered in selecting course content: To what extent can children's art appreciation development be described as universal or nonuniversal? Do Parsons's (1987) five stages of development of aesthetic experience describe children's development in art appreciation? How might planned educational intervention affect children's development in art appreciation? Can data on the development of aesthetic experience (Parsons, 1987) and preference studies be coordinated? Are Parsons's and Gardner's (1990) theories of artistic development compatible?

Additional issues can be raised by considering development in social studies understanding and general cognitive development. Here are a few of those issues: How does a child's understanding of history affect the ability to appreciate art from the past? How does a child's understanding of geography and world cultures affect the ability to appreciate art from non-Western cultures? Do Piaget's stages of cognitive development explain children's development in art appreciation? What role does the development of cognitive processes such as perception, attention, memory, encoding, retrieval, and problem solving play in the development of art appreciation?

STUDENT COMPONENT ISSUES

Moving our attention now to the preservice elementary education majors who are the intended students in the proposed course on art appreciation and child development, let us consider some of the issues that arise in contemplating the relationship between these prospective classroom teachers and the course content.

Some issues address preservice teachers' present knowledge and beliefs about art and their present patterns of art appreciation. What knowledge do elementary education majors have about Western and non-Western artworks? With what Western and non-Western artworks are elementary education majors familiar? What Western and non-Western artworks do elementary education majors value? What qualities in those artworks do they value? What cultural factors influence elementary education majors' patterns of art appreciation? What range and variety of objects do elementary education majors appreciate as art? What correlations can be found between elementary education majors' experience in art criticism, aesthetics, and art production and their patterns of art appreciation?

Other issues address preservice teachers' appreciative, cultural, and cognitive developmental levels. How sophisticated are elementary education majors in their appreciation of art? Is there a correlation between elementary education majors' understanding of history and

world cultures and their appreciation of art through time and across cultures? Is there a correlation between elementary education majors' cognitive development and their appreciation of art?

ELEMENTARY SCHOOL SETTING COMPONENT ISSUES

The proposed course in art appreciation and child development is intended to better equip prospective elementary classroom teachers to teach art appreciation content to children. A number of issues can be raised about teaching art appreciation in the elementary school setting. Here are a few general issues: How do school administrators, inservice teachers, school board members, parents, and other community members understand the concept of art appreciation? Is increased art appreciation a valued educational goal for school administrators, inservice teachers, school board members, parents, and other community members? What arguments can be built to justify art appreciation as an essential component of elementary education? Is increased art appreciation an objective the achievement of which can be measured? To what extent can art appreciation learning be adapted to various instructional systems (e.g., authentic assessment or cooperative learning)?

Additional issues surface when considering the cultural make-up of the school community and familiar life experience of children in that community. How ought the cultural diversity of an elementary school's student population affect, if at all, the content of art appreciation instruction? How can culturally and historically based art appreciation be planned in communities in which activities addressing religion, politics, and other cultural factors are carefully scrutinized by community interest groups? To what extent, if at all, does familiarity with visual objects (e.g., popular art, folk art, and mass-produced consumer goods and images) increase children's interest in art? Can historical, cultural, critical, and aesthetic analyses of familiar visual objects build skills and attitudes that can be transferred to less familiar artworks from different eras and different cultures?

Other issues arise in attempting to coordinate art appreciation learning with other educational priorities in the elementary school. Can art appreciation with an art criticism emphasis increase children's vocabulary and language skills? Can art appreciation with an emphasis on aesthetics increase children's higher-order thinking skills? Do tactile learners respond favorably to art appreciation instruction with an emphasis on art production?

A number of developmental issues related to community members, as well as children, can be raised in contemplating teaching art appreciation in the elementary school. At what level of art appreciation sophistication are school administrators, inservice teachers, school board members, parents, and other community members? Are artworks effective in reinforcing learning in social studies, especially with children who are visual learners? What effect, if any, does the concreteness of direct experience with artworks have on children's understanding of the times and cultures within which those works were produced? What cognitive skills are necessary for increasingly sophisticated art appreciation?

The first three sets of issues related to course content, students, and the elementary school setting can be considered in planning reading material, experiences, activities, and assignments for a university course on art appreciation for preservice teachers. The following six objectives, synthesized from the first three sets of issues, might be used to direct the planning of such a course:

1. Preservice teachers learn that the appearance and meaning of artworks are rooted in the culture in which they were produced.

2. Preservice teachers learn that a wide range of visual objects and images can be appreciated as art.

3. Preservice teachers learn that increasingly sophisticated levels of understanding can be used to describe aesthetic, cultural, and cognitive development.

4. Preservice teachers learn how to describe their own pattern of art appreciation.

5. Preservice teachers learn how to assess educational and cultural factors that may have affected their own art appreciation development.

6. Preservice teachers learn that school administrators, inservice teachers, school board members, parents, and other community members maintain a variety of understandings of and expectations for instruction in art appreciation.

TEACHER COMPONENT ISSUES

Course content, students, and eventual setting are crucial factors to be considered in effective course planning. However, at least two addition-

al factors play a major role in determining whether that planning will ultimately be successful. The characteristics of the college or university art educator teaching the course and the environment of the college or university bear directly on the success of any university course.

University art educators interested in teaching prospective classroom teachers about art appreciation and child development might want to consider the following issues as they apply to the university teachers themselves: What patterns of art appreciation do university art educators exhibit? How knowledgeable are university art educators about Western art history? What Western artworks do university art educators value? What qualities in those artworks do they value? How knowledgeable are university art educators about non-Western art history? What non-Western artworks do university art educators value? What qualities in those artworks do they value? To what extent are university art educators able to identify cultural influences on their own pattern of art appreciation? What range and variety of objects do university art educators value as art? How knowledgeable are university art educators in art criticism, aesthetics, and art production? How knowledgeable are university art educators non-Western notions of aesthetics, non-Western practice of art criticism, and non-Western art production? How knowledgeable are university art educators in aesthetic, historical/cultural, and cognitive development?

Issues such as these might be used to guide staff development activities for university art educators from graduate teaching assistants to full professors.

UNIVERSITY SETTING COMPONENT ISSUES

The university as an institution influences what can be done (or at least what is encouraged) in any preservice art appreciation instruction. Here are some issues that might be raised in attempting to implement a course addressing art appreciation at the university level. Given the historical "nonacademic" connotation of *art appreciation* and university art educators' need to sustain academic credibility, should art appreciation content be approached through more traditional academic disciplines such as art history and anthropology? What effect does the lower priority of educational service courses have on efforts to educate elementary education majors in art appreciation? How might campus debates on "political correctness" influence the selection of artworks, eras, and cultures identified in proposed art appreciation course syllabi?

These additional issues impact the strategic and political planning that might be undertaken to put a course such as "Art Appreciation and

Child Development" in place within the university. What academic "territorial battles" (with departments such as Art History, Anthropology, and American Studies, or Philosophy) might university art educators confront when proposing art appreciation instruction with a broad historical and cultural base? What interdisciplinary options might be explored in planning, staffing, and administering a broad-based art appreciation course? Given the tendency for universities to disallow studio courses as part of general studies courses, should production activities be diminished or eliminated from art appreciation courses? Given the scarcity of electives in elementary education programs, should art production and art appreciation be combined into one course offering?

The research environment of the university may encourage faculty to identify prospective research issues for their own or their graduate students' investigation. Here are a few research issues related to art appreciation and child development: Can a coherent developmental theory be constructed that integrates developmental research findings in aesthetic experience, preference studies, and general artistic development theory? Given the lack of a substantial research base in children's development in art appreciation, to which research questions should art educators give priority? What research questions might be investigated to determine whether there is evidence of universal stages or levels of development in art appreciation? Should Parsons's (1987) research be replicated and revised in order to establish a data base in art appreciation development? What research questions might be investigated to describe nonuniversal development in art appreciation? What instructional interventions (e.g., instruction in art history, art production, aesthetics, or art criticism) might be studied for their possible effects on art appreciation development? Do some instructional strategies (e.g., cooperative learning, lecture/discussion, journal keeping, or the use of manipulative resources) yield greater increases in art appreciation than other strategies?

Additional research issues can be generated by broadening the focus to include development in social studies learning and general cognitive development. How can research in social studies—for example, Levstik's (1986) work in the development of historical understanding—be coordinated with present and future research in the development of art appreciation? What research might be undertaken to discover how the development of various cognitive processes such as perception, attention, memory, encoding, retrieval, and problem solving affect art appreciation development?

CONCLUSION

The sheer magnitude of issues generated (77 in all) might lead some to be discouraged about the prospects of successfully teaching art appreciation and child development to preservice classroom teacher. However, the intent of this chapter is not to discourage but to encourage. Reflecting on these issues (and even generating more) should help university art educators plan (a) their preservice teaching; (b) their professional development as teachers; (c) their research agenda as scholars; and (d) their service contribution to the university and the larger educational community.

REFERENCES

Clark, G. A. (1991). *Examining discipline-based art education as a curriculum construct.* Bloomington, IN: ERIC:ART.

Galbraith. L. (1991, October). *Research on art teacher education: Images and issues.* Unpublished lecture notes, Arizona State University, Tempe.

Gardner, H. (1990). *Art education and human development.* Los Angeles: The Getty Center for Education in the Arts.

Levstik, L. (1986). Teaching history: A definitional and developmental dilemma. In V.A. Atwood (Ed.), *Elementary school social studies: Research as a guide to practice* (pp. 68-84). Washington, DC: National Council for the Social Studies.

Parsons, M. J. (1987). *How we understand art: A cognitive developmental account of aesthetic experience.* New York: Cambridge University Press.

Chapter 11

A Brief History of Preservice Education for Art Teachers in the United States

Peter Smith
Purdue University

Peter Smith
Purdue University

Dr. Smith is Associate Professor of Art and Design and Curriculum and Instruction at Purdue University, West Lafayette, Indiana. He received a Ph.D from Arizona State University, Tempe. His scholarship and research focus on historical and curricular developments within art education and preservice issues. He has written numerous articles on past art educators who have strongly influenced the field. Dr. Smith has published widely, including articles in *Studies in Art Education, Art Education,* and *Visual Arts Research.* He is also a practicing artist who frequently exhibits his own work.

Chapter 11

A Brief History of Preservice Education for Art Teachers in the United States

Peter Smith
Purdue University

Preservice education for teachers is essentially a concept born of the exigencies of public universal education. Before the people of the United States embraced (with surprising unanimity) the idea that all should be given at least a minimum education, it was sufficient to have a teaching corps of young college men—especially those intending to enter the Protestant ministry—teach for a few weeks. Such teaching probably consisted of work in reading and arithmetic, but we have little evidence of what went on day to day in early American schools. If art appeared at all in such schools, it was introduced because the individual amateur teacher had a personal interest in it, although we should not overlook the prestige of fine penmanship or the modeling of artistry seen in Pennsylvania Dutch *Fraktur*, which included certificates of

excellence devised by school teachers. There were plenty of women edu-
cators, but their lives and educational practices were veiled in the pur-
dah of gender bias and we know as little about most of them as we know
about the elusive Mrs. Minot whom Saunders (1964) attempted to find.

Art education, of course, has always existed in the United States. It
originally took the form of instruction in crafts from mother to daughter
or master to apprentice, and its strong presence in the home made craft
instruction superfluous in the school. Art instruction was available at a
very early date for those of means in larger American towns (Flexner,
1947). Becoming an artist meant essentially undergoing training with
an acknowledged artist in a nonschool setting.

No mention of nonschool art education in the United States can be
made without a mention of the extensive art education carried on by
Native Americans. The craftsmanship and aesthetic quality of much
Native American artwork obviously could not have been achieved with-
out a great deal of teaching and the structure to pass artistic knowledge
on to younger generations.

As Bailyn (1960) has pointed out, as American families abandoned
functions hitherto expected of them, such as inclusion of several genera-
tions of relatives and servants and apprentices within one household as
a family unit, schools had to assume many familial tasks. Thus, when
masses of parents began to work outside their homes as the Industrial
Revolution grew, the teaching of craftsmanly ability in the family was
abandoned. The schools' assumption of that task, however, was not
immediate.

The use of drawing copy books was one attempt to overcome the
shortcomings of home and school art education. Several of the authors
of these also attempted to introduce art education into the public
schools (Korzenik, 1985; Wygant, 1983). However, the economic condi-
tions of the schools and the conservative attitude of the taxpayers
always seemed to prevent the complete acceptance of art as a school
subject. Not the least of the adverse conditions was the fact that teach-
ers had a largely literary education. They had been taught through
books and were usually expected to teach from books. That is, every-
thing was reduced to the written word. The first white schools in what
is now the United States had, after all, been set up to teach students to
read the book, the Bible. The shift from the known practice of dealing
with words—spoken, written, and read—to the unfamiliar practice of
dealing with visual imagery was difficult for most, and impossible for
some (Smith, 1989b). There was nothing in the teachers' preservice

education, philosophical or practical, that prepared them for such a change.

At the same time, the rise of industrialism brought about a fragmentation of life that has had far-reaching and fateful consequences. Before the Industrial Revolution, all workers learned their particular tasks as part of an easily perceived whole. For example, while the apprentice carpenter might be assigned just to sand wood to be used for a chest, he could see its relationship to the completed piece and eventually he would learn every part of the work that went into the tasks his master did. He could identify his life and work with meaningful accomplishments. Indeed, life and work were an almost seamless whole. In this the worker was similar to the artist. Artists, despite the abandonment of this attitude toward work in Western industrialized culture, have retained the belief in self-identification with a commitment to their work. Anderson (1989) has traced the marginalization of art in school and society to this loss of the individual's belief in self-identification with work. School has also become a place where fragmented little tasks, meaningless in themselves, are carried on without concern for the whole life of the student. The teacher becomes a shop foreman in the factory model school.

The Boston area industrialists who made the proposals that brought into being the 1870 Massachusetts Free Instruction in Drawing Act must have held that the schools could teach drawing (for their benefit) as a discrete skill (Bolin, 1986). However, it was obvious that preservice education had to be instituted in order to prepare teachers to give instruction in industrial drawing. The result was The Massachusetts Normal Art School, which became the first important preservice institution for training public school "art" teachers.

As Efland (1983) has shown, art education's 19th century form was class determined. The working classes were restricted to industrial drawing, whereas education for the wealthier classes gave more emphasis to art appreciation. The first kind of art education was accomplished through drillwork of progressive complexity. The latter, while it included instruction in still life, landscape, and sometimes architectural drawing, reached its most complete form in the tour of European sites (frequently the student was led about by a privately hired expert).

The preservice education of teachers of industrial drawing tended to be anti-artist. That is, the Prussian model that underlay the English design education had been deliberately chosen to prevent graduates from attempting to claim the social status of artists (MacDonald, 1970). The French had used a system in which designers and artists received a

similar education. The Prussian model was chosen in England, according to Macdonald, despite the better sales of French-designed industrial products. This choice reinforced beliefs about social classes then current in Britain. The acceptance of this English system in Massachusetts by way of the hiring of Walter Smith gives even more credence to Efland's analysis.

Preservice education for industrial drawing was to involve rigorous, highly structured, sequential training units. The teacher was to become a technician passing on received information as unvarying and impersonal as multiplication tables. In the century of romanticism, this certainly was not accepted unopposed (Wygant, 1983). Lurking beyond the industrial drawing modes of preservice education was the opposite view that the teacher of art should be educated as an artist. Once art ceased to be regarded as a skilled imitation of nature and originality became a sine qua non of art, *training* for the artist became an ambiguous notion. The artist was a unique individual whose insights could not be gained by pedagogues who had never undergone the same experiences.

As Smith's industrial drawing began to be replaced by other models or simply eroded through repetition, those who espoused progressive education took up the view that mere technical training could not make an art teacher. Rugg and Shumaker (1928), in their classic *The Child-Centered School: An Appraisal of the New Education*, stated:

> *Only painters, sculptors, dancers, musicians, poets, who combined great visions of their art with an equal vision of the child's potential, were sensitive through their own artistic travail to the requirements of the creative spirit. They could truly understand the philosophy and aims of the child-centered school.* (p. 228)

If this was meant as an expression of a mystical vision of the artist and art, it was a self-defeating view of art education. If only the artist can understand art, then what is the use of teaching it in schools? Art is, in this view, indeed marginal to the normal life. If, however, the progressive educators attempted to develop a school in which learning was to be a seamless whole, with the artist as a model of the worker-learner committed to self-identification with work integrated with life, then it was an expression of the view Dewey (1934) was to explicate in *Art as Experience*.

The first interpretation negates preservice art education. The art teacher would be educated as an artist, then go into a school and model

the artist role. Florence Cane was cited by Rugg and Shumaker (1928) as an example of the creative artist in the classroom. In her work at the Walden School, Cane's aim was more to use experience with art materials as an emotional safety valve than to provide education about art. Nevertheless, as Cremin (1964) pointed out, student artwork from the Walden School was on a high level.

Another progressive educator, but in a public school rather than an elite private school, was Natalie Robinson Cole. She claimed that her students' success in producing excellent artwork resulted from her abandonment of her preservice education and development of her own educational model. Educated as a generalist elementary classroom teacher, Cole came in contact with Galka Scheyer—a onetime associate of Klee and Kandinsky—and received reinforcement of her belief that children naturally produce excellent art (Smith, 1991). This is not the place to analyze why Cole did not actually do what she believed she did, but her belief implied that the art teacher needs only charisma and knowledge of a few techniques to produce a sound art program.

One of the centers of progressive education, Teachers College, Columbia University, was the source of an entirely different concept of preservice education. There Arthur Wesley Dow promulgated what he termed *synthetic art education.* Dow believed that art could be analyzed to derive elements and principles that could be taught as separate units. Once all the units were mastered, a synthesis would take place within the learner's understanding and art could be both understood and produced. Dow's *Composition* (1913) set forth these ideas and, partly through the many editions of this book and partly through his teaching of many who became teachers, Dow's ideas took root and spread through much of art education in the United States, especially at the high school and college levels.

Dow provided a form for teaching art that fit well with the art that emerged in the early 20th century. Modern art's rationale, as explained through the theory of art known as *formalism* and Dow's reduction of art to elements and principles of design were obviously suited to each other. Dow was personally well prepared to explain early modernism, since he had achieved artistic excellence in his own work, as Mock-Morgan (1985) has attempted to explain and as a visit to the Chicago Art Institute, which displays Dow's *Blue Boat,* demonstrates. Furthermore, Dow went beyond the art for art's sake aspects of formalism to attempt to show that good design, or *art* in his sense of the word, was the necessary foundation for everything about us, from teacups to cathedrals. This also suited Dewey's idea that the aesthetic experience is not unique to fine art objects, but is an integral part of life.

With the influx of ideas from the Bauhaus that came at the start of World War II, another design-oriented form of art education entered U.S. schools. Although in their original form Bauhaus exercises usually took the form of challenges (often in use of materials) to be solved in original ways, foundation design exercises soon began to resemble Dow's ideas as much as the Germanic Bauhaus models. In 1968, Raleigh, then head of art education at Pratt Institute, claimed, "Today there is barely an art program at any level of education that does not ... contain some remnant of the old Bauhaus' preliminary course" (p. 277). However, as a student at Pratt in the middle 1950s, I can testify that the art education students' foundation exercises were Dow-like, whether the faculty teaching then knew it or not. The Dow and Bauhaus exercises had become so conflated that they could not be separated.

Speaking in 1983 at a conference for New York State art teachers, Clahassey criticized a proposed state curriculum for junior high school by pointing out that its only real rationale was formalism. Typically, she explained, when art teachers attempted to give an intellectual justification for what they did, they fell back on formalism. The Dow explanation for how art could be taught had become the permeating model for structured and sequential art programs. Teacher preservice education had failed to provide art teachers with a range of intellectually convincing alternatives, and rhetoric about the holistic growth of the student borrowed from Lowenfeld was not integrated with actual or proposed practice.

Over decades, the public schools gradually changed from institutions intended to provide minimal literacy and numeracy skills to a small part of the population to the expectation that all children would attend school through the elementary grades and, finally, to the ideal that all children and youth should finish high school. This ideal required the education of more and more teachers. Teachers had to be more numerous than lawyers or doctors or preachers, and funds for their pay were finite. The first condition caused schools for the education of teachers to attempt to find and train large numbers and aim for speedy production, rather than setting high admission standards or devising lengthy programs of study that would eliminate considerable numbers of potential teachers. Since teacher education was to be neither exclusive nor costly, salaries could be lower than those of professionals. In turn, this meant that those seeking teaching positions would not find it practical to undergo expensive education at prestigious or exclusive colleges.

The *Stevens Point [Wisconsin] Normal Bulletin* (Stevens Point Normal School, 1918) states that the Normal School accepted eighth

grade and high school graduates for its teacher education program. High school graduates could obtain life certification after attending the Normal School for 2 years, and after teaching for 2 years they could receive a bonus of $60 to $80 per month. Eighth grade graduates could attend the Normal School for 3 years and obtain a temporary certificate that could be renewed if the teacher attended summer institutes.

Given such educational limitations, it is not surprising that the range of what could be expected to be taught by these teachers was limited. Thus, when it came to teaching about art, graduates of such schools relied on picture study and seldom ventured into studio production. We can admire a figure such as O. W. Neale for his desire to bring aesthetic concerns into the classrooms of early 20th century midwestern rural America (Smith, 1986), even as we can see with the clear vision of hind sight that a more rounded preservice art teacher education was needed for fuller and stronger art education in the schools.

Post-World War II education witnessed rapid growth in the school-age population and vastly expanded college enrollments. Facing the reality that many who would teach the younger school-age population would have little or no knowledge of art, Lowenfeld devised a theory of art education that enabled the teacher to encourage the child to engage in art-like activities while providing the teacher with rationales for those activities based on newly popularized psychological ideas. These were similar to the safety-valve concepts of Cane, but were underpinned by Lowenfeld's thorough knowledge of the child development literature he had read in Austria (Smith, 1982). The preservice education that Lowenfeld's *Creative and Mental Growth* (1947) seemed to require included (a) some minimal practice with art materials, (b) concentration on child development, and (c) acquaintance with theories of child psychology.

A careful examination of *Creative and Mental Growth* reveals that the earlier school years are described, analyzed, and explained much more thoroughly and convincingly than the secondary years. This probably can be traced to limitations of the developmental theories on which Lowenfeld based his writings. For this reason, practitioners at the secondary level often used simplified versions of the Dow-Bauhaus design exercises in their art classes. They frequently did this while espousing the rhetoric of a Lowenfeld student-centered art education.

While Lowenfeld set in motion research intended to bring the field to new levels of intelligent action, internal *contradictions* in his theory, misinterpretation of that theory, and thoughtless repetition of past practices caused extreme reaction by the 1960s. Manzella (1963), in

Educationists and the Evisceration of the Visual Arts, blasted preservice art education in language we now see as sexist, but which gives a vivid idea of the outrage felt by many viewing the condition of art education at that time along with its attendant preservice education. The education of the art teacher, Manzella claimed, required only

> *a superficial acquaintance with the history and practice of art while demanding a great portion of time in education. . . .The pointed exclusion of depth and knowledge of a subject field as a prerequisite for the prospective teacher is one of the great mysteries of educational philosophy. This philosophy resulted in the usual art education major being a nice young woman of unexceptional abilities and little ambition to do anything with her art on a personal level. The young man in the program is usually interested in crafts and the decorative rather than painting or sculpture and is often rather low in male hormones.* (1963, pp. 76-77)

Since the 1960s, and most especially since the Penn State Seminar of 1965 (Mattil, 1966), there has been a general trend toward increasing the art history and art criticism content in school art programs. These areas began to be covered in preservice education, although art criticism usually took the form described by Feldman (1970) rather than that practiced in the world of professional critics. Even so, Lowenfeld-based preservice practices have shown an interesting tenacity, suggesting that they still serve needs overlooked by advocates of a more discipline-based approach.

In 1982, the Getty Center for Education in the Arts published *Beyond Creating: The Place for Art in America's Schools.* This publication asserted that the only good art program was one that included studio production, art history, art criticism, and aesthetics. As I have pointed out elsewhere (Smith, 1989a), this suggested a richer, fuller form of art education, a direct descendent of the ideas of the Penn State Seminar. However, naming the four components did not tell us what was meant by these labels. Various people, implying that they have received the imprimaturs of the Getty Center, have suggested various meanings and practices for each component. This is not the place for a listing of what each term might mean, but the reader can infer the difficulty of devising a preservice education to prepare art teachers for discipline-based art programs.

Whatever the meanings of the four labels, the implications for preservice education are manifold. Art teachers will have to know more about art, and that knowledge will be not only of practice but also of theory. I

have noted for some years that art education students and art teachers in the schools often complain about a lack of depth in their preservice studio preparation. With this in mind, as a university teacher preparing students to become art teachers, I have to ask whether the study of art history, art criticism, and aesthetics should be subtracted from the time allotted for studio work. Or should courses in the three subjects be added to the older, mostly studio preservice requirements? Or should some integrated form of studio with one or all of the other components be devised?

Many of us would opt for full attention to all four components, but the experience of Manzella, the muckraking art education critic of the 1960s, is instructive. During an interview I had with Manzella in 1988, he told of his frustrations with establishing a preservice program for a quasi-discipline-based concept of art education at the Rhode Island School of Design. For 4 years, students took courses exactly like those for students intending to have art careers. A fifth year was added during which teacher preparation was studied intensively. Manzella admitted the plan proved economically impractical. This more expensive and lengthier education was not compensated for by the schools. School people simply would not pay for the extra preparation, no matter what it might have meant in the way of a better school art program. No preservice program, however lofty its ideals, can operate in isolation from the economic realities of the schools and the lives of teachers.

CONCLUSION

Preservice education has been shaped by the theoretical requirements of the art of its time and limited by the resources of the schools in which graduates will teach. It has aspired to prepare teachers who are able to give students a basic knowledge of art, insofar as the schools can and will compensate teachers for their education. Economic conditions of schools and limitations of teachers' salaries have restricted preservice (as well as inservice) education. In the end, the quality of teacher education may be restricted not by measures related to the ideal of providing a greater knowledge of art, but by the potential art teacher's asking, "Considering what I will be paid as a teacher, is the cost of this schooling worth it?" Preservice art teacher education has seen a steady increase in the time required for its accomplishment. The latest developments in art education seem to call for even lengthier periods of instruction and a restructuring of what we have known to date as the education of art teachers.

REFERENCES

Anderson, J. (1989, October). *Historical perspectives on manual training and liberal education.* Paper presented at the Second Penn State Conference on the History of Art Education, University Park, PA.

Bailyn, B. (1960). *Education in the forming for American society.* New York: Vintage.

Bolin, P. (1986). *Drawing interpretation: An examination of the 1870 Massachusetts act relating to free instruction in drawing.* Unpublished doctoral dissertation, University of Oregon, Eugene.

Clahassey, P. (1983, September). *The proposed middle school curriculum.* Paper presented at the New York State Art Teachers Association Capital District Conference, Skidmore College, Saratoga, NY.

Cremin, L. (1964). *The transformation of the school.* New York: Vintage.

Dewey, J. (1934). *Art as experience.* New York: Capricorn.

Dow, A. (1913). *Composition.* New York: Doubleday Doran. (Originally published in 1899).

Efland, A. (1983). School art and its social origins. *Studies in Art Education, 24*(3), 49-57.

Feldman, E. (1970). *Becoming human through art.* Engelwood Cliffs, NJ: Prentice-Hall.

Flexner, J. (1947). *The first flowers of our wilderness.* New York: Dover.

Getty Center for Education in the Arts. (1982). *Beyond creating: The place for art in America's schools.* Los Angeles: Author.

Korzenik, D. (1985). *Drawn to art: A nineteenth century American dream.* Hanover, NH: University Press of New England.

Lowenfeld, V. (1947). *Creative and mental growth.* New York: Macmillan.

MacDonald, S. (1970). *History and philosophy of art education.* New York: American Elsevier.

Manzella, D. (1963). *Educationists and the evisceration of the visual arts.* Scranton, PA: International Textbooks.

Mattil, E. (Ed.) (1966). *A seminar in art education for research and curriculum development.* University Park: Pennsylvania State University.

Mock-Morgan, M. (1985). The influence of Arthur Wesley Dow on art education. In B. Wilson & H. Hoffa (Eds.), *History of art education: Proceedings from the Penn State Conference* (pp. 234-237). Reston, VA: National Art Education Association.

Raleigh, H. (1968). Johannes Itten and the background of modern art education. *College Art Journal, 27*(3), 284-287; 302.

Rugg, H., & Shumaker, A. (1928). *The child-centered school: An appraisal of the new education.* New York: World Book.

Saunders, R. (1964). The search for Mrs. Minot: An essay on the caprices of historical research. *Studies in Art Education, 6*(1), 1–7.

Smith, P. (1982). Germanic foundations: A look at what we are standing on. *Studies in Art Education, 23*(3), 23–30.

Smith, P. (1986). The ecology of picture study. *Art Education, 39*(5), 48–54.

Smith, P. (1989a). A modest proposal, or using ingredients at hand to make an art curriculum. *Art Education, 42*(6), 8–15.

Smith, P. (1989b). *A troublesome comedy: The causes of Walter Smith's dismissal.* Presentation at the Second Penn State Conference on the History of Art Education, University Park, PA, October 12-14.

Smith, P. (1991). Working with art education history: Natalie Robinson Cole as a "living document." *Art Education, 44*(4), 6-15.

Stevens Point Normal School. (1918). *Normal School Bulletin.* Stevens Point, WI: Author.

Wygant, F. (1983). *Art in American schools of the nineteenth century.* Cincinnati: Interwood.

Chapter 12

The Professional Art School

A NOTABLE SITE FOR THE PREPARATION OF ART TEACHERS

*Karen Lee Carroll, Renee Sandell,
and Henry Jones*

Maryland Institute, College of Art

Karen Lee Carroll, Renee Sandell and Henry Jones
Maryland Institute, College of Art

Dr. Carroll is Director of Graduate Programs in Art Education at the Maryland Institute, College of Art in Baltimore. She teaches both preservice and professional development courses, chairs the department, and is responsible for program development. Prior to coming to the Institute, Dr. Carroll was the Arts Area Coordinator for the Providence, Rhode Island, Public Schools, supervising all instruction in art, dance, music, theatre, and media, grades K-12. Carroll began her association with gifted education in 1971 as the Art Coordinator for the Houston High School for the Performing Arts. Since then, she has directed The Center for Career Education in the Arts for the State of Rhode Island, developed an Arts Magnet Program for the City of Providence, and acted as a consultant to several other gifted programs. Her dissertation focused on issues related to gifted education and the arts. Dr. Carroll holds an Ed.D. from Teachers College, Columbia University, an M.Ed. from the Pennsylvania State University and a B.S. in Art Education for S.U.N.Y. College at Buffalo. Carroll served as the Program Coordinator for the NAEA 1991 National Convention and was named the 1992 National College Art Educator of the Year by the Higher Education Division of the NAEA. In 1993, Dr. Carroll was the recipient of the Reston Prize, for her article entitled Taking Responsibility: Higher Education's Opportunity to Affect the State of the Arts in the School and future schools.

Dr. Sandell is Professor of Art Education at The Maryland Institute, College of Art in Baltimore. Prior to her appointment in 1989, Dr. Sandell taught art education courses at George Mason University, University of Maryland, George Washington University, and The Ohio State University Newark Campus. Her professional experience includes teaching private studio classes for children and adults in addition to serving as a consultant to government agencies and museums as well as private schools and public school districts. Dr. Sandell holds a Ph.D. and M.A. in Art Education from The Ohio State University. Her research on gender and multicultural issues in art and education can be found in art and art education books and journals. With Dr. Georgia Collins), Renee Sandell is co-author of *Women, Art, and Education*, published by the National Art Education Association in 1984 and co-editor of the forthcoming NAEA anthology entitled Gender Issues in Art Education: Content, Contexts, and Strategies. Dr. Sandell has been active in state and national professional organizations, serving in leadership positions and on editorial boards. A past president of the NAEA Women's Caucus, Dr. Sandell's honors include the 1990 Higher Education Art Educator of the Year by the Maryland Art Education Association, the 1991 NAEA Eastern Higher Education Art Educator of the Year award, the 1994 Manuel Barkan Award (with Georgia Collins), and the NAEA Women's Caucus 10994 Mary J. Rouse Award.

Mr. Jones is the newest full-time member of the Art Education faculty at Maryland Institute, College of Art. As Director of Practicum, he has the responsibility for the internship and student teaching programs and teaches other courses as well. Mr. Jones has 20 years classroom experience as a high school and middle school art teacher and 10 years experience as supervisor of the K-12 art program in Baltimore County school system. As art supervisor, he coordinated the development of curriculum, participated in the on-going guidance and assessment of the K-12 art instructional staff, coordinated staff development programs for art teachers, and designed and taught a class for new art teachers to help them deal with their special needs and issues. IN coming to the Maryland Institute as an instructor, Mr. Jones has made a full circle. He graduated from the Institute with a BFA and an MFA in Fine Arts and Art Education. He also holds a MA from The Ohio State University, where he studied under Dr. Manuel Barkan. Mr. Jones has been a contributor and editor of many curriculum publications in the Baltimore County Schools. He also participated in the development of Maryland State frameworks Goals for Art Education and Goals for the Fine Arts. More recently, Jones was invited to participate on a committee to write assessment tasks as part of the NAEP.

Chapter 12

The Professional Art School

A NOTABLE SITE FOR THE PREPA-RATION OF ART TEACHERS

Karen Lee Carroll, Renee Sandell,
and Henry Jones

Maryland Institute, College of Art

There is a certain logic in the notion that a professional school of art would be well served by investing in art teacher preparation: well-prepared art teachers produce better candidates for art school. While few professional art schools offer art education, it may be possible that such institutions are one of the best settings for art education. The Maryland Institute, College of Art has a commitment to art education that stretches back into the 1850's when a normal art program was offered to classroom teachers. The Institute's current president, Fred Lazarus IV, set out to build a high quality art education program, recruiting Dr. Al Hurwitz to undertake that task in 1981.

The art education program at the Maryland Institute presently illustrates that it is possible to craft a teacher preparation program in a professional school of art that maximizes certain aspects of the task. First,

the program draws upon students who have a highly developed interest in art, often the result of contact with good art teachers—specifically at the secondary level. Second, the intensive studio coursework allows students to reach an advanced level of performance and independent work. In this process, they encounter a faculty of excellent teachers, many of whom are artists unafraid to articulate their commitment to teaching.

Third, the curriculum of the art school has a structure that is sharply focused. The BFA in Studio is two-thirds studio work. In addition to a core of liberal arts requirements, students take a minimum of 15 credits in art history that includes western survey, modern art, a non-western art history, and an elective from the areas of women's art, ethnographic studies, Hispanic art, African/African-American art, and/or Asian studies. Thus, all students have a rich background in art historical information as well as their studio expertise to draw upon.

Candidates for teaching can then add a comprehensive education sequence to their preparation. Students who want to make an early commitment to art education enter a "five year program" in which the student carries a minor in art education as an undergraduate and completes the teacher education program as a graduate student. Others may enter the Master of Arts in Teaching (MAT) program at any point following the completion of their BFA in studio. MAT students range in age from those immediately out of college to students in their 40s and 50s. Many who apply for the MAT are involved in a career change and bring a high level of maturity and commitment to the program.

The intent of this article is to illustrate some of the potential inherent in an art school fully committed to art education. The ideas and practices that have been designed and tested at the Maryland Institute reflect its studio-centered philosophical orientation and pedagogical approaches that nurture the art student into the art teacher through careful advising and review at each stage of the program. Due to limitations of space, we will briefly identify unique features and highlights of the program, including the entry and review process, the preservice program of study and the practicum. We will then conclude with some observations regarding the relationship between the professional art school and the larger art education community in the area as well as the impact of a quality art education program on a professional school of art.

THE ENTRY AND REVIEW PROCESS

Because the art education program leads to state certification and reciprocity with approximately 30 other states, a careful screening and advisement process is used with students seeking entry to the program at both the undergraduate and masters levels. In either case, students are required to present a portfolio, a writing sample, transcripts showing a minimum 3.0 GPA and a strong recommendation from one or more teachers.

One third or 15-17 credits into the program, students are eligible for a departmental review. The total student's progress is considered individually and reviewed in a conference between the student and all members of the art education faculty, which includes 3 full-and 4 part-time members.

The third step in the review process comes at the conclusion of a sequence of internship experiences. At this point, the master teacher and art education faculty evaluate students for their readiness to student teach. This is determined by a "Bridge Conference" consisting of self and faculty evaluations of the individual student's performance in the internship experiences and in other aspects of the program. On occasion, students have repeated an internship course in order to qualify for student teaching. At the conclusion of this conference, students are asked to formulate goals for student teaching to strengthen areas of need. Shared later with the student's cooperating teacher, these goals provide focus for observations by college supervisors.

Throughout student teaching, students are evaluated on their professional deportment, their ability to effectively plan and implement instruction, and their ability to evaluate themselves as teachers and student learning as well as quality of product resulting from their efforts.

PRESERVICE COURSEWORK

Having a solid foundation in studio and art history, art education students take an intensive set of 11 courses in art education theory and practice. The introductory course to the program is "Introduction to Teaching Art in the Schools." "Foundations of Education" provides an introduction to the profession and acquaints students with philosophical and social issues facing the field. "Curriculum and the Psychology of Teaching and Learning" presents learning theory that informs the practice of classroom teaching. Two methods courses focus separately on expression in and response to art. Two other courses center on the

nature of the K-12 learner and the design of teaching strategies to provide motivation and challenge in nurturing artistic development. Another course focuses on special students and their particular instructional needs as art learners. In addition, a course comprised of a series of topical seminars addressing broad issues for MAT students is included. These courses are complemented with 2 practicum experiences that precede student teaching.

The Introductory Course

The initial course, "Introduction to Teaching Art in the Schools," focuses on the concept of "teaching as a performing art." This course takes the student into the art room of public and private, city and county, elementary and secondary, regular and special schools. Students are prepared to use a variety of criteria and methods for evaluating the educational environment, the act of teaching, and the relationship between instruction and learning. Here they are encouraged to begin to think about themselves as teachers and to develop a "critical eye" for the teaching act.

Methods for Teaching Expression Through Art/Response to Art

Two courses, "Visual Thinking Through Media" and "Critical Response to Art" rely on theory and practice to address the basics of art expression and response. "Visual Thinking Through Media" centers on studio practice with materials and media appropriate for use with children in the schools. Students keep journals to record intense experimentation with art processes, materials and teaching ideas. Through an in-depth investigation of a single medium, each student becomes an studio "expert." This investigation involves intensive research in the studio, library and community. Their ideas for teaching are presented and demonstrated to the class at large.

In "Critical Response to Art," critical processes and concepts from the fields of art history, aesthetics are studied for their potential relationship to studio practice and the needs of the child. Students examine diverse strategies to develop visual literacy and critical thinking through multiple modes of learning about works of art. Working with the Baltimore Museum of Art's collection, an in-depth exploration of a work of art through art historical and studio research is employed to sharpen their critical and analytical abilities.[1]

[1] For detailed description of this project, see *Talking About Art: Past to Present, Here to There—Preservice Art Teachers Collaborate with a Museum* by Renee Sandell and Schroeder Cherry, *Art Education*, July 1994.

The Learner, the Curriculum, and Effective Methods of Teaching

In order to prepare the art teacher to be a mediator between the world of the learner and the world of art, students must have a solid grounding in developmental issues and effective methods of teaching. "The Arts and Human Development" focuses on the growth and development of children throughout early adulthood, the ways in which art development parallels that growth, and the roles that art plays in peoples' lives. While the preceding course focuses on the nature of the learner, another course "Strategies for Teaching Art" considers the various approaches to making art and their translation into strategies for teaching K-12. The course features the participation of a series of master teachers from local school systems who present and discuss their pedagogical approaches with examples of student artwork. The course concludes with students writing lessons and units wherein students practice making curricular choices, drawing upon the repertoire of ideas generated by the sum of their methods courses.

Addressing the nature and nurture of children and their art, these courses involve students in an active and concrete search for ideas and insights. For example, in "The Arts and Human Development" course, periodic sessions at neighborhood public schools provides our students contact with children where they can explore and test ideas presented in the literature on child development. Close observation of children at work and careful analysis of children's art sharpens students' critical eye and helps them see the child in a holistic manner. In the process, students gain confidence in talking before the group, reading and analyzing the literature, and begin to form a theoretical and philosophical basis for their observations.

We actively seek opportunities to involve students in activities related to current instructional issues and practices. For example, a recent outcome of one methods course was a collaborative, interdisciplinary experiment: The Math-Art Exchange. Students prepared an introduction to the artistic growth and development of the child which they presented to elementary education majors from The John Hopkins University. In exchange, Hopkins students provided a presentation on the mathematical development of the child. As a follow up, the two groups held a brainstorming session to identify connections which might be made between art and math. Beyond fulfilling curricular gaps existing in both teacher preparation programs, this effort represents an attempt to create, *at the preservice level,* a dialogue across disciplinary lines.

The MAT Seminar

The MAT Seminar, taught by Dr. Al Hurwitz, addresses topics and issues including the history of art education, art education from an international perspective, the nature of research, teaching criticism and art history, and DBAE in curriculum planning. These graduate seminars help to provide a "big picture" of the profession with an outlook to its continuing role in the education of young people.

An Art-Based Introduction to Special Education

Another preservice methods course provides for an art-based introduction to special education. This course, taught by a practicing art specialist who deals with special needs children, provides both a theoretical grounding and a practical base of information that helps students modify curriculum and activities for special education students mainstreamed into art classes. The course also addresses the issues and needs surrounding gifted and talented students and how the art curriculum may be differentiated in response.

THE PRACTICUM

The practicum includes a three-semester sequence consisting of 2 internship courses followed by student teaching. During the student teaching, our students teach 7 weeks in an elementary school and 7 weeks in secondary. The students also meet regularly as a class on campus to discuss issues that arise from the school site teaching experiences. The practicum is concluded with the "Student Teacher Showcase," MICA's rites of passage for art teacher candidates.

The Internship Sequence

The internship portion of the practicum continues to grow and evolve. Traditionally, art education students have participated in a Saturday program for K-12 students, The Young People's Studios (YPS). Directed by an art supervisor from a local county and staffed by master art teachers from area schools, the offerings include a comprehensive set of studio-based classes for grades K-12. In many ways, the YPS classes illustrate very specific and innovative approaches to teaching.

Art education students spend two semesters in the Saturday program. During the first semester, students observe in each of the classrooms under the guidance and supervision of the program director, becoming acquainted with all the different offerings and faculty.

During the second semester, students would select one master teacher as their mentor. It has been at this time that our students would teach their first lessons under clinical supervision. As part of an on-going assessment of our program, we are currently modifying the internship program and exploring additional practicum possibilities that allow our students to plan and present art experiences for children as part of both internship courses.

A variation of the sequence currently being piloted involves students in "Internship in Teaching, Part I," planning and teaching lessons on Saturdays in a laboratory school environment under the guidance and supervision of the faculty and master teachers. These Saturday classes are comprised of students who are recommended by their art teacher to receive a scholarship for a special workshop at the Maryland Institute, College of Art. Scholarships are awarded by teachers who have served as cooperating teachers in our student teacher program. The number of scholarship classes is determined by the number of students enrolled in the Internship I course. This course involves the interns working in teams of 2 or 3 with faculty and master teachers in planning a sequence of learning experiences for an elementary class and, later in the semester, a middle school class. Feedback to interns regarding the writing of plans, the selection and development of instructional material, and lesson implementation is ongoing. Additionally, a session at the end of the semester is used for reflection, assessment, goal setting, and an introduction to the next internship experience.

"Internship in Teaching, Part II" places the preservice student in a "real world" teaching experience, focusing on the needs of urban preadolescents. Working with a neighborhood middle school, students under the direction of art education faculty, are assigned to a grade level interdisciplinary team of teachers. The task of the intern, in serving as an interdisciplinary team member, is to design a substantive art correlation and team teach a unit. (The instructional unit is taught as part of the academic team and is in addition to the students' regularly scheduled art classes). Our students begin by attending weekly team meetings and observing at the school site where they become familiar with the program and the students they will teach. Weekly meetings with the instructor on the college campus focus on planning the interdisciplinary unit and issues related to working in the urban school setting.

The instruction of the art unit is done by students in teams of 2, both having instructional responsibilities in each lesson. Each team teaches two different sections, twice a week, under the supervision of the college instructor and the mentorship of a teacher from the grade level inter-

disciplinary team. Working in the school environment, the student becomes aware of the variety of demands and challenges that constantly confront teachers as well as the need to make decisions that best serve the students, the school, and the instructional program. Students quickly find that they need to modify planned strategies and approaches while strengthening their management skills. Assessment and reflection is an essential and on-going part of the course. It becomes the basis for individual student goals to be set in student teaching.

Student Teaching and the Student Teacher Showcase

Student teachers spend seven weeks in both elementary and secondary settings with carefully selected cooperating teachers and schools. Student teachers begin to teach as soon as possible. To maximize their experience, they take over the entire program for the last three weeks. Three to four formal observations performed by college supervisors are followed by three-way conferences with the cooperating teacher, student teacher and supervisor. Student teachers keep an extensive log to document their work and experience. An accompanying seminar meets periodically to discuss issues which emerge around each placement as well as seeking a job.

The Student Teacher Showcase is the culminating event of the student teaching semester and the art education program. Held at the end of the experience, this formal event is shared with the entire art education department to celebrate the achievements of the student teachers. Additionally, area supervisors come to delight in the new ideas from neophyte teachers and, in some instances, to seek job candidates. Each student teacher sets up an installation illustrating the highlights of their experience through student work, lesson plans, and teaching visuals. In turn, they make a brief oral presentation to the entire assembly. The Showcase closes with our rites-of-passage ceremony in which these student teachers are awarded their first teacher's apple. The cooperating teachers are also recognized for their role in mentoring a young teacher into the profession. Scheduled each December and May, the Student Teacher Showcase provides an opportunity for art educators of all stages—from newly-declared majors to area teachers and supervisors—to professionally connect around new approaches to art in education.

OBSERVATIONS AND CONCLUSIONS

The Maryland Institute's mission as a professional school of art includes the preparation of art teachers; its art education program

serves to illustrate some of the potential inherent in such a setting. To draw highly committed art students from an intensive studio program is its first clear advantage. Its second advantage is the ability to shape a teacher preparation sequence which is equally rigorous and demanding. A careful screening and advisement process as well as a built-in review process helps in two ways: it attracts quality students and also assures cooperating teachers that students will be sent out to student teach only when they have demonstrated the readiness to do so. Such a policy serves the student well and makes working with our student teachers a highly positive experience.

We have noted certain trends as the program has matured. First, there appears to be a certain pride that comes with being in the program and entering the profession. Second, the program has begun to attract as many young men as women candidates and the number of minority candidates, while small, remains steady. There is a passion about teaching and a desire to make a difference in someone else' life through art which marks the candidates we see coming into the program. By the time they leave, we have the sense that something special has happened to them: they seem transformed by the experience--confident, articulate, well grounded, equally able to relate to students, parents, colleagues in the educational community, and members of the artistic community.

Yet, this account would be incomplete if we did not recognize the role the larger education community plays in the shaping of our teachers. Maryland is blessed with a history of curriculum development in art and it has been no problem to develop an extended family of master teachers who participate in our internship courses and mentor our students into the profession. Student teaching is still where the most significant transformation takes place; it is one third of the program and we are indebted to our cooperating teachers for the important role they play.

We have tried to make these contributions professionally reciprocal. Our provision of student scholarships for Saturday classes that cooperating teachers can award, will bring recognition and skills to individual students while enhancing the school's art program. As part of our continuing education program, we offer professional courses for art teachers. One pioneering effort is our MFA in Studio Art for Art Educators, a program designed for art educators who can commit four summers to residency on our campus. As with the pre-service program, these efforts are supported by a president, a dean, and a comprehensive faculty committed to contributing to the quality of art education in the schools.

Are there other ways of structuring a program? Certainly — and we muse on the possibilities constantly. The point is that within these smaller institutions with their sharply focused emphasis on the development of the artist lies tremendous potential for art education. Several other schools of art are now rebuilding and strengthening their programs. Probably the most exciting residue of a quality art education program in an art school is the increasing dialogue we hear among studio faculty about teaching. In addition, the art education department has periodically offered a seminar on the College Teaching of Art, which has involved a number of studio faculty and serves students in the Maryland Institute's various MFA programs. Thus, it appears that a quality art education program within a professional art school can do more than just impact upon the teaching of art in the schools. It has the potential of affecting the quality of art education at the post-secondary level as well.

Chapter 13

Adopt-A-School Project

ART EDUCATORS IN RESIDENCE

George Szekely
University of Kentucky

George Szekely
University of Kentucky

Dr. Szekely is Professor of Art Education and Director of Graduate Studies at the University of Kentucky in Lexington. He is also a painter who has had 12 one-person shows in New York City and has exhibited in major galleries throughout the United States. Dr. Szekely has contributed over 75 articles to journals of art and education. He is the author of six books, including *Encouraging Creativity in Art Lessons,* published in 1988 by Teachers College Press, and his most recent book, *From Play to Art,* published by Heinemann Educational Books. Dr. Szekely is on the editorial board of *Art Education* and is the editor of the *Kentucky Journal of Art Education.*

Chapter 13

Adopt-A-School Project

ART EDUCATORS IN RESIDENCE

George Szekely
University of Kentucky

I think we would all agree that the ultimate "client" of the art educator is the pupil in the school. Yet the pupil exists at a far remove from the contemporary art world, where new ideas, techniques, and materials are constantly being discovered and used. Somehow, despite the best efforts of art educators (many of whom are themselves practicing artists), these innovations—and the creative vitality they represent—seldom find their way to the school child. The Adopt-A-School Program is meant to bridge the gap between the art and university worlds, on the one hand, and the schools on the other.

TRADITIONAL ART EDUCATION PREPARATION

This gap can be traced to several causes. One of these is our traditional art teacher education program. Colleges of education have always been the ultimate agents of change at the school level, and teacher educators have always been aware of their responsibility in this area. In their studio courses, preservice teachers are taught to work independently, think innovatively, and break boundaries and tradition; in their educa-

tion courses, they are given all the latest theoretical developments in the teaching of art. But the actual teaching remains separated, both physically and conceptually, from the elementary school itself, and the workability of the imaginative projects our preservice teachers devise is never tested in actual work with children.

This is hardly the fault of classroom teachers, most of whom were not art majors yet were given no opportunity in their college careers to develop confidence in either their own art ability or their potential creativity in teaching others. After limited practical experience (consisting essentially of observing isolated art classes), the preservice teacher discovers, with the arrival of the student-teaching semester, the almost total void between college coursework and the realities of teaching in a school. Here the busy staff views the student teacher as an outsider and the student teacher's professor arrives only infrequently to answer questions (most of which arise from a school system relatively unfamiliar to the professor).

At graduation, the new teacher is cut adrift. The links between the university and the school are usually tenuous at best: alumni questionnaires, on-campus graduate courses (which the practicing teacher often sees as mere continuations of graduate work), and inservice workshops at the school, which tend to confront teachers with compulsory "one-shot" presentations by visiting specialists and participants who seek not creative ideas, but project formulas.

Thus, the new teacher-custodian of fresh new ideas is absorbed into the school world, where limitations of time, materials, space, and even support conspire to scale down ideas, soften experimental views, and confine inventiveness.

ADOPT-A-SCHOOL PROGRAM

The Adopt-A-School Program constitutes a change in both the preservice and inservice training of art teachers, in that the school becomes a base for fieldwork in art education rather than an appendage to the college classroom. It is a project that I have instituted over the last 20 years in elementary schools in various parts of the United States, most recently at the University of Kentucky.

The program is initiated by the college. Interested members of the art department present the plan to local schools—usually those that are not currently serviced by an art specialist—and the schools that are interested become participants in the program. Each faculty member may adopt a school over several semesters, an arrangement that pro-

motes interactions among the adopted schools such as invitations to each other's exhibits, exchange demonstrations, and newsletters for sharing ideas.

School principals often agree to this program because they recognize their obligations to the university and are willing to help, clearly indicating that they do not expect the school to benefit in having outside help from the university—a rather sad comment on the previous relationship between the schools and the university. Because elementary school enrollments have been declining, many schools have an unused room that they are happy to assign to the program. This room becomes the art resource center in the school and is used as a lecture room, an in-house studio, and a resource room for the school staff.

During the semester, the college faculty member acts as an art-educator-in-residence, using the school as a base of operations for teaching methods courses for majors and nonmajors and for working with student teachers. The majority of the preservice teachers tend to be nonmajors taking their single state required art education course in preparation for elementary school teaching. I usually teach two sections of methods for nonmajors each semester and adopt two schools, spending the bulk of my teaching time in the schools. Each class is made up of approximately 25 prospective teachers, each of whom is assigned to work with the same seven to eight children for the entire semester. During the session, each teacher candidate teaches a different art lesson.

On a typical day, our schedule begins with a 9:00 A.M. meeting in the art resource center, where a workshop and lecture are presented by the resident professor, followed by planning sessions for the afternoon's teaching and studio assignment. (The school's teachers are invited to join us at any or all of these morning sessions.) After planning sessions, the preservice teachers work on their studio assignments in various open school spaces. Lunchtime is used for informal discussions among the preservice teachers, the resident, and the classroom teachers. From 1:00 to 2:00 P.M., the preservice teachers go to their assigned classes to work with the children, while being observed by the classroom teacher and the (perambulating) resident. Those interested in particular grades or special populations are placed in those settings. The preservice teachers are encouraged to develop individual art presentations that are based on and developed from their own discoveries during the studio lessons.

Teaching experiences are followed by evaluations and discussion of the children's artwork, the preservice teacher's and the resident's notes,

and comments by the classroom teachers, who often attend the evaluation sessions. Of course, because the resident is always on the spot, the preservice teachers get immediate and constant response, praise and criticism, shared perceptions, and observations. Through methods coursework, various field experiences, and student teaching, the resident gets to know the preservice teachers not only as students, but also as teachers, and can work with them to enhance their strengths and overcome their weaknesses.

Both the theoretical and the practical content of the methods courses are much the same as those of regular methods courses. The difference is that the content is put into practice immediately, so that theoretical principles and curriculum designs are all tested with the children, constituting some form of laboratory work. Each assigned presentation is designed to incorporate specific objectives and teaching strategies for these future teachers to learn by doing.

A new and creative lesson deserves and needs extra work if it is going to succeed. The thought and care that go into a good lesson are demonstrated not only through the resident's own work, but also through the projects that he or she sets up for the preservice teachers. The art lessons to be taught are planned carefully and in great detail, from their innovative uses of space and (often nonschool) materials through the environment around the artwork—color, surface, lighting, even floor coverings—to the preservice teacher's use of movement while teaching.

The art-educator-in-residence contributes to the lessons by helping to arrange for the use of appropriate space, the purchase of special materials, and the transporting of unusual props to the school. A part of the preservice teacher's assignment is to keep a visual record of his or her accomplishments through photographs, slides, and videotapes, which are made available to the school staff and may be used by the resident in presentations to parents, administrators, teachers, and others.

A part of our strategy is to interest the school's teachers, so we hold our lessons not only in the classrooms but also in interesting alternative spaces: the school hallways, stairwells, lunchrooms, and so on. Not only does this approach benefit the children by breaking their association of art and art classes with particular prescribed places and procedures, but it also allows our program to be very much in evidence, a sure way to invite interest and inquiries. The teacher candidates are instructed to share ideas, answer questions, and generally welcome any interest shown by the classroom teachers. Our aim, I'm afraid, is to be frankly conspicuous, and we "go public" in our work, including our col-

lege classes, in order to make new ideas and approaches accessible to the whole school staff. Our art resource center is kept open at all times—even when we are not there—and it is constantly filled with intriguing objects, artwork, lesson files, videotapes, slides, and displays for the teachers to inspect and borrow whenever they like. All of our handouts and materials are made available to the school staff.

The preservice teachers become involved in all aspects of school life, not just in the art program. They help with media exhibits and media presentations; exchange ideas with staff; discuss the program with parents; and find out from bulletin boards, textbooks, and conversations what units are being covered in other subject areas, so they are often able to incorporate this content into their teaching of art. In this way, they establish formal relations and easy communication with the teachers, learn about how an actual school functions, and see how the art program can become a vital part of the school. The school's art program becomes not the object of an academic debate, but a practical concern.

ART EDUCATOR RESPONSIBILITIES

What are the responsibilities of the art-educator-in-residence in all of this? There are many. First, and perhaps most important, the resident serves as a liaison and buffer between the school and the preservice teachers. He or she can help lift the traditional restrictions and expand the school's self-imposed limitations, which seem to stay in place regardless of vast changes in the art world. As a result, instead of being forced to conform, the preservice teachers are encouraged to experiment and try out new techniques of teaching and approaches to art, gaining confidence because they are important elements in introducing a new program into the school. Merely the supportive presence of the resident bolsters the preservice teachers' willingness and eagerness to try new ideas and explore new possibilities.

Through the resident, all facets of school life become far more open to the preservice teachers than if they were individual observers. Instead of observing an individual class, they explore the school's entire art program and its possibilities and get a balanced picture. Moreover, because a resident becomes thoroughly familiar with the school, its art program, and its staff, rather than appearing once a semester to observe a student teacher, he or she can give real and specific guidance when student-teaching questions and problems arise.

The resident also assists in the transition of content from college to school, helping the preservice teacher keep the content meaningful and innovative rather than watering it down until it is "appropriate" or "fea-

sible" for a school art program. The resident encourages the preservice teachers to set up personal routines that allow them to continue their own artwork, so that they do not separate art making from art teaching. Too many teachers either think of their own work as totally isolated from the classroom or, unfortunately, abandon it altogether—I believe that working artists are simply better art teachers.

The second major responsibility for the resident is the responsibility to the school and its teachers and pupils—in other words, to art education itself. The resident should help design new and innovative curricula and teaching approaches, bring in new resources or put the school staff in touch with outside resource people, act as a liaison with the art world, build teachers' morale and their skills and confidence in the teaching of art, and demonstrate a sense of caring through service and full participation in school life.

At the beginning of the project, the resident may be seen as an intruder, an outside critic from the ivory tower. It is hoped that this view will soon change and the resident will be seen as a resource person and ultimately as a valued colleague who wants not to change the system, but to work within the system and with individuals toward common aims. To promote this view, the resident establishes an informal and cordial relationship with the school staff, showing a genuine and active interest in all elements of school life as related to the arts—not just his or her own preservice teachers.

The resident becomes "part of the scene" and is available at coffee breaks and lunchtimes for creative dialogues that promote trust and mutual support, stimulate both negative and positive comments, and invite contributions. All the time, the resident must show sensitivity to his or her position as an outsider (at least at first); the teachers' fears and insecurities about their art training, art ability, and art teaching and their isolation from artists and the art world; the teachers' self-esteem and individuality; the difficulties for teachers involved in the institution of any new program; and the uniqueness of each school. The teachers are experienced professionals. They have developed techniques that work within their school and are valid. Not only is it hard (for all of us) to part with favorite tried and true methods, but teachers' complaints about lack of space, time, and supplies required for the innovations and about scheduling difficulties may well be legitimate. The teachers need understanding and support in their new efforts and help in solving the problems that come up. The answers are not easy, and they are not the same for each school.

As an art-educator-in-residence, I use a variety of strategies for working with school staff. Many workshops are offered to the teachers, ranging from miniworkshops in new art techniques to informal discussions of personal art skills. I share handouts with them or bring in the latest periodical. We may meet at a flea market to search for "found objects" or at a gallery or museum for an informal tour. Teachers may want to help with planning an exhibit. The library may be used as a minimuseum for the display of artists currently exhibiting in the area.

I try to bring the teachers in touch with the art world, and by extension encourage them to do their own artwork. I invite teachers to visit my studio and perform the function also of artist-in-residence. I invite teachers as special guests to my own exhibitions, and they are treated as preferred guests. I try to keep them informed of programs of interest to them, such as training in special skills, community arts center offerings, and art therapy groups. I also help in gaining art funds for the school to purchase materials and artworks and to bring in community guest artists.

Above all, I try to build the staff's confidence through a variety of means: demonstrating pride in the school's activities and bringing them to the attention of other school and community groups; showing interest in all the creative efforts of the school staff; and not overshadowing them with model presentations. I also keep the college faculty informed so that they may observe our work whenever possible. And I try to maintain the school's long-term interest in its new art program through social visits after our residency has ended and by offering leadership training sessions for interested teachers to be held at the school, in galleries, or at the college.

What is gained by all of the time, energy, and effort that go into the Adopt-A-School Program? First, the school and its pupils get a new, tailor-made art program without the need for grants or other kinds of outside financial support. The advantages of the preservice and inservice training programs have already been covered extensively. I would like to point out in addition, however, that when methods courses for nonmajors are taught in the school, the nonmajors get valuable experience in teaching art that ordinarily would be totally missing from their training. They quickly gain confidence in their own art abilities, which is reinforced immediately by sharing their discoveries with the children and by the positive responses of the children and others in school.

As for the art educators, they have the satisfaction of putting their ideas into action and seeing their results, of coming alive in a setting full of experimentation and interaction, of graduating teachers who

they know from personal experience will be good teachers, and of returning to their college classrooms full of rich examples and a more realistic appraisal of the art teacher's needs.

SUGGESTED READINGS

Szekely, G. (1979). Uniting the roles of artist and teacher. *Art Education, 31*(1), 17-21.

Szekely, G. (1982). Adopt-a-School: A program of visibility. *Design for Arts in Education 82*(3), 28-31.

Szekely, G. (1982). Art Partnership Networks: A supportive program for the artistically gifted. *The Elementary School Journal, 14*(2), 59-67.

Szekely, G. (1982). Art partnerships. *The Teacher Educator, 14*(2), 59-67.

Szekely, G. (1988). *Encouraging creativity in art lessons.* New York: Teachers College Press.

Szekely, G. (1991). *From play to art.* Portsmouth, NH: Heinemann.

Szekely, G. (1993). The Adopt-a-School Project. *Art Education, 45,* 18-25.

Chapter 14

Aesthetic Scanning with Preservice Elementary Classroom Majors

Sally Myers
Ball State University

Sally Myers
Ball State University

Dr. Myers is Assistant Professor of Art at Ball State University in Muncie, Indiana. She coordinates the elementary education program for non-art majors in the Art Department. She received her B.F.A. in crafts at Virginia Commonwealth University, her M.F.A. in fibers at the University of Washington, and her M.A. and Ph.D. in art education and higher education at the University of Arizona. Her research interests focus on preservice elementary education students and their conceptions of art and art education.

Chapter 14

Aesthetic Scanning with Preservice Elementary Classroom Majors

Sally Myers
Ball State University

In 1985, Hannah Wilke gave a lecture on her photography and sculpture at the University of Arizona. During her presentation, she included some remarks about the general public and modern art. Her ideas were not unusual for a 20th-century visual artist, yet they seemed to strike a familiar note with me. They made me aware of my rationale for teaching preservice elementary education majors to use aesthetic scanning as a way to look at and understand artworks.

To paraphrase Wilke's remarks, she said that people who would have no expectations of reading a scientific journal article on a scientific development that evolved over the course of 10 years, nevertheless hold

the view that their lack of formal tuition should not keep them from an immediate understanding of any artwork they encounter. She found this attitude disheartening and was angry at the general public for their lack of sophistication and what she perceived to be their simplistic expectations about art. In her comments and their implications, I believe that she was both right and wrong.

The sciences have never pretended to be enjoyable and understandable to everyone. The general public has few expectations about understanding any but the most basic concepts and, in fact, is mostly content to be left with the directions of how to turn things on and off without considering the scientific constructs behind the technology. The arts do not seem to enjoy this latitude. For many reasons, including a lack of any straightforward, utilitarian use for the visual arts, the general public seems to believe that art should represent a less definable concept such as beauty and that it should touch them in some "universal-truth" way. Art should, in this belief system, require nothing in the way of study. People do not consider this to be an unusual expectation, and, in some ways they are right.

My experience of this expectation has been through my students, who are preservice elementary classroom majors, and a random sample of museum visitors. Members of both groups often make comments about artworks such as "My little sister could do that." Advocates of more required classes in the humanities would say that these preservice teachers, as college students, should know better, but the fact is they often do not.

The present reality is that this group has neither the time nor the interest to really see and understand the art they encounter—that is, to see it through the lenses provided by their education (Broudy, 1972a). This is not necessarily the reality that we must accept for the future. Preservice teachers who develop an interest and some naive understanding of artwork may chip away at and finally dispel these ideas if they can begin to feel comfortable looking at and talking about art.

The dilemma for art teacher education is how to get this population to acquire the rudimentary skills they need to look at art, get past their initial likes and dislikes, and so form their opinions based on careful observation. In the time frame of a university or college semester or two, how do they get on the road to "enlightened cherishing" (Broudy, 1972b) without the requisite study? What is needed is a short course in art appreciation that does not depend upon a knowledge of either history or criticism, or a background in humanities, but is authentic to the discipline of art criticism.

AN ORGANIZED APPROACH TO
VIEWING ARTWORK

In my courses, I rely on a quasi-formalist approach that simplifies the process of looking at art by giving the students an organized way to approach the work, namely aesthetic scanning. The effects of this system are instantaneous. My preservice teachers are relieved to have an understandable, clear system through which to "enter" an artwork. The organization of this system guides them as they look closely at the work.

The system has clear steps by which the preservice teachers identify and describe the elements or sensory properties of a work. Finally, they add up their gathered information to reach a conclusion about the expressive property: a metaphor, content idea, emotion, or mood that the work seems to embody. The result should be a range of plausible choices in which the preservice teacher contributes by referring to information from the artwork.

For the purposes of the exercise, the preservice teachers adopt a philosophical stance in which they act as if the feelings, moods, and ideas are *in the work*, not in the person viewing the artwork. This means that every description must refer to some aspect of the artwork, not the viewer. In this way, preservice teachers can agree and disagree about the work, and these conversations can be resolved by each preservice teacher's referring to aspects of the work, not to his or her own memories, unique experiences, or feelings. That frees the preservice teachers to make choices and state them without challenging the legitimacy of their classmates' feelings. The scanning system provides the questions, and the artwork provides plausible answers.

ANSWERING THE CRITICS

The aesthetic scanning system is open to some criticism. Among these criticisms are the rigidity of the system, its emphasis on formalism, and its lack of contextual information concerning the artwork. For answers to these criticisms, we must turn to the intended use of the system. It claims only to be the "A B Cs" of looking at art, and it is aimed at the naive viewer. The naive viewers with whom I work delight in its structured aspects, because it gives them something firm to hold on to in the beginning.

Context, which is important to any artwork, especially those from cultures other than the ones the viewer knows, can only be understood through study. This goes back to the original premise of this chapter. I

believe that scanning provides a way into the work, a way to spark further interest in the context.

Contextual questions such as "Why are those symbols placed in a circle above the forehead of that mask?" can only be answered through further research. Before a viewer can ask questions such as this, he or she has to take a careful look at the mask. That is the purpose of aesthetic scanning. Do naive viewers arrive at different plausible conclusions than those who know the context of the work? Sometimes. Yet, more often than not, I have found that plausible explanations found by naive viewers through the scanning process are enhanced, not confounded, by knowledge about the context of the artwork.

The format of the scanning process can take many forms with preservice teachers. Small- or large-group discussions are easy possibilities. Small groups of preservice teachers or individuals can fill out "fill-in-the-blank" scanning sheets that ask specific questions about a specific artwork. I have asked my prospective teachers to choose an artwork and then describe and follow one or two elements through the scanning process. I have asked them to find and match certain elements and principles according to their use in different artworks.

Preservice elementary education majors probably do have a reasonable expectation to be able to see and appreciate the art they encounter. The required formal study in the aesthetic domain is within the realm of general education (Broudy, 1972a), but so far, most public schools have not provided the background needed to appreciate art forms. For this population, aesthetic scanning is important.

All of us who teach preservice elementary classroom teachers want our students to enter their future classrooms with a sense of understanding and awe concerning artwork. Aesthetic scanning is one authentic way to simplify the process of the aesthetic experience by concentrating on properties found in the work itself and by describing them systematically. It is not a perfect system, but it accommodates many learning and teaching styles, time frames, and populations without sacrificing the expressive content of artwork.

REFERENCES

Broudy, H. S. (1972a). *Enlightened cherishing.* Urbana-Champaign: University of Illinois Press.

Broudy, H. S. (1972b). *The real world of the public schools.* New York: Harcourt, Brace, Janovich.

Wilke, H. (1985, Fall). *The photographs and sculpture of Hannah Wilke.* Unpublished lecture given at the University of Arizona, Tucson.